114

# Leonardo's Legacy

# Leonardo's Legacy

## AN
## INTERNATIONAL
## SYMPOSIUM

### EDITED BY C. D. O'MALLEY

*(a collection of opinions or essays)*
*(on a given subject)*

1969 BERKELEY AND LOS ANGELES

UNIVERSITY OF CALIFORNIA PRESS

U C L A Center for
Medieval and Renaissance Studies
Publication Number 2

---

University of California Press
Berkeley and Los Angeles, California

University of California Press, Ltd.
London, England

Library of Congress Catalog Card
Number: 68–14976

Designed by Wolfgang Lederer
Printed in the United States of America

# Foreword

FROM the 2nd to the 8th of May 1966 an international symposium on Leonardo da Vinci was held at the University of California, Los Angeles. The occasion was part of the celebration marking the opening of the new Dickson Art Center. The subject was chosen in recognition of Dr. Elmer Belt's generous donation of his great collection on Leonardo which, sumptuously housed within the Center, thanks to the generosity of the Norton Simon Foundation, was formally opened as the Elmer Belt Library of Vinciana to coincide with the opening of the symposium. As one participant in the symposium declared, "Possibly the British Museum or the Library of Congress contains, scattered throughout the immensity of its shelves, most of the volumes in the Belt collection. But nowhere else can we have the physical feeling that the knowledge we are seeking is concentrated to the degree that it is here." Moreover, "As with some chemical reactions so with books; the concentration of the reagents is sometimes critical for the production of certain phenomena, in this case an inspired stimulation."

Although it was not a "Leonardine year," the theme of the symposium was obviously the proper one, and it was by sheer coincidence that the opening lecture by Sir Kenneth Clark was delivered on the same day on which Leonardo's life came to its close in 1519. But if in this respect the symposium may be considered as having represented a memorial to one of the great figures of the past, nevertheless, as one reads its now published lectures, it will quickly become apparent that through his achievements and influence Leonardo remains very much with us.

It was the purpose of the organizing committee to seek out the most distinguished authorities on the many facets of Leonardo's career, and although, as mentioned above, the occasion was the opening of the Dickson Art Center, yet, as Dr. Keele remarked in his presentation, drawing from the words of another participant, Professor Heydenreich, "the great mass of Leonardo da Vinci's manuscripts was directed towards the goal of three great publications, one on Painting, a second on Mechanics, and the third on Anatomy." One has merely to consult the table of contents to realize the width of subject matter covered by the lectures as originally presented and as contained herein: art, physiology, literature, technology and automation, architecture, hydraulics, and bibliography.

In the instance of each of these wide-ranging subjects an attempt was made to gain the participation of the major authorities—happily and gratifyingly achieved—with the results that may be read below. It should be immediately apparent that large areas of Leonardo's investigations and conclusions have hitherto remained untouched if not, indeed, unknown, such as the influence

of antiquity upon his art, in turn Leonardo's influence upon Bramante, his stylistic practices as a writer, his hitherto unconsidered but very important studies in neurophysiology, his great interest in and long-unappreciated contributions to many of the problems of technology and engineering, and his concern as both scientist and artist with the subject of hydraulics. It would be possible to refer in detail to many more hitherto unconsidered Leonardine novelties, but the reader need only turn to the papers to discover them.

It seems unlikely that anyone could read these papers without gaining a wider and deeper appreciation of Leonardo's accomplishments; and to some they will undoubtedly indicate wholly new areas for investigation and research.

The symposium itself and its now published lectures were both made possible through the generous and gratefully acknowledged support of the Samuel H. Kress Foundation. The contributors wish to express their deep gratitude to Her Majesty Queen Elizabeth II for gracious permission to reproduce drawings from the manuscripts of Leonardo da Vinci in the Royal Library, Windsor. Sincere expressions of appreciation are also extended to Chancellor Franklin D. Murphy for his continued interest and support and to the many others who helped to make the symposium a success and thereby contributed as well to the present volume.

C. D. O'Malley

# Contents

vii

# Abbreviations
# occasionally used

Trat.   (1) *Treatise on Painting*. Published by H. Ludwig, 1882.
Ed. I. A. Richter (1955). *Notebooks of Leonardo da Vinci.*
(2) *Treatise on Painting*. Trans. A. P. McMahon.

C.A.   *Codex Atlanticus*. Published by Giovanni Piumati.
Milan, 1894–1904.

A, B, C, D, E,
F, G, H, I, K,
L, M   *Notebooks of Leonardo in the Library of the Institut de France.*
Published by Ravaisson Mollien, Paris, 1881–1891. They include B.N. 2037,
B.N. 2038, formerly in the Bibliothèque Nationale.

Ash.   *MS Ashburnham 2038*, now in the library of the Institut de France.

Wind.   *Manuscripts at the Royal Library, Windsor.*
Catalogued by Sir Kenneth Clark, Cambridge, 1935.

Fors.   *Codices Forster (I, II, and III)* in the Library of the Victoria and Albert Museum,
South Kensington. Published by the Reale Commissione Vinciana, Rome,
1930–1936.

Q. I–VI   *Leonardo da Vinci Quaderni d'Anatomia.*
Published by O. C. L. Vangensten, A. Fonahn, H. Hopstock,
Christiania, 1911–1916.

F.B.   *MS di Leonardo da Vinci della Reale Biblioteca di Winsor. Dell' Anatomia fogli B.*
Published by T. Sabachnikoff and G. Piumati, Milan, 1901.

Tr.   *Codex Trivulzianus*, Castello Sforzesco, Milan.

C. Ar.   *Codex Arundel*. 1923-1930.

# Leonardo
# and the Antique

## by SIR KENNETH CLARK

THE romantic concept of genius carried with it, in the nineteenth century, the notion that the greatest poets and painters achieved their ends almost unaided by study, imitation, and all the other disciplines through which lesser men have sought to master their arts. Shakespeare's "small Latin and less Greek" was taken to mean that he had somehow acquired the richest vocabulary in the English language without reading. Rembrandt was usually described as almost illiterate. And Richter could say of Leonardo that it was no part of his ambition to be well read. For Leonardo this position was changed by the publication of Solmi's masterly studies on the sources of the note-books. But scholars still maintained that, unlike other great artists of the Renaissance, Leonardo made little use of that quarry of visual ideas, the sculpture of ancient Greece and Rome.[1] To his contemporaries such a point of view would have seemed incomprehensible, for to them a knowledge of antique art was a prerequisite of excellence in design, almost to the same extent that mathematics has become a prerequisite to the study of physics. Cesariano was expressing the accepted opinion when he said, in one of his notes in the Como Vitruvius,[2] that

[1] Only two studies of Leonardo and the antique are known to me. One of them is the chapter in E. Müntz's *Leonardo* (Paris, 1899) in which he quotes Springer as follows: "Souvent déjà on a signalé la pénurie véritablement extraordinaire de l'influence exercé sur lui par l'antiquité"; the other is a lecture by K. T. Steinitz reprinted in *Proceedings of the IV International Congress on Aesthetics* (Athens, 1960), pp. 114 ff. The *Bibliografia Vinciana* of E. Verga (Bologna 1931) lists another work which I have not seen: H. Klaiber, *Leonardostudien* (Strasburg, 1907), which includes a chapter of general observations on "Leonardo und die Antike."

[2] Vitruvius, *De architectura,* commentary by Cesare Cesariano (Como, 1521), fol. XLVI*v:* "Ma per le publice memorie ītra le altre cose che hano lassato li gloriosissimi & liberalissimi Romani: li architecti: & sculptori: & pictori dignamente havendo di quelle cose immitati le symmetrie & exempli: molti sono peruenuti

a la excellentia: Et chi ha cōsequito la nobilitate: Si como Andrea Mantegna: Leonardo Vince: Bramante urbinense: & alcuni altri como Michele Angelo Fiorentino: quale in pictura & sculptura si uede Egregio." Cf. C. Pedretti, *Leonardo da Vinci on Painting . . . Libro A* (Berkeley and Los Angeles, 1964), p. 136. In the 1536 edition of Vitruvius, fol. 55*v,* another commentator who was personally acquainted with Leonardo, Gianbatista Caporali, speaks of the classical revival in Milan at the end of the fifteenth century and adds: "Diremo alla Citta di Firenze similmēte da poi la Casa di Medici esser' peruenuti, come Michelangelo Bonarote statuario & dipintore dignissimo, āchora Leonardo vinci." Finally, Paolo Giovio, in his *Dialogus De Viris Litteris Illustribus* (ed. C. Pedretti, *Italian Quarterly,* VIII [1964], 3–9), writes of Leonardo: "qui picturam aetate nostra, veterum ejus artis arcana solertissime detegendo, ad amplissimam dignitatem provexit."

1

Leonardo, together with Mantegna, Bramante, and Michelangelo, was one of those who had achieved excellence as well as nobility by the study of Roman antiquities. For that matter, Leonardo himself, in a well-known passage, says "l'imitazione delle cose antiche è piu laudabile che le moderne." [3] Why, then, have scholars so frequently and categorically denied that Leonardo achieved inspiration from the forms and images of antiquity? There are two possible answers. First, Leonardo's choice of antique models and the use to which he put them were, to a large extent, anti-classical. We now agree that a great deal of antique art is as far from our established concept of classicism as antique mythology is from a serene rationalism. But to nineteenth-century critics antique art was essentially classical art and they could not have believed that a mannerist like Rosso drew on the repertoire of Graeco-Roman images almost as frequently as Poussin, but sought them in different works and with different implications. Leonardo, who anticipated the mannerist style in so many respects, discovered in antique art images of violence and mystery.

The second reason is that during Leonardo's youth in Florence the inspiration of antique art was in fact going through a period of eclipse. The first great age of creative assimilation, the period of Donatello and Ghiberti, had ended some twenty-five years earlier. To the founding fathers of the Renaissance, antiquity had been what nature was to Wordsworth, a passion and an appetite, and a living force which they could make their own. We can find in their work hundreds of quotations from antique art; but they are all completely subordinate to the artists' individual styles and are used to further the high purposes of their themes. In the 1460's there was a reaction. Fashion demanded a more sprightly and decorative style, and painters turned back to the linear tradition of international Gothic. As for sculpture, one need only compare the David of Verrocchio, probably made when Leonardo was in his workshop, with the David of Donatello, done about thirty years earlier, to realize how the sense of antique fullness and calm had been discarded in favour of an alert elegance. In the same period the study and interpretation of antique literature had undergone a similar change. In the place of the philological and historical approach of Poggio, there had developed the esoteric fancies of Marsilio Ficino and Pico della Mirandola. Of the earlier generation only Leon Battista Alberti survived, Alberti who had guided Ghiberti and Donatello round the ruins of Rome, and whose manual on painting, written in 1435, must have seemed, by 1470, ridiculously old-fashioned and severe.

Meanwhile the two greatest painters outside Florence, Piero della Francesca and Mantegna, had discovered two new implications in antique art. Piero had been fascinated by the metric of Greek sculpture and the light atmospheric tone revealed by fragments of Hellenistic painting. Mantegna, who was, in a sense, the closest follower of Donatello, was a romantic antiquarian, for

---

[3] Codex Atlanticus 147r b, one of a series of notes connected with the Sforza Monument and having special reference to the equestrian figure in Pavia known as the Regisole. See Leonardo da Vinci, *Fragments at* *Windsor Castle from the Codex Atlanticus,* ed. C. Pedretti (London, 1957), pl. 9. See also L. H. Heydenreich, "Marc Aurel und Regisole," in *Festschrift für Erich Meyer* (Hamburg, 1959), pp. 146–159.

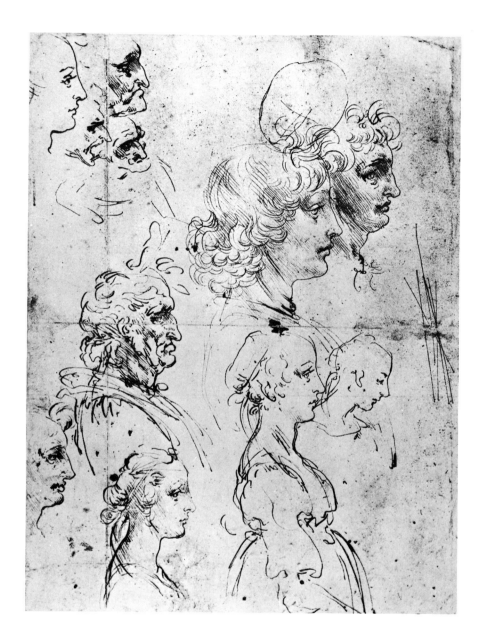

*Figure 1*
Drawings of heads. Windsor 12276*v*.

whom every vestige of the Roman world was so precious that he felt bound to cram it into his reconstructions of early Christian history. But Piero, after his apprenticeship to Domenico Veneziano, left Florence in about 1440 and seems never to have returned; and although Mantegna visited Florence in 1466 as a famous and respected master, his particular brand of antiquarianism had no influence till a later date. Thus during the six or seven years in which Leonardo was a member of Verrocchio's workshop, from 1470 to 1476, the influence of antique art was at a low ebb. No doubt its authority was still invoked; and no doubt pattern-books of antique motifs, drawn

3

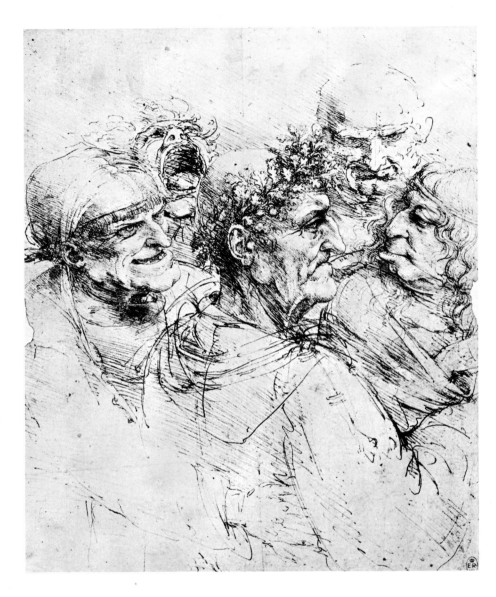

*Figure 2*
Emperor and
grotesques.
Windsor
12495*r*.

from coins, gems, and reliefs, were available in artists' workshops and were used in decorative detail. But it was not the living force it had been and was shortly to become.

A famous drawing at Windsor, 12276 (fig. 1), done when Leonardo's long association with Verrocchio had just come to an end, reveals to us, for the first time, a deep-seated dichotomy in his spirit. It consists of eleven heads in profile, and dominating them are a resolute elderly man and a classically beautiful youth. These two heads are symbols of the active and passive elements in Leonardo's character, and it is an extraordinary fact that they retained this symbolic function practically unchanged for almost forty years. One might easily run across the elderly man in the lobby of the Mayflower Hotel; and one could certainly find the charming youth in the streets of

4

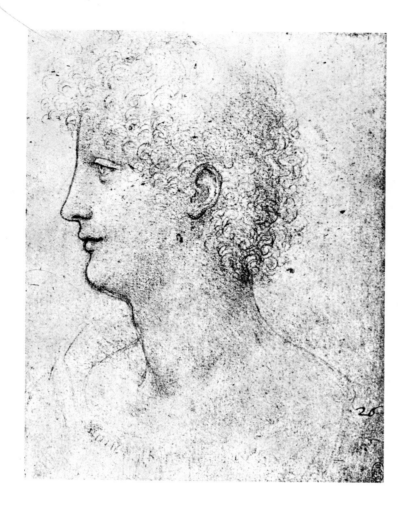

*Figure 3*
Profile study
of youth's head.
Windsor
12557.

Florence. Nevertheless, they are both ideal types with their roots in antiquity, the elderly man in Rome, the youth in Hellenistic Greece. I do not myself think, as Emil Möller maintained, that the youth is directly inspired by an antique; he is the regular Verrocchiesque type, comparable to the St. Thomas of Or San Michele. The willful old senator, on the other hand, is unquestionably influenced by a portrait of a Roman emperor, perhaps by a coin of Galba. It is true that this type of hard-bitten warrior had already appeared in the work of Verrocchio and had even served as the basis for his idealized head of Colleoni. But Leonardo's profiles are more positively Roman, and we can be sure that he thought of them as emperors, because in several drawings they appear crowned with wreaths of laurel.[4] In a later drawing at Windsor the emperor type is definitely inspired by a

[4] E.g., Turin, Biblioteca Reale, no. 15575; cf. also the profile on the verso of the British Museum sheet of studies for the Burlington House cartoon (Popham 144).

5

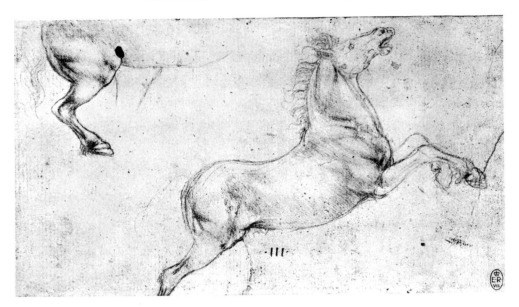

*Figure 4*
Studies of horses.
Windsor 12315.

Roman bust.[5] How deeply the idea of the Roman emperor was rooted in Leonardo's imagination is shown by the famous drawing at Windsor, 12495 (fig. 2), where the crowned emperor, old and exhausted, is surrounded by grotesque figures, who seem to be mocking at his infirmity.

To say that in Leonardo's art Roman [6] and Hellenistic elements alternate and supplement one another would be an over-simplification. But in so far as it is true that throughout his life he seemed to be possessed by two contrary spirits, the virile spirit of energy and the feminine spirit of mystery and grace, we can perhaps say that the former was nourished by Roman art and the latter by Hellenistic (fig. 3).

The earliest echoes of antiquity in Leonardo's work are the drawings of graceful, nervous, moonlit horses done in connection with the Adoration in the Uffizi. A drawing in Windsor, 12315 (fig. 4), shows one of these horses in its simplest form. It almost certainly goes back to sarcophagus reliefs that were known to other artists of the Renaissance; for example, a similar horse appears several times in the albums of Jacopo Bellini, who transforms it into a Pegasus. That we are justified in calling this type of romantic horse Greek (in spite of its more rounded quarters) is shown

[5] No. 12556. P. Meller (*Acts of the XX International Congress of the History of Art* [1963], II, 55–57) believes it to be an idealized portrait of Gian Giacomo Trivulzio and that it is the same man as nos. 12502 and 12503.

[6] I use the word "Roman" in the sense of the style used on monuments as expressive of the Roman ethos, without wishing to imply that it was invented by the Romans. In fact the origins of the style can be traced back at least as far as the kingdom of Pergamon.

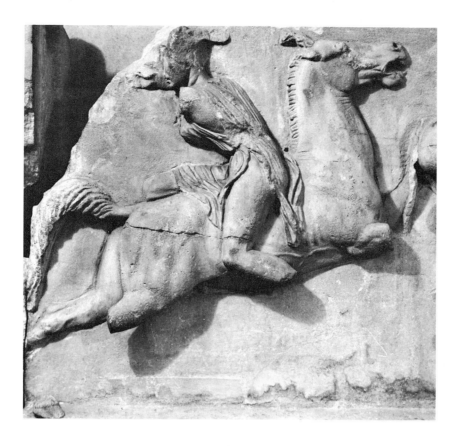

*Figure 5*
Detail of horse from frieze
of antique mausoleum.

by its appearance on the frieze of the Mausoleum (fig. 5); and although, of course, Leonardo can never have known the originals, it is extraordinary how closely he has recaptured their spirit (fig. 6), even down to the turned-back head which gives to the rider the same dreamlike disregard for stability.

Immediately after the Adoration (fig. 8) Leonardo transferred his ideas about rearing horses to his studies for the Sforza Monument, and began by experimenting with a similar pose in which the horse is cavorting over a fallen warrior (fig. 7). This, too, was a relief motif and we have several indications of the relief from which it was derived. One of them is a marble relief on the façade of the Duomo of Pavia.[7] Since the decoration of the façade continued over many years, it could conceivably be derived from a design by Leonardo. The other is a drawing in the London volume of Jacopo Bellini's album (fig. 9), in which classical reminiscences are fancifully combined into a sort of monument. The date of the drawing is a matter of dispute. The London album bears on the

[7] Reproduced in F. Malaguzzi Valeri, *La Corte di Lodovico il Moro,* II (Milan, 1915), fig. 49g

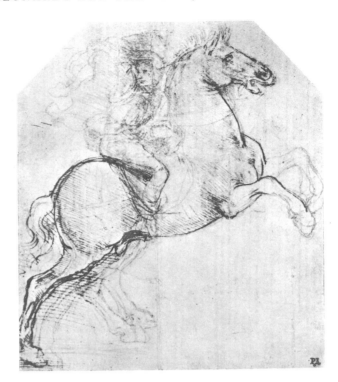

*Figure 6*
Horse with rider. Private
collection, London.

fly-leaf the date 1430, but on stylistic grounds most of the drawings it contains would seem to have been done about the middle of the century. At least we can say that it antedates the Leonardo by over thirty years. It is probable that Leonardo knew other reliefs of horsemen prancing over prostrate foes and he must have made several designs for the monument in this form, four of which were considered important enough to be engraved (fig. 10). Of these four designs only the top right-hand figure has the flat, open pose of a genuine antique. In the others we see for the first time what was to prove a characteristic of Leonardo's borrowings from antiquity: the more complicated rhythms and denser plasticity that he imposed on his figures.

One can hardly believe that Leonardo seriously considered carrying out these projects in the round and on a heroic scale. And the problem would not have been made any easier if, as other drawings indicate, he had transferred the pose from a horse and rider *all'antica* to a horseman in Renaissance armour. It is not surprising that in 1489 Ludovico il Moro wrote to Lorenzo de' Medici in Florence asking him to recommend one or two masters more apt for the work. Such was the first result of Leonardo's interest in the antique.

The next ten years were those in which the imagery of Graeco-Roman art had least obvious effect on Leonardo's art. True, the antique equestrian statue at Pavia known as the Regisole, and perhaps the horses of St. Mark's, may have had some influence on him when, after 1493, he made his second attempt on the Sforza horse. But, in general, his studies for this phase of the monument

8

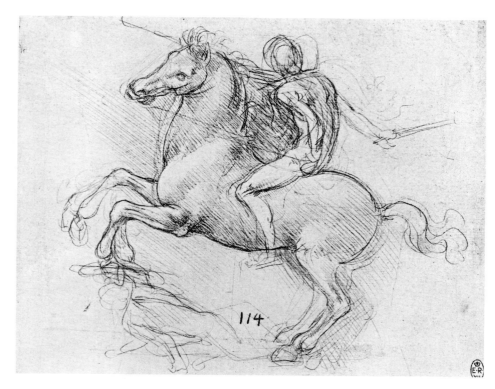

*Figure 7*
Horse with rider.
Windsor 12358*r*.

are studies from life; and there is no direct reference to antiquity in his other works, the portraits and the Last Supper. We cannot attribute this absence of antique influence solely to the scarcity of examples, because we know from Bramante that antique fragments were not unknown in Milan and its surroundings. Rather, it is due to the fact that this is the period when the theory of antique art, rather than its visible practice, began to occupy his mind. It was during these years, as we know from the vocabularies in MSS H and I, that he extended his knowledge of Latin so that he could cope with the difficulties of antique authors like Vitruvius, or with those humanists like Leon Battista Alberti whose principal works had not yet been translated into Italian.

Now, although the Last Supper shows no direct influence of antique art, it was essentially a development of the type of composition which had been brought to something near perfection by the founding fathers of Florentine humanist art, Masaccio and Donatello. It belongs to the same imaginative world as Masaccio's Tribute Money, and its centralized composition with a heroically simple perspective scheme recalls Donatello's reliefs in the Santo. It is the supreme illustration of Leon Battista Alberti's *della Pittura*, and in fact there can be little doubt that Leonardo had first read Alberti during this period, although the numerous paraphrases of the *della Pittura* in the note-books seem chiefly to belong to a later date.[8] By Alberti he would have

[8] Cf. Pedretti, *Libro A,* pp. 117, 119.

9

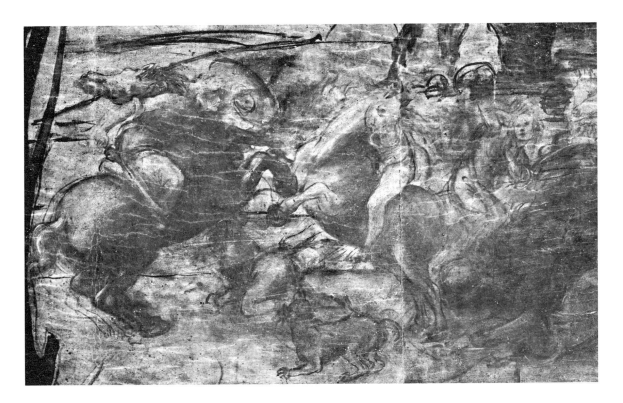

*Figure 8*
Detail of horses from Adoration
of the Magi. Florence, Uffizi.

been encouraged in a theoretical study which may be called classical in the narrower sense, the analysis of human proportion and its relation, through geometry, to ideal beauty. Later in his life Leonardo was to link these speculations to the study of anatomy. But in this first appearance they are Pythagorean. The famous drawing in Venice of a Vitruvian man, which has become a sort of trade-mark of Leonardo, although in fact it is exceptional, must date from between 1485 and 1490. It is exceptional not only because it is a show-piece intended for some patron or perhaps an engraver, but because it is *a priori*. Leonardo's first encounter with theory has frozen for once his scientific curiosity, and this drawing is without the questioning eye and mind that mark his later studies of the human body. Several of the drawings that have come down to us from this period of theoretical studies [9] show him attempting to establish a proportion for the human head which could be stated in terms of Euclidian geometry, and these must, I think, be related to the work of the leading mathematical theorist of the day, Luca Pacioli.

I have said earlier that during Leonardo's youth one of the two artists who had found fresh inspiration in the art of antiquity was Piero della Francesca. We have no reason to believe that

[9] E.g., Windsor 12601; Venice Academy 236*r* and *v;* Turin, Biblioteca Reale, 15574*r*. All of them date from about 1490–1495.

10

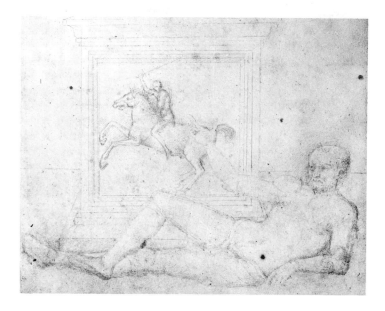

*Figure 9*
Horse with rider. Album of
drawings by Jacopo Bellini,
London.

Piero's paintings were known to Leonardo (although at a later date he was in Arezzo), and Piero's grave, static figures are at the furthest remove from Leonardo's ideal of animation. Yet there was a direct link between them, and that, of course, was Pacioli. He was the friend of Piero, who even included his portrait in his last great altar-piece, now in the Brera. As is well known, Pacioli took over, almost word for word, Piero's conclusions on proportion and published them in 1509 in a book called *Divina Proportione* which he had completed in 1498. He made rather unobtrusive acknowledgement to Piero, but he referred in glowing terms three times to Leonardo. He states unequivocally that the illustrations could not have been better, because they are by the infallible left hand of the prince of men, Leonardo the Florentine. There can be no doubt that he not only instructed Leonardo in mathematics (Leonardo himself tells us this), but also transmitted to him Piero's Euclidian approach to human proportions.

Thus by 1500 Leonardo had studied the pictorial science that, in Renaissance times, was believed to be one of the chief legacies of antique art; but he had shown little interest in its imagery. From 1503 to 1510, on the other hand, he was obsessed by two or three motifs drawn directly from the antique. How can we account for this remarkable change of direction? I believe that only one answer is possible: that at some point between leaving Milan in 1500 and settling in Florence in 1503 Leonardo had visited Rome. His wanderings in these years are fairly well documented. We can follow him to Venice, Bologna, Florence, Piombino, Arezzo, Imola, and Cesena.

11

Our documentary evidence of a visit to Rome is extremely meagre: one sheet in the Codex Atlanticus with an address in Tivoli, dated 1500,[10] and one receipt from the customs for Leonardo's clothes sent on from Rome, dated 1505.[11] There is also the mysterious note in the Codex Atlanticus, known to Leonardists as the Ligny memorandum, which suggests that in 1499 Leonardo was planning to follow the French general, Prince Ligny, from Rome to Naples.[12] All recent evidence suggests that Leonardo travelled oftener and more extensively than was formerly supposed.[13] We must also consider the fact that in about 1500 an author calling himself Perspectivo Melanese Dipintore dedicated to Leonardo a poem on Roman antiquities which would have been gratuitous, though not impossible, if Leonardo had never been to Rome. Feeble evidence. But if we turn from documents to works of art, the evidence becomes extremely strong. It is simply a fact that almost all the designs that Leonardo executed after his return to Florence in 1503—the Battle of Anghiari, the Kneeling Leda, the Standing Leda, the cartoon of Neptune, and many of his most important drawings—all derive more or less from Graeco-Roman sarcophagi; and every one of these sarcophagi was in Rome, in fact in the same place in Rome—on the steps of the Ara Celi. Now, of course, it is just possible that Leonardo knew these sarcophagi from drawings. They were all famous works and figure in the early collections of useful antiquities which were circulated in Renaissance studios; a manuscript in the library of the Escurial and another in Coburg are the best-known survivors. However, I think it extremely unlikely that these somewhat discouraging outlines had the effect of changing Leonardo's attitude to antique art from a theoretical curiosity to a creative engagement. The extraordinary impact of antique art which is first perceptible in the year 1503 would seem to me to be the result of direct experience.

It has long been accepted that in preparing his designs for the Battle of Anghiari Leonardo had in mind the battle sarcophagi of antiquity, in particular the example in Pisa, which had profoundly influenced the earlier generation of Florentine artists. During the years in which Leonardo had been away in Milan this famous, but very battered, piece of carving had, so to say, been brought up to date in a bronze relief by Lorenzo de' Medici's tame sculptor, Bertoldo. In the background he added a cavalry charge taken from a sarcophagus in the Borghese collection. This skillful academic work—one of the first works of art to which the word "academic" can be applied with its full meaning—undoubtedly had an influence on Michelangelo's cartoon of the Battle of Cascina, and certain features, for example, the helmeted riders bent forward over their horses,

[10] Codex Atlanticus 227v, a: "a roma / attivoli vechio casa dadriano." Cf. C. Pedretti, *A Chronology of Leonardo da Vinci's Architectural Studies after 1500* (Geneva, 1962), pp. 79–81. Professor Pedretti informs me that on the same sheet of the newly discovered MS at Madrid in which Leonardo records the day he began painting on the Battle of Anghiari (6 June 1505) is a note referring to architectural works in Rome. He also tells me that one of the books listed in the same MS is a "libro danticagle" (book of antiquities), which is probably the one referred to by the Anonimus Bramantinianus as being in Leonardo's possession. See Pedretti, *A Chronology*, p. 79.

[11] Beltrami, *Documenti*, no. 165.

[12] Codex Atlanticus 247r, a (Richter S 1379). Cf. G. Calvi, in *Raccolta Vinciana*, III (1907), 99–107.

[13] In fact during his "Roman period" Leonardo visited both Parma and Florence. Cf. Pedretti, *A Chronology*, pp. 107 ff.

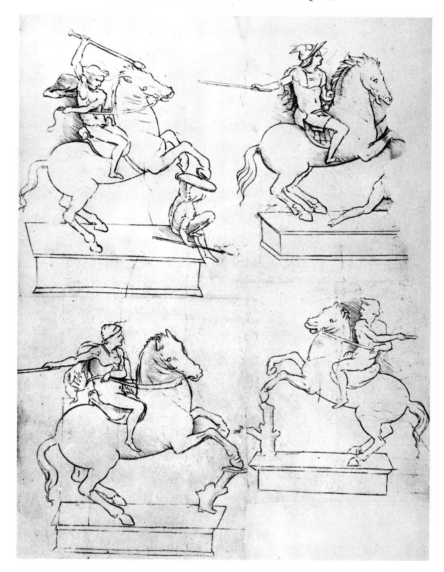

*Figure 10*
Engravings of horses and riders.
After Leonardo's designs
for the Sforza Monument.

probably influenced Leonardo. But there is a basic difference in the general design. Bertoldo, following the Borghese sarcophagus, represents a body of horsemen charging foot-soldiers. The horses are all going one way. In Leonardo's Battle of the Standard the main motif is a head-on encounter or clinch (fig. 12); this does not exist either in the Bertoldo or in the Pisa sarcophagus.

13

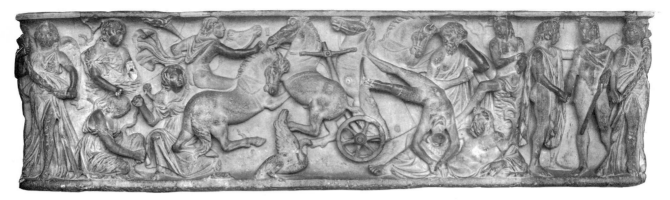

*Figure 11*
Detail of Phaeton's Fall from
antique sarcophagus. Florence, Uffizi.

The subject of confronted horses had attracted Leonardo ever since the background of the Uffizi Adoration (fig. 8), but there the horses' heads had been violently twisted away from one another, giving the centrifugal effect that marked so much of his early work, for example, his drawings of the Virgin and the Cat. The idea that the horses should be locked in a concentrated group, with their heads pressed into their necks, is not to be found in his early work, nor in the work of his contemporaries. But it does occur in a sarcophagus of the Fall of Phaeton which had been discovered in Trastevere in the Quattrocento and been moved to the Ara Celi (fig. 11). This sarcophagus, now in the Uffizi, is considerably rubbed down, but a notion of its original impact can be derived from several sixteenth-century drawings. I think it difficult to resist the conclusion that this group was the inspiration of the interlocked horses in the Battle of the Standard, and I am strengthened in this belief by a famous and beautiful drawing at Windsor, 12326*v*, for one of the horses' heads (fig. 13). This drawing is a fresh departure in Leonardo's studies of horses. It differs both from the ideal horses of the Adoration, with their long, thin muzzles, and the naturalistic horse studies for the Sforza Monument. In the pose of the head, the large Scopaic eye, and the rich undulations of the forelock and mane, it is the idealized horse of antiquity and could be a direct reminiscence of a sarcophagus.

That the design of the Battle of Anghiari was influenced by a representation of the Fall of Phaeton was noticed as long ago as 1899 by Eugene Müntz,[14] and was certainly familiar to Aby Warburg, who characteristically included a photograph of the Rubens copy in his Phaeton material. Perhaps the reason that it was not referred to more confidently by subsequent writers was that Müntz's term of reference was a sardonyx now in the Uffizi. Müntz himself was at first sceptical about the antiquity of the gem, and it is now generally believed to be a Renaissance imita-

[14] Müntz, *op. cit.,* p. 274.

14

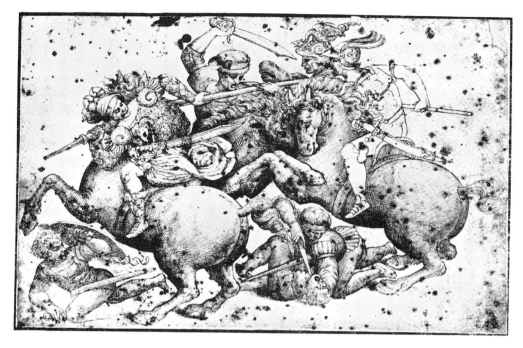

*Figure 12*
Detail from the Battle
of Anghiari.

tion.[15] For some curious reason the doubts cast on the gem extended to doubts on the connection between the Fall of Phaeton and the Battle of Anghiari, although if the gem is a Renaissance forgery it is clearly derived from a genuine antique, the sarcophagus in the Uffizi.

The subject of Phaeton had something more than a formal interest for Leonardo.[16] It appealed to him because in it the horses play the principal part, independent of human guidance; and this was precisely the theme that he wished to include in his representation of war.[17] The concept of *pazzia bestialissima*, "most beastly madness," could be made more vivid when it was embodied in actual beasts. This idea was in Leonardo's mind before 1500; it occurs in descriptions of a battle in the Ashburnham MS of about 1490, and we may suppose that the frenzied horses in the Fall of Phaeton gave antique sanction to a theme that obsessed him. And it continued to do so long after the painting in the Sala del Consiglio Grande had been abandoned and Leonardo had returned to Milan. One instance of his extended interest is a drawing at Windsor, 12332 (fig. 14), which on

[15] E. Kris, *Steinscheidekunst in der italienischen Renaissance* (Vienna, 1929).

[16] It is interesting that Francesco Scannelli, in his *Microcosmo della Pittura* (Cesena, 1657), p. 141, mentions a sketch by Leonardo representing the Fall of Phaeton, "con figure picciole, opera molto dotta e capriciosa."

[17] The Fall of Phaeton was an aspect of the battle which greatly impressed Vasari, "for rage, hatred, and revenge are seen no less in the men than in the horses, among which two, with forelegs interlocked, are fighting fiercely with their teeth" (Milanesi, IV, 41).

15

grounds of style and technique I should not hesitate to date after 1508.[18] The lower half of the drawing represents a battle of horsemen of a kind very similar to the studies for Anghiari in the Venice Academy. Above them is a preposterous *melée* of animals which, by comparison with the horsemen in the foreground, are of gigantic size. It would be incorrect to say that no work by Leonardo has moved art historians to more extravagant flights of fancy: on that score the Mona Lisa remains unequalled. But this drawing runs her close. It is generally considered an allegory of war and is known to scholars by Leonardo's own description of war, *pazzia bestialissima*. Imaginative critics, like Dr. Popp, have identified a headless lion, symbolizing blind courage, a ram kicking out with its hind legs, symbolizing stubbornness, and a horse with a jester's cap, symbolizing boastfulness.[19] All critics of this persuasion agree that the horses are headless because they are emblems of stupidity. More prosaic interpreters identify these gigantic animals as elephants, and A. E. Popham expresses his surprise that Leonardo has not drawn them more correctly.[20] Had they been elephants they would have been very much smaller, and we can be sure that they would have been correctly drawn, for the shape of the elephant was familiar to Renaissance artists (Mantegna, Matteo dei Pasti) and there was in fact a live elephant in Rome. They are obviously horses which have been drawn on a different scale; and their abandoned poses are due to the fact that they too have been inspired by a sarcophagus relief of Phaeton—not the one used for the Battle of Anghiari, but another, now in the Borghese Collection, which stood near it on the Ara Celi.[21] And why are they headless? Because, as we know from a drawing of this sarcophagus in the Coburgensis,[22] their heads had been knocked off and in Leonardo's time had not yet been restored. Delightfully simple. But from that point forward the problem is less easy, because the whole drawing seems to have been done at one time and with a single intention. There is not the slightest evidence that the large, headless horses were added to a diminutive battle scene, or vice versa; and we are thus left with the conclusion that Leonardo intended to exploit the nightmare effect of disproportion. It is interesting to find a similar disparity of scale in a drawing at Windsor, 12388, which certainly had an apocalyptic intention, the vision of destruction by fire, in which one gigantic figure rises above the others. And this in turn is connected with another destruction drawing, Windsor 12376 (fig. 15), which is like a prelude to the famous series of deluges. In the foreground of the drawing is a group of horses and riders who have been thrown to the ground by the fury of the wind. The poses of the horses are even closer to the Phaeton sarcophagus, for example, the horse lying on its back and kicking up its legs which is barely identifiable on the left of the monstrous animals in 12332. This inglorious pose leads to another train of thought, for it

---

[18] A group of drawings in the same technique, red chalk touched in with black, on red prepared paper, can be dated from many indications, 1508–1511.

[19] A. E. Popp, *Leonardo da Vinci Zeichnungen* (Munich, 1928), pp. 11–12. Although her interpretations strain our credulity, Dr. Popp was one of the most perceptive of all students of Leonardo's drawings.

[20] A. E. Popham, *The Drawings of Leonardo da Vinci* (London, 1946), p. 78: "It just shows that even the greatest artist cannot invent that unique creature."

[21] C. Robert, *Die antiken Sarcophag-Reliefs*, III (1899), 418.

[22] *Ibid.*, Pl. CIX.

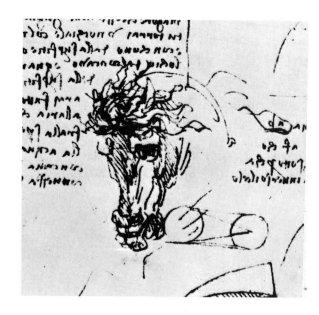

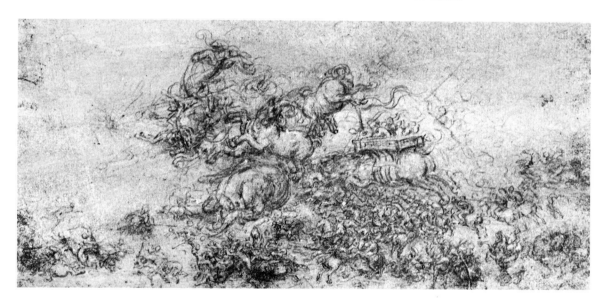

*Figure 13*
Sketch of horse's head.
Windsor 12326*v.*

*Figure 14*
"Beastly madness."
Windsor 12332.

reminds us of Michelangelo's famous drawings of Phaeton (fig. 16) at Windsor, the British Museum, and the Venice Academy. That Michelangelo, who did not at all share Leonardo's interest in horses, should have dwelt so long on this theme, and even included the horse showing its belly, would seem to me unthinkable unless he had been encouraged to do so by some antique precedent. The composition suggests that this precedent was a gem, and in fact the composition appears on a gem in the Uffizi; but this, too, is thought to be a Renaissance imitation.[23] However, I am in-

[23] Kris, *op. cit.*

17

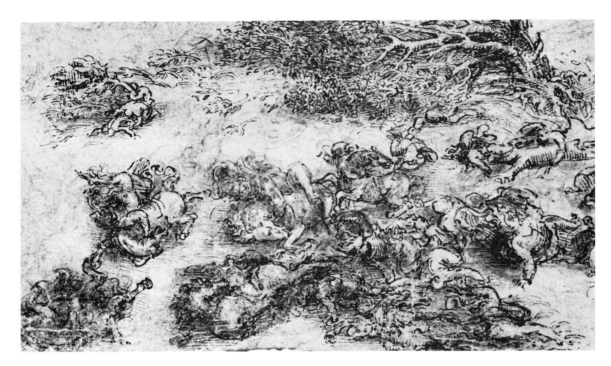

*Figure 15*
Windstorm and destruction.
Windsor 12376.

clined to think that some genuine antique gem must have existed which inspired Michelangelo and was also known to Leonardo when he made the two strange drawings of collapsing horses at Windsor.

The *pazzia bestialissima* may seem to us a curious result of the study of antique art. But before the classicism of the seventeenth century, with its confluence of static forms and stoic morality, the antique was a less clearly delineated concept than it later became. In the early sixteenth century pagan figures were still popularly thought of as demons, and the Colosseum, as we know from Cellini, was famous for its ghosts. Leonardo's imagination, which passed so easily from observation to prophecy, must have found in many of the antique myths similar transition from reason to monstrous fantasy; and an image as peculiar as Phaeton's horses, struggling and kicking as they fall from the sky, would have seemed to confirm his own feeling, "la natura è piena d'infinite ragioni che non furono mai in esperienza."

A less extravagant instance of the same feeling is to be found in Leonardo's treatment of the myth of Leda. His earliest representations of the subject are on a sheet at Windsor, 12337*r* (figs. 17 and 21), which also contains a study for the horse and rider on the right of the Battle of the Standard. They consist of two small drawings in pen and ink (a third in black chalk is just visible) of a kneeling woman and baby. No swan is depicted, but we know from drawings at Rotterdam

18

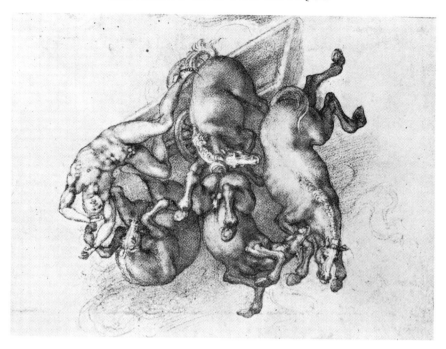

*Figure 16*
Michelangelo.
Phaeton's Fall.

(fig. 18) and Chatsworth that these are drawings for a kneeling Leda. Why did Leonardo, with his lack of interest in the female body, and his exceptional indifference to the charms of paganism, devote himself to this subject? I think we can, without extravagance, once more invoke that dualism in his character between the aggressive and the passive elements in the human psyche. The Battle of Anghiari was his most extreme expression of heroic energy; at the same moment the opposite principle demanded expression. And while he was studying antique reliefs of battles and of the Fall of Phaeton, his eye fell on a sarcophagus of another type, one of those representations of the channel crossing of the soul which were perhaps the most widely diffused of all images of antique art. Unlike his contemporaries, however, Leonardo was not interested in the Nereids, but in the figure of a kneeling Venus Anadyomene who appears, framed in a shell, at the centre of the composition (fig. 20). This is in fact rather an unusual motif and only two instances are recorded in Robert and Rodenwaldt's great publication,[24] but both of these come from Rome and one of them was certainly visible in Leonardo's day. As always in dealing with derivations from the antique, one must allow for others having disappeared.

[24] Rodenwaldt, *Die antiken Sarkophagreliefs*, V (Berlin, 1939), 36–37. They are no. 92 in the Villa Borghese and no. 93 in the Louvre.

Compared with these Venuses, Leonardo's kneeling figures on the Anghiari sheet are in poses denser, more complex, and plastically more inventive. In the drawings at Rotterdam and Chatsworth the arm across the breast is given up for an opener pose, but the body is still twisted with an abandon more Indian than antique. However, if the picture by Giampetrino at Schloss Neuwied (fig. 19) really represents a stage in Leonardo's design which was carried as far as a cartoon, we can say that he finally returned to something closer to his original Venus including the motif of the child on Leda's arm, which would be an interpretation, or, if you like, a misunderstanding of the attendant Eros in the Louvre sarcophagus. The motif exists elsewhere in Nereid sarcophagi, and shows us, incidentally, how their swarms of erotes reformed themselves in Leonardo's imagination, as the children of Leda.

That Leonardo derived the motif of his kneeling woman and child from a Venus Anadyomene is evident. What is not so clear is why he should have transformed her into a Leda. But I think there is no doubt that he had identified the feminine principle with what the mediaeval philosophers called *natura naturans* and in his imagination, Leda with her four children begotten by a swan had come to symbolise the procreative union of the human and the natural world. That this symbol had great power over him is shown by the fact that shortly after the kneeling figure he set to work on a standing Leda (fig. 22).[25] I say "shortly after" because the kneeling Leda cannot be dissociated from a comparatively early stage of Anghiari; and a version of the standing figure was copied by Raphael when he was in Florence sometime between 1504 and 1508. A cartoon, and perhaps a painting, were completed then. But there is evidence that Leonardo continued to work on a standing Leda even after his return to Milan.

The relationship of the standing Leda to an antique original is not as striking as it was in the case of the kneeling figure, partly because there is no single, obvious model, but a large number of sources. A frontal female figure, with her right arm stretched across her body, appears on dozens of sarcophagi and is present in that summary of dionysiac motifs—formerly one of the most famous relics of antiquity—the Borghese vase. There, as so often, the weight is on the left leg, giving a different balance; but in other dionysiac figures the body is in almost exactly the same pose as the Leda. Only the head, with its bold, extrovert gaze, is in revealing contrast to Leda's downcast eyes. Leonardo's Leda, like his derivations from Phaeton, seems remarkably unclassical. This is sometimes attributed to a physical fullness that is more Hindu than Greek; but in fact there is plenty of antique precedent for her swelling breasts and accentuated *déhanchement*. Her unantique character is due to a deep-rooted difference of intention which has somehow made itself perceptible in the inclination of the head and every movement of the figure. Antique figures of Venus and the Bacchantes are simply themselves, existing heartily in the present. The Leda is an infinitely complex symbol of the female aspect of creation. Everything about her, from the swan's curling neck to the coils of her hair, seems to suggest the organic intricacy of generation;

[25] For the complex question of the various versions of the Leda, see my *Leonardo da Vinci* (Cambridge, 1939), p. 124, and the forthcoming new edition of my Windsor catalogue.

20

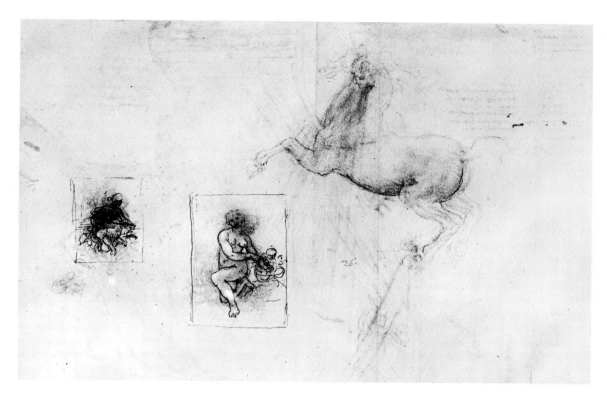

*Figure 17*
Sketches of the Kneeling
Leda and prancing horse.
Windsor 12337*r*.

that this was no subjective fancy, but was really Leonardo's intention, is proved by the fact that a small study of Leda is on a sheet at Windsor, 12642*v*, which can be related to certain drawings in the anatomical MS B where the problem of generation is studied scientifically.

This transition from a symbolic to a scientific approach is entirely characteristic of Leonardo and can be observed in the complementary drawings of the same period, in which he finds symbols for the male principle. We know that Leonardo, like nearly all his contemporaries, was impressed by the most widespread and enduring of all symbols of virility, the myth of Hercules. A drawing in Turin, identified by Carlo Pedretti,[26] actually represents Hercules seen from behind with his club shown in various positions (fig. 23). Leonardo, with his usual lack of interest in the iconography of antique art, has made the Nemean lion's skin into a live, but docile, lion. This

[26] C. Pedretti, "L'Ercole di Leonardo," in *l'Arte,* LVII (1958), 163–170. The attribution of this drawing to Leonardo, first suggested by Frizzoni (*Raccolta Vinciana*, VI [1910], 123–126), has always been rejected. Berenson, 1262 A, lists it as an imitation of Leonardo (". . . looks like copy of the man with sword on my 1089, but done in an almost Michelangelesque way"), and Middeldorf ("Su alcuni bronzetti all'antica del Quattrocento," in *Il Mondo Antico nel Rinascimento* [Florence, 1956], pp. 167 ff.) considers it as "ignoto dei primi del sec. XVI." It is indeed by Leonardo.

21

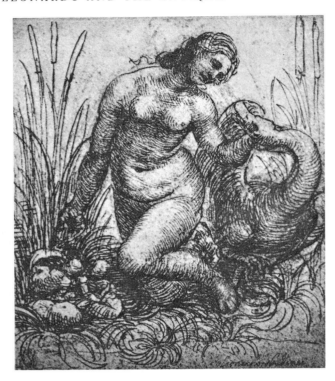

*Figure 18*
Sketch of
the Kneeling Leda.
Boymans Museum,
Rotterdam.

figure may be derived from a statue in the round rather than a relief, perhaps from the Nemean Hercules in the Vatican (Clarac 1981). Closely related to the Turin Hercules are the numerous studies of muscular nudes, all inspired by the antique. An example is the superb drawing at Windsor, 12640 (fig. 24), in which two studies of a heroic torso and legs are combined with small sketches of men fighting. For obvious reasons this drawing is usually associated with the Battle of Anghiari, but Professor Pedretti has given me convincing reasons why it could be later.[27] At all events, it was done during the long period of work on the Leda. I suppose it possible that an actual human being would have muscles like this, but the way in which they are seen reflects that stylisation of the torso which was achieved by Greek sculptors in the third century (probably by Lysippus) and which, through Michelangelo, was to make such an overwhelming impact on Italian artists of the Cinquecento. The arm broken off, as in an antique torso, is only a confirmation of what we learn from the musculature. We cannot doubt that these beautiful drawings are

[27] The drawing is obviously related to 12625, which contains a reference to Milan (". . . . g sta alla stadera / del corduso"), thus pointing to a period later than 30 May 1506 (cf. Beltrami, *Documenti,* no. 176). Similar references to Lombard localities are on a drawing in the Ambrosiana, which is also related to 12625 (repr. in Pedretti, *Studi Vinciani* [Geneva, 1957], Pl. XVII). Finally, in the third volume of MS K (*ca.* 1507), fols. 102*r* and 109*v,* are preliminary studies for 12625, etc.

*Figure 19*
Giampetrino.
The Kneeling Leda.
Schloss Neuwied.

what we call works of art, that is to say, they express symbolically an imaginative truth; but they have been immediately turned into works of science, because even as the drawing was being done the muscles were marked *a, b, c, d,* and their movements were described in a note. An even more remarkable instance is one of the later drawings in Windsor, 19032*v* (fig. 25), where the intention is scientific and the execution devoid of graphic charm; [28] but the image is still deeply influenced by antique invention of the *cuirasse ésthetique.*

Leda and Anghiari, with their satellite studies extending over at least five years, were the climax of Leonardo's creative use of Graeco-Roman art. There are many other instances in his work where he has turned to antique models for inspiration; but they are in a sense an anti-climax. They do not express his thoughts and emotions but are experiments in a largely alien style, under-taken in order to achieve formal completeness. A few of them are related to Roman busts, like the drawing of a head at Windsor, 12553 (fig. 26), which takes its point of departure from a bust of Lucius Verus. But most of them are derived from coins and gems, works that had not lost their perfection, rather than from sarcophagus reliefs, battered by time till they had become almost as suggestive, to Leonardo's eye, as his celebrated stains on walls. The most obvious derivation is a

[28] For the diagrams of the "muscolo antico" and "moderno" in this sheet, see Pedretti, *Libro A,* p. 135.

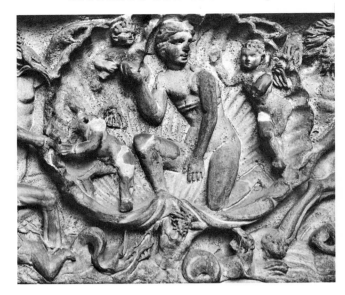

*Figure 20*
The Kneeling Venus
Anadyomene. Paris,
Louvre.

*Figure 21*
Detail of the
Kneeling Leda.
Windsor 12337*r*.

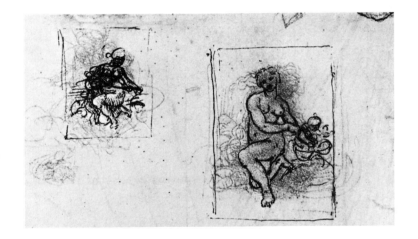

drawing at Windsor, 12508, of a woman in profile (fig. 27) which is clearly inspired by a cameo. It must date from about 1510 and so anticipates by over fifteen years the classical–mannerist heads that Michelangelo and his pupils were doing in the 1520's.[29]

The first and most important of what we may properly call his classicizing works is the drawing at Windsor, 12570, of Neptune and his sea-horses (fig. 28). This drawing is generally accepted

[29] The best known of these drawings in the Uffizi, nos. 598*e* and 599*e*, may have been presentation drawings to Gherardo and Perini, and if so, dateable *ca.* 1522. But they look somewhat later in style. Johannes Wilde, in his catalogue of the Michelangelo drawings in the British Museum (London, 1953), dates the famous drawing known as the Marchesa di Pescara, no. 42, as *ca.* 1525–1528.

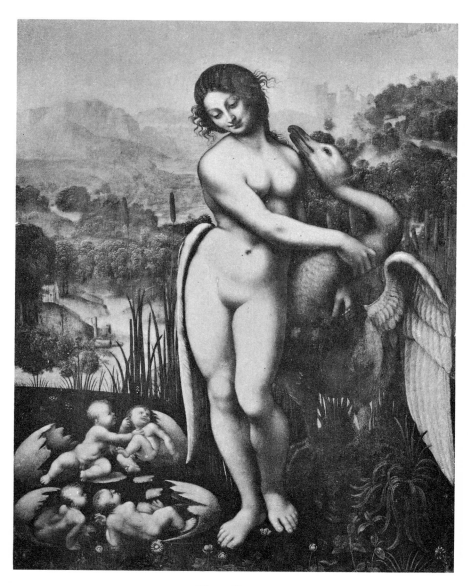

*Figure 22*
Leda and the Swan.

as a preliminary study for the cartoon that Vasari tells us was done for Antonio Segni. Segni left Florence in 1504, so the drawing must belong, as the horses would indicate, to the early years of Anghiari. The design suggests very strongly the idea of an oval frame, and writers on Leonardo have said that it must be derived from a gem. Perhaps they are right; but no antique gem of this subject has been recorded (on the whole, the antique gems of the Renaissance were famous enough to be documented) and I think that we must look once more on the steps of the Ara Celi. We

25

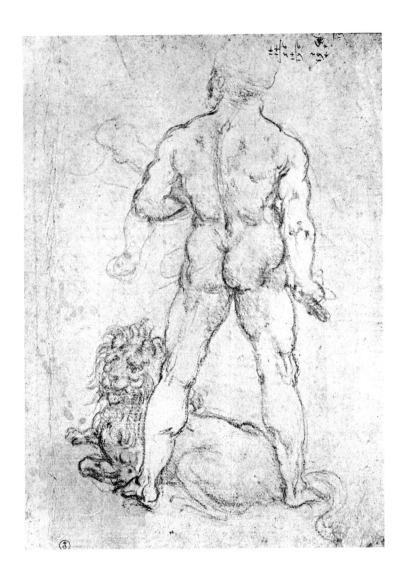

*Figure 23*
Hercules. Turin.

find that there stood there yet another sea-horse sarcophagus with at its centre the very unusual motif of Poseidon driving his horses.[30] Poseidon, of course, is frequently found at the centre of such sarcophagi, but always as a large, bearded head—the head that became an obsession to Celtic craftsmen of the sixth century. The full-length Poseidon on the Ara Celi sarcophagus seems to be unique and was probably identified in the Renaissance as an illustration to the famous passage in the first book of the Aeneid describing a storm, which ends with the words *quos ego?* It was without doubt one of the most influential antiquities of the Cinquecento, and from it derived a quantity of bronzes and plaquettes. Having seen the effect of these other sarcophagi in this place,

[30] Rodenwaldt, *op. cit.,* p. 45, now in the Vatican. We know that it was on the Ara Celi from a sixteenth-century drawing in the Wolfegg sketch-book. It also appears in the Coburgensis. Both drawings are reproduced by Rodenwaldt.

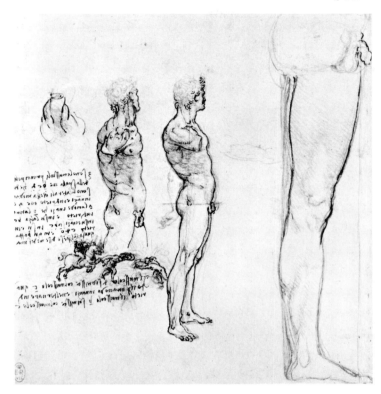

*Figure 24*
Studies of the
male figure.
Windsor 12640.

and at this time, on Leonardo's imagination, one cannot avoid the conclusion that this Poseidon was also the point of departure for Leonardo's Neptune. As in all his other adaptations of antique motifs—but this is an extreme example—Leonardo has taken a flat, open pose and made it complicated and involved. The circular movement of the arms—what Giacometti called Leonardo's swastika movement—had appeared already in the projects for the Trivulzio. In Segni's final drawing Leonardo came closer to the sarcophagus. Already on the Windsor drawing he had made up his mind to give the figure greater prominence, and had written the note *abassa i cavalli*. At one point, in order to avoid the flat, frontal Poseidon, he tried putting sea-horses round the feet of a figure drawn from a memory of Michelangelo's David (Windsor 12591). Not a satisfactory solution; and finally he thought of another, of which a drawing in Bergamo [31] may be a record and is certainly a *reminiscente* (fig. 29). Unfortunately this drawing does not include what Vasari mentions as one of the features of the design, "alcune teste di Dei Marini, bellissimi." But it does show that Leonardo reverted to the complex, unclassical movement of the original Neptune, and put the god standing on his conch-shell chariot.

[31] C. Gould, "Leonardo's 'Neptune' Drawing," in *Burlington Magazine,* XCIV (1952), 289–294. The author shows that there are also reminiscences of the design in drawings at Windsor by Figino.

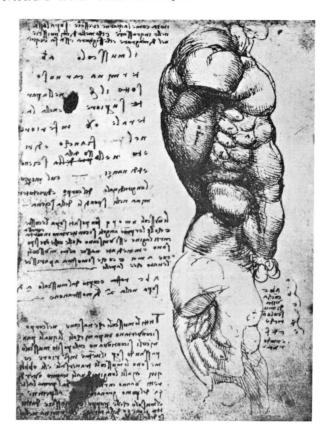

*Figure 25*
Studies of the male torso.
Windsor 19032*v*.

My next example of Leonardo's classicism—a drawing in Windsor, 12540 (fig. 30)—is perhaps the most direct of all Leonardo's references to an antique work of art, also the most obvious; but I am ashamed to say that the catalogue of the Windsor collection has only recently recognized its source.[32] It represents a nude youth seated in profile, with his left leg tucked under his right thigh. This curious pose was known to Renaissance artists through an antique gem, inscribed with the name of Diomedes, which was then one of the most famous relics of antiquity. It had belonged to Nicolo Nicoli who sold it to Pius II, from whom it had been purchased by Lorenzo de' Medici. It may well have been the starting-point for Michelangelo's *ignudi* But curiously enough none of these derivations comes as close to the original as Leonardo's drawing. The head, in particular, is far more classical than in Michelangelo's athletes. The only major change is the position of the left arm which, in the gem, is covered with Diomedes' cloak. Leonardo at first made the arm

[32] It was recognized independently by Bettina H. Polak in a note, "A Leonardo Drawing and the Medici Diomedes Gem," in *Journal of the Warburg and Courtauld Institutes,* XIV (1951), 303–304. See also E. Möller, "Lionardos Johannes B. in der Wüste. Cesare da Sesto bei Lionardo," in *Fontes Ambrosiani,* XXVI, *Miscellanea G. Galbiati,* II (1951), 351–368.

28

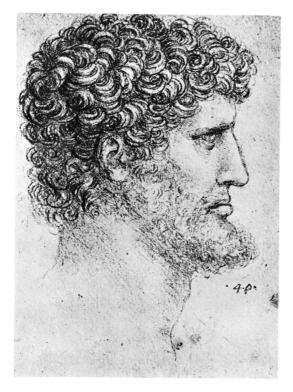

*Figure 26*
Profile of man's head.
Windsor 12553.

*Figure 27*
Study of woman in profile.
Windsor 12508.

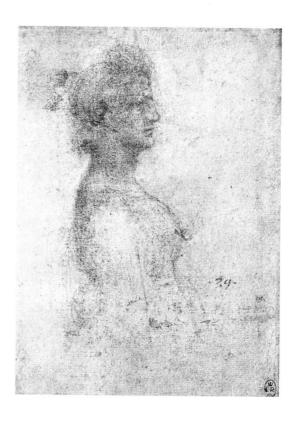

stretch down to the leg, as it does in Michelangelo's version, but afterwards altered it to his most typical gesture—the hand that is both beckoning and pointing upwards to infinity—and it was, I suppose, the simple addition of this arm which prevented scholars from recognizing the familiar source from which the figure is derived.

Leonardo uses the pose again in the two indications of figures on the base of the Trivulzio Monument, figures that have sometimes been considered memories of Michelangelo's *ignudi*. And I think this is probably a correct indication of the date of the Diomedes drawing, because it is also related to sketches for the Trivulzio Monument by style and technique.

Of all Leonardo's works the series of drawings at Windsor of the horse and rider for the Trivulzio Monument [33] are those in which he strives most for the finality of antique art, and hav-

[33] They are 12342, 12343, 12344, 12359, and 12360.

29

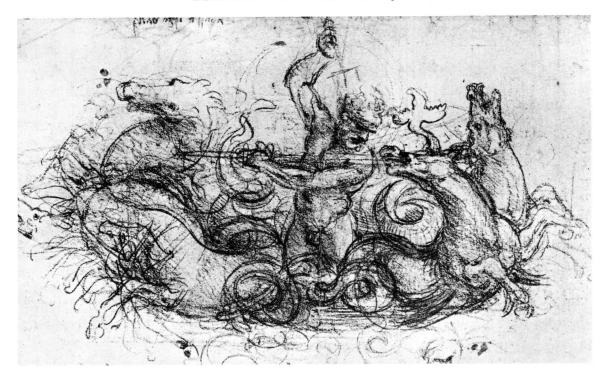

*Figure 28*
Poseidon and sea-horses.
Windsor 12570.

ing achieved a perfectly classical horse, more perfect perhaps than anything that has survived from the Graeco-Roman world, even the horses of St. Mark's, he tries to work out rhythmic unity between horse and rider. In doing so he follows a number of antique precedents. The head of the rider in the upper drawing on 12342 is so close to a cameo that it could almost be Napoleonic.

The Trivulzio horsemen seem to be Leonardo's last effort to assimilate the lessons of antique art. If, when he finally returned to Rome and took up residence in the Vatican (1515–1518), he looked with interest at the many famous antiquities that were already being assembled on his doorstep in the Belevedere, he has left, as far as I know, only one indication of it, a tiny and almost invisible scribble of Hercules and the Hydra which Professor Pedretti has discovered in the corner of folio 230*v*, *b* of the Codex Atlanticus, a sheet of geometrical studies dated 3 March 1516. [34] It was not antique art that had lost interest for him, it was simply art. Such drawings as he made

[34] Pedretti, *Studi Vinciani*, p. 276.

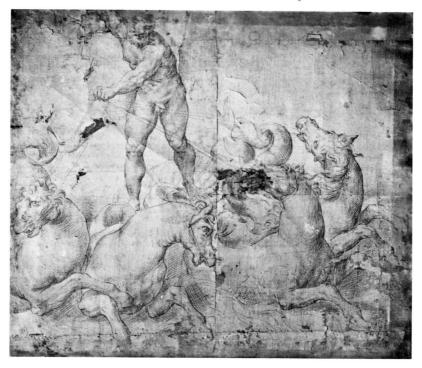

*Figure 29*
Poseidon and sea-horses.
Bergamo.

were concerned with architecture and science. The ancients may have said the last word on design, but in the analysis of cause and effect they were to be surpassed.

I have been concerned, in this paper, with those works by Leonardo in which the effect of antique art can be traced to a definite work, or group of works, which can have been known to him. But beyond such rather pedantic examples is that more pervasive influence of the Greek spirit which made Mr. Bernard Berenson, in a famous passage, compare the Burlington House cartoon with the Elgin Marbles (fig. 31). I will remind you of his actual words: "There is something truly Greek about the gracious humanity of the ideals here embodied, and it is no less Greek as decoration. One can scarcely find draped figures contrived in a more plastic way without going back centuries to those female figures which once were clustered together on the gable of the Parthenon." The likeness is undeniable, and I suppose that we could once more postulate, as a starting-point, some sarcophagus in a vaguely Parthenonic style, although I have never found one close enough to be wholly convincing. If one tries to analyse the likeness, it seems to depend on two things: first the draperies, in which Leonardo follows the advice he himself gives in the

31

*Figure 30*
Figure of young man in
profile. Windsor 12540.

*Trattato della Pittura*, "As much as you can, imitate the Greeks . . . in the way of revealing limbs," [35] and second it depends on a quality which might be called smoothness of transition, or continuous involvement. The naturalism of the Quattrocento is planimetric; the *grand souffle* of classicism is conceived in a single rhythmic sweep. The love of twisting movement, which in the earlier work Leonardo has expressed through a combination of atmosphere and line, he now embodied in a weighty plastic style which necessitated a change in his technique of drawing from diagonal shading to lines of shading following the form. The paradigm of this continuous movement was the classical woman's torso, with the sensuous cylinder of the neck set deeply in the

[35] Codex Urbinas, fols. 167*v*–168 (Ludwig 533; McMahon 573; Pedretti, *Libro A,* p. 202, as dating from 1500–1505).

32

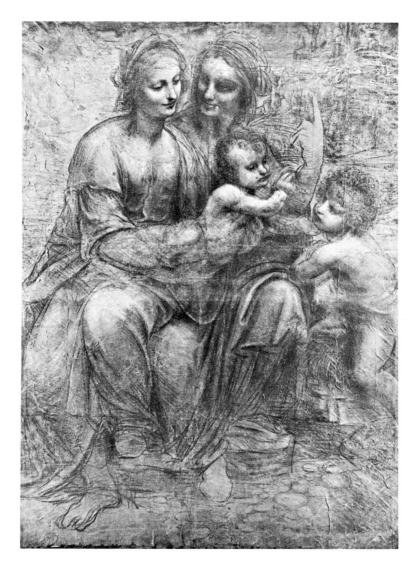

*Figure 31*
St. Anne, Virgin
and Child. London,
National Gallery.

smooth, well-covered shoulders, which are slightly turned so that they set in motion a larger arc. Almost any fragment of a late Hellenistic Venus, from the Venus of Milo downwards, displays this movement, and it is from the accumulated memories of such fragments that Leonardo has created the classic arc of the Virgin's shoulder. But what a transformation has taken place! On the counts that Mr. Berenson found so Greek, both as humanity and as form, what complications have intervened! For although the Greeks invented intellectual curiosity, they never suc-

33

ceeded in combining it with what we call their sense of beauty. On the contrary, they banished from their smooth, symmetrical images anything that could suggest the restless, unsatisfied life of the mind, and it was precisely for this intellectual disease Leonardo was determined to find a beautiful embodiment. So when all is said of Leonardo's debt to antique art, and I hope you will agree that it is both more precise and more substantial than used to be allowed, it remains no more than the point of departure for a far more intricate and mysterious journey.

# Leonardo da Vinci's
# Physiology of the Senses*

## by KENNETH D. KEELE

Ludwig heydenreich has suggested that the great mass of Leonardo da Vinci's manuscripts was directed towards the goal of three great publications, one on Painting, a second on Mechanics, and the third on Anatomy. These three subjects may be looked upon as the three main aspects of Leonardo's outlook. Indeed, there are few human problems upon which he failed to focus these three different points of view; if, for example, we examine Leonardo's anatomy and physiology without seeing its problems from the mechanical or the painter's point of view, we cannot fully grasp his understanding of the subject.

This triple aspect of Leonardo's genius applies particularly to the problems of vision and the other senses of the body, for he was intensely aware that these were the channels through which he obtained all his knowledge. He therefore gave them his own inimitable brand of passionately diligent attention. His theory of painting assumed throughout that act of faith upon which all scientific activity depends, that the internal logic of man's mind is closely related to the external logic of natural phenomena. "The observer's mind must enter into nature's mind," he writes, "to act as interpreter, to expound the causes of the manifestations of her laws" (Trat., fol. 40). "Experience," he insists, "interprets between formative nature and the human race; it teaches that that which nature does among mortal things is constrained by necessity and cannot be done otherwise; and that reason, the helm, determines the work" (C.A., fol. 85r).

These laws, reasons, and necessities of nature are all defined by Leonardo as "mathematical"; and in his visual mind mathematics means those forms and figures into which nature has shaped her structures and forces; it means her divine geometry.

As a painter he sought to depict those geometrical laws at work. As a physicist he sought to

* I would like to acknowledge my debt of gratitude to Miss A. Scott-Elliot for her ready help and guidance in my work in the Royal Library, Windsor. I am indebted to Dr. F. N. L. Poynter, director of the Wellcome Historical Medical Museum and Library for his interest and advice, and also for the preparation of the illustrations. I would like to thank Dr. E. H. Gombrich, director of the Warburg Institute of the University of London, for his kind assistance and response to my requests.

explain the mechanics of the images of sensation. As an anatomist he dissected out their sensory instruments. These are therefore the three aspects through which I shall try to trace his studies of sensation: from their geometry through their mechanics into their physiology. In doing so I hope to be able to show that in the end Leonardo constructed a physiology of sensation as interesting and original as anything he created.

## 1. THE NATURE OF THE SENSORY STIMULI

Leonardo's search for the origin of sensory stimuli led him to the root sources of all experience. "All true sciences are the result of experience which has passed through the senses . . . Science is the mental analysis which has its origin in ultimate principles, beyond which nothing can be found which is part of that science. For example, continuous quantity, that is, the science of geometry, beginning with the surface of bodies, is found to have an origin in line which is the boundary of the surface . . . and the line ends in the point, and the point is that than which nothing can be smaller" (Trat., fol. 1).

The point, the line, surfaces, all these geometrical aspects of continuous quantity are seen in the illuminated image of objects; and Leonardo is not long coming to the conclusion that "among all the studies of natural causes and reasons light chiefly delights the beholder . . . Perspective therefore must be preferred to all the discourses and systems of human learning. In this branch of science the beam of light is explained on those methods of demonstration which form the glory not so much of mathematics as physics."

First, let us briefly see how he brings the geometry of perspective into the physiology of vision. "Perspective," he writes, "is a rational demonstration by which experience confirms that every object sends its image to the eye by a pyramid of lines; and bodies of equal size will result in a pyramid of larger or smaller size according to the difference of their distance one from another. By a pyramid of lines I mean those that start from the surface and edges of bodies, and converging from a distance, meet in a point. The point is said to be that which having no dimensions cannot be divided, and this point being placed in the eye receives all the points of the cone" (MS A, fol. 3r). Here one sees how Leonardo converted his mathematical abstractions, the point and the line, into physical entities. The point now lies "in the eye," and the pyramid is no mere abstract geometrical figure; it has become a physical reality.

The closeness with which Leonardo binds geometry to the concrete physical world is demonstrated by his note on what he calls "the natural point." "The smallest natural point," he writes, "is larger than all mathematical points; and this is proved because the natural point has continuity, and anything that is continuous is infinitely divisible; but the mathematical point is indivisible because it has no size" (Ash. III, fol. 27v). And with regard to the line he says: "The line has in itself neither matter nor substance, and may be called an imaginary idea rather than a real object; and this being its nature it occupies no space. Therefore an infinite number of lines may be

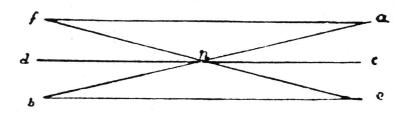

*Figure 1*
"Whether the central line of the image can be intersected or not within the pupil. It is impossible that the line should intersect itself, i.e., that its right side should cross over to its left side because such intersection demands two lines. A line having no center or thickness cannot be divided, therefore it can have no sides to intersect each other." Let afeb be a beam of light with sides af and eb; and let the sides af and eb be joined by ab and ef. "If you move ab and ef so that their ends meet at c, you will have moved their opposite ends f, b, to meet at d. From the two lines you will have made the straight line cd, which lies in the middle of the intersection of these two lines in the point n, without any intersection. If you imagine these two lines to have body it is necessary that by this motion the one will cover the other completely, being equal with it, without any intersection, in the position cd" (Wind. 19151).

conceived of as intersecting each other at a point which has no dimensions and is only of the thickness (if thickness it may be called) of one single line" (Wind. 19151). A beam of light remains a beam as long as it possesses a right and left side; as it narrows to a line its left and right sides fuse into one (fig. 1). The central line of a light beam as with any other power carries maximal force. These statements are brought to bear on the origin of the visual image. "Every body in light and shade fills the surrounding air with infinite images of itself; and these by infinite pyramids diffused in the air represent this body all in all parts and all in every part. Each pyramid which is composed of a long convergent beam of rays includes within itself an infinite number of pyramids, and each has the same power as all, and all as each. A circle of equidistant pyramids of vision will give to their object angles of equal size, and an eye at each point will see the object of equal size [fig. 2]. The body of the atmosphere is full of infinite pyramids composed of radiating straight lines which are produced from the surfaces and edges of opaque bodies existing in the air; and the more distant they are from the object producing them, the more acute their angles become. And although in their distribution their lines intersect and interweave, they never interfere or mix with one another, but pass through all the surrounding air independently, converging or diverging. And they are all of equal power. By these the images of bodies are transmitted through all space in all directions, and each pyramid in itself includes in its minutest part the whole form of the cause" (C.A· 101*v*, *b*). With the figure illustrating this passage Leonardo introduces the circle into his geometry of nature. The pyramid of perspective spreads its power outwards in the form of dynamic circles. Whence did he derive these circles in nature? This Leonardo answers by his observations on the effects of a stone thrown into still water. "Just as a stone flung into water becomes the centre and cause of many circles, and just as sound diffuses itself as circles in the air, so any object placed in the luminous atmosphere diffuses itself in circles and fills the surrounding air with images of itself" (MS A, fol. 9*r*). Thus he reaches his circular pattern of the spread of light by analogy

37

from the circular spread of ripples of water (fig. 3). And both are analogous to the spread of sound in air. He has found by observation that movement in the element of water spreads by circular waves. He applies this pattern of spread to the other elements: in air it spreads sound; in fire or light it spreads visual images; and in earth it spreads in tremors, or shock-waves of pressure. In all these instances he makes extensive experiments and observations for confirmation of the idea that wave motion pervades all four elements of earth, air, fire, and water. And he is very conscious of the fact that it is of these same four elements that the human body, with its sense organs, is composed; and that this body is a microcosm built on a pattern similar to the macrocosm of the world.

## 2. THE MECHANICS OF SENSORY STIMULI

What is the nature and origin of these circular waves which spread out with diminishing pyramidal power? In all cases, says Leonardo, these arise from percussion.

Percussion he defines as "the end of movement created in indivisible time, because it is caused at the end point of a line of movement made by a weight which is the cause of the blow" (Fors. III, fol. 32r). He often illustrates percussion by a rebounding blow from a hammer (fig. 4). He stresses that percussion is instantaneous; the hammer does not stay in contact with the object struck. "Percussion," he writes, "is the immense power of things which is generated by the elements" (Q. I, fol. 1r). This importance in Leonardo's view arises from the fact that percussion is the one form of force which gives rise to wave motion. As he puts it, "The wave is the recoil of the percussion and it will be greater or less in proportion as the percussion is greater or less" (MS I, fol. 18r). Again he uses the stone thrown into water to illustrate: "I say that if at the same time you throw two small stones into a large lake of still water . . . you will observe two distinct sets of circles form round the two points where they have percussed . . . The reason for this is that although some show of movement may be visible there the water does not depart from its place, because the openings made there by the stones are instantly closed; and the movements made by the sudden opening and closing of the water make a certain tremor which one would describe as a quivering rather than a movement. That what I say may be more evident to you just consider bits of straw which on account of their lightness float on the surface of the water and are not moved from their position by the wave that rolls beneath them as the circles widen. This disturbance of the water therefore being a tremor rather than a movement, the circles cannot break one another as they meet [fig. 3]; for as all the parts of the water are of a similar substance it follows that these parts transmit the tremor from one to another without changing their place . . . its force steadily decreasing to the end" (MS A, fol. 61v). Just as the force of percussion in water decreases as the waves spread out, so do the images of light and sound fade. "Every body situated within the luminous air fills the infinite parts of this air circle-wise with its images, and goes lessening its images throughout equidistant space . . . The stone flung into the water becomes the centre of various circles, and these have their centre at the point percussed. The air in the same

38

Figure 2

"Every body . . . fills the surrounding air with infinite images of itself" (see text). Note how the pyramid abc includes within itself the pyramids terminating at d, e, f, and g. Note also how pyramids with equal angles to f form a circle" (Richter 63)

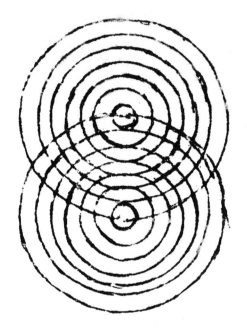

Figure 3

Spread by circles, with intersection of waves. This mode of spread Leonardo applied to the forces of movement of light, sound, and water, etc. (A, fol. 61r).

Figure 4

"Percussion is the immense power of things." Studies in the angles of incidence and reflection of the percussion of different types of bodies (A, fol. 8r).

way is filled with circles the centres of which are the sounds and voices formed within them" (C.A., fol. 373r–v).

I would draw attention to two significant phrases in these passages; in one, wave motion is described as "steadily decreasing to the end," and in the other the circle-wise spread of images "goes lessening its images throughout equidistant space." In both Leonardo is quantitating the loss of the power of percussion with distance. Both describe a perspectival or pyramidal decline of the power of percussion whether in the medium of light, air, or water.

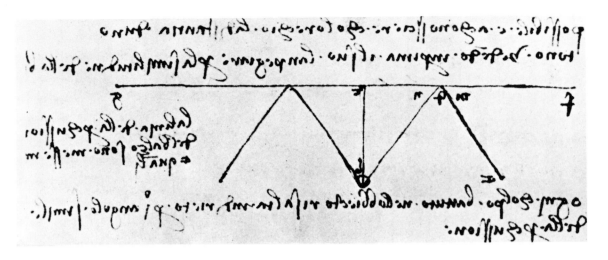

*Figure 5*
Percussion; the angle of incidence equals the angle of reflection. The strongest percussion is along the line cd, from which the rebound takes the line of incidence (A, fol. 19r).

Leonardo's experiments with percussion revealed to him the phenomena of resonance. "The stroke in a bell leaves its likeness behind it, impressed, as the sun in the eye or the scent in the air . . . The percussion given to the bell will cause response and some slight movement in another bell similar to itself. And the string of a lute as it sounds will cause response and movement in another similar string of like tone in another lute; and this you will see by placing a straw on the string similar to that which was sounded" (MS A, fol. 22v). This concept of resonance he uses again for sensations impressed on the imprensiva of the brain.

Leonardo appreciates that waves travel at different velocities. He thinks that this velocity depends on what he calls the "power of movement in different media" and that it diminishes from the highest velocity in light, down through air, water, and earth, in that order. But he also believes that wave velocity is proportional to the power of the percussion that sets it off. Though he gained so great an insight into the properties of wave motion, it is interesting to note that he never mentions longitudinal wave transmission, and he failed to attribute any physical event directly to wave-length or frequency. The pitch of sound, for example, he relates to the velocity of the movement that sets up percussion. A swift movement of air through a reed, trumpet, or human larynx produces a high-pitched sound; and the narrower the passage, the swifter the movement. He fixed honey to the wing-tips of flies and noted the lowered pitch of the note made by their weighted wings, and he related this to their diminished velocity of percussion and condensation pressure on the air, not to their diminished frequency of vibration.

From these and a great many other basic observations on the properties of water waves and analogous properties of light, sound, and pressure waves, Leonardo derived for all of them similar laws regarding the angles of incidence and reflection, comparing them in all cases with those made by a ball thrown against a wall (fig. 5). The greatest power of percussion is along the central line, a

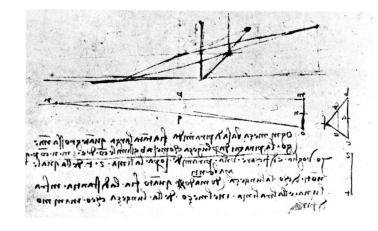

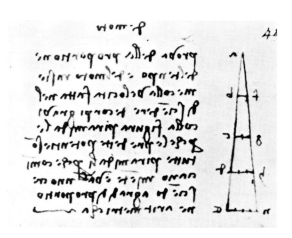

*Figure 6*
Linear perspective and the
pyramidal law. Note the
proportions of the pyramid.
"The size of half the base of
any pyramid equals the size
of this pyramid taken at
the middle of its length."
ab = de; mn = pq
(A, fol. 37*v*).

*Figure 7*
The pyramidal law of
acceleration of gravity
(see text).

point he elaborates in relation to cannon-balls as much as light entering the eye. Also he finds that action equals reaction, Newton's third law of motion. This law Leonardo demonstrates by experiment (MS A, fol. 24*r*), and he uses it in his studies of the phenomenon of percussion in all the four "elements." "Every spherical body of dense and resisting surface when moved by an equal force will make as much movement in the rebounds caused by its percussion on a solid ground as if it were thrown freely through the air." This statement is experimentally demonstrated by measuring and comparing the rebounds of a "small glass ball" on a "smooth polished stone" with its "free motion" on a similar surface. This result moved Leonardo to exclaim, "How admirable thy justice, O thou Prime Mover."

Percussion power, however, declines with distance, and this decline he represents by the figure of a pyramid. From the ratios of the height and base of the pyramid he derives his law for all the powers that take on pyramidal form. "The size of half the base of a pyramid equals the size of the pyramid taken at the middle of its length," he writes. The law is more easily understood from his accompanying figure in MS A, folio 37*v* (fig. 6). He states the pyramidal law in words most clearly

41

in relation to the acceleration due to gravity. "This," he writes, "is in the shape of a pyramid because the aforesaid powers are all pyramidal seeing that they commence in nothing and proceed to increase in degrees of arithmetical proportion. If you cut the pyramid [fig. 7] at any stage of its height by a line equidistant from [i.e., parallel with] its base, you will find that the proportion of the height of this section from its base to the total height of the pyramid will be the same as the proportion between the breadth of this section and the breadth of the whole base" (MS M, fol. 44r). Thus Leonardo reveals that his pyramidal law is his geometrical law of proportion, and we know quantitatively exactly what he means when he states that "the luminous ray is of pyramidal power" (MS I, fol. 33r). Its power of percussion diminishes pyramidally with its distance from the observing eye, as also do the perspectival visual powers of colour, size, and form.

As we have already seen in relation to the acceleration due to gravity, this pyramidal law he extended into the mechanics of all movement and percussion. For example, he refers to the force of a spring increasing pyramidally for, "with every degree of movement it acquires volume and speed" (MS G, fol. 30r). And he sums up a great deal of his work on the power of multiple pulleys with the remark, "The power that moves tackle is pyramidal since it proceeds more slowly with uniform lack of uniformity down to the last rope" (MS G, fol. 87v).

Thus for Leonardo all the forces that impinge on the human body, whether they consist of light, sound, scent, taste, or pressure, stimulate the sense organs by percussion; and the strength of their stimulation varies with the pyramidal law governing percussion.

Let us now see how the sense organs of the body deal with these various forms of percussion to produce sensation in Leonardo's scheme of things.

## 3. THE PHYSIOLOGY OF THE SENSORY ORGANS

Leonardo's most intensive studies on the physiology of sensation were made about the years 1490 to 1495. Two passages written about this time summarize the process as he saw it.

"The senso comune [common sense] is that which judges the things given to it by the other senses. And these senses are moved by the objects; and these objects send their images to the five senses by which they are transferred to the imprensiva, and from this to the senso comune. From thence, being judged, they are transmitted to the memory, in which according to their power they are retained more or less distinctly" (C.A., fol. 90r–v). Two points to be emphasised about this statement are (1) that it is couched entirely in mechanical terms of movement and power, and (2) that there is introduced a part that takes the sensory impressions called the imprensiva. This "imprensiva" intervenes between the sense organ on the surface of the body and the senso comune. Leonardo makes it the receptive centre for all sensory impressions. He locates it at first (about 1487) in the anterior of the three traditional ventricles of the brain (fig. 8). Later, about 1504, he places it in the lateral ventricles (fig. 9), the shape of which he himself had delineated by making waxen moulds of the cavity. Its place in the sensory process is described as follows: "That

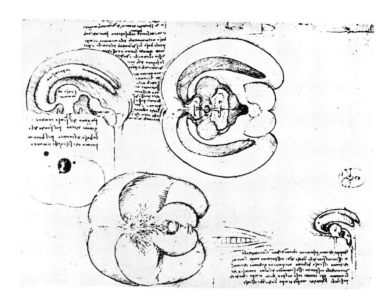

*Figure 8*
Early figure of the cerebral ventricles (*ca.* 1487). The optic nerves are seen to end in the anterior ventricle, labeled (rather illegibly) "imprensiva." The olfactory and auditory nerves pass to the middle ventricle, labeled "comocio" (senso comune). The posterior ventricle is called "memoria."

*Figure 9*
Later figure of the cerebral ventricles (*ca.* 1504). The shape and relationship of the cerebral ventricles is now more accurately defined by taking wax casts. The "imprensiva" is now located in the large, paired lateral ventricles. The senso comune is in the middle ventricle, and memoria in the posterior ventricle (Q. V, fol. 7*r*).

faculty of judgement which is given to man is caused by an instrument with which the five senses are connected by means of the imprensiva. To this instrument the ancients applied the name sensorium commune. The sensorium commune is set in motion by means of the imprensiva which is situated in the middle between it and the sense organs. The imprensiva is moved through the images of things given to it by the instruments on the surface of the body, that is, by the senses, which are placed in the middle between external things and the imprensiva. And similarly the senses are moved through the objects. Surrounding objects send their images to the senses, the senses transfer them to the imprensiva, the imprensiva sends them to the senso comune, and from that they come to rest in the memoria . . ." (C.A., fol. 90*r–v*). The whole sensory process is here described as movement arising from percussion of the sensory organs. No vital or psychic spirit comes into the process anywhere; it is a wholly mechanical concept of sensory physiology, the movement ceasing only with its final percussion in the ventricle of memory.

43

## 4. THE SENSE OF SIGHT

Vision was the sense that interested Leonardo most of all. His first step towards a mechanical interpretation of this sense is to be found on folio *270r–v* of the Codex Atlanticus, where he holds a long debate with himself as to whether sight arises from a power projected by the eye or consists entirely in the reception of light. He concludes this crucial debate with the decision that the eye projects nothing, and that its function is to receive light rays from without.

Leonardo then asks himself: "In what way does the eye see objects placed in front of it?" and continues: "Suppose that the ball figured above is the ball of the eye [fig. 10]; and let the small portion of the ball which is cut off by the line s.t. be the pupil, and all the objects mirrored on the centre of the surface of the eye by means of the pupil pass on at once through the crystalline humour (lens) . . . which does not interfere with the things seen by the light. And this pupil having received the objects by means of the light immediately refers and transmits them to the intellect by the line a.b. And you must know that the pupil transmits nothing perfectly to the intellect except when the objects presented to it through the light reach it by the line a.b. as if from the line c.a. For although the lines m, n, f, g, may be seen by the pupil, they are not considered because they do not coincide with the line a.b. And the proof is this: if the eye shown above wants to count the letters placed in front of it, the eye will be obliged to turn from letter to letter because it cannot discern them unless they lie in the line a.b. or c.a. All visible objects reach the eye by the lines of a pyramid and the point of the pyramid ends in the centre of the pupil as figured above" (C.A., fol. 85*v*). Thus Leonardo distinguishes between the acuity of central and peripheral vision, between what we now recognize as vision mediated by cones and rods. He attributes the clarity of central vision, however, to its being the line of maximal power of percussion and velocity of the light ray carrying the image of the object. Following the path of the image onwards, he writes: "This circle has in it a point which appears black; this is a perforated nerve which goes within to the seat of the powers charged with the power of receiving the impressions, the imprensiva, and for forming judgements it penetrates to the senso comune. Now the objects that are in front of the eyes act with the rays of their images after the manner of many archers who wish to shoot through the bore of a carbine, for the one among them who finds himself in a straight line with the direction of the bore of the carbine will be most likely to touch the bottom of the barrel with his arrow. So the objects opposite the eye will be more transferred to the sense when they are more in line with the perforated nerve" (C.A., fol. *270r–v*). The "perforated nerve" referred to here is the optic nerve, the central cavity in which is formed by the retinal artery. All nerves of the body were, in the Galenic tradition, perforated. The analogy of the arrow-shooting emphasises the importance of the central line in relation to the line of percussion. It is a point that Leonardo stresses in relation to all powers, in particular to the destructive power of cannon-balls, in which context he illustrates both the wave spread and trajectory corresponding to his analogy of the archer's arrows (fig. 11). The force of percussion gives rise to impressed movement (impetus) which is the same as

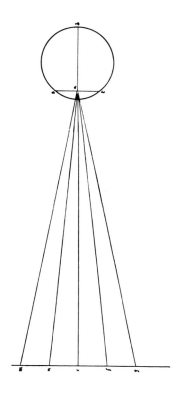

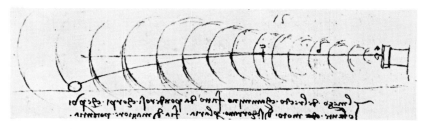

*Figure 11*
The central line of percussion. This is illustrated here, with its spreading waves of force, by the trajectory of a cannonball. Like all percussive forces, Leonardo applied this to light and sound (A, fol. 43*v*).

*Figure 10*
"How the eye sees objects placed in front of it" (see text; Richter 51).

"accidental gravity." Accidental gravity, like natural gravity, has a centre; it condenses into a point. The central line of the force of percussion is the line of movement of this point. Accidental gravity can be in any direction—horizontal, as in the projection of a cannon-ball or as light to the eye. This is the line along which the force is concentrated. The more powerful the force of percussion, the longer does the impression on the sensitive body last. Thus are produced after-images of sight and sound in eye and ear.

The part played in vision by the aqueous and vitreous humours of the eye is next described: "The watery humour which is in the light part that surrounds the black centre of the eye serves the same purpose as the hounds in the chase, for these are used to start the quarry and then the the hunters seize it. So also with this, because it is a humour that holds the power of the imprensiva and sees many things without holding them, but quickly turns them towards the central beam, which proceeds along the central line to the senso comune; and this seizes on the images and confines such as please it within the prison of the memory" (C.A., fol. 270*r*, *b*). The function of the optical humours, including the lens, is therefore to deflect light rays towards the vitally important central line, because this central line is that which carries the greatest power of percussion along the optic nerve. Leonardo links this central visual power with his general law of mechanical powers in the comment, "Nature did not give equal power to the sense of vision, but gave to this sense increasing power as it nears the centre. Nature did this in order not to break the law common to all other forces which become increasingly powerful as they approach the centre. One sees this in the action of percussion made by any body, and in the arms of a balance where the weight ap-

45

*Figure 12*
The eyeball, and its field of vision extending to over 180°. Rays are shown converging on the cornea in which they are refracted to the pupil, passing through to the lens and the optic nerve stalk applied to its posterior surface. This diagram is used by Leonardo to show that the central line of vision is the only line that has no intersection (Wind. 19152; Richter 79).

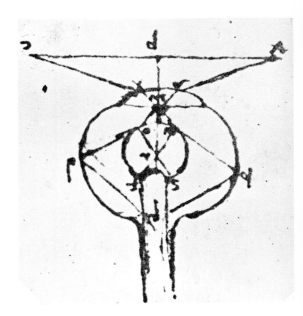

proaching the centre lessens its gravity. It is seen in columns, walls, and pillars; it is seen in heat and in all other natural powers" (MS D, fol. 1*r*).

Thus Leonardo saw the whole function of the dioptrics of the eye as a propulsion of beams of light towards the central line of vision. The cornea (fig. 12) he saw as a device for collecting light rays from a visual field of more than 180 degrees; the pupil is the space in which these rays crossed, so behaving like a camera obscura and inverting the image. The further passage of light rays within the eye-ball is either through the lens in which the image is reinverted and then cast on the optic nerve, upright; or it is cast onto the retina (fig. 13). From his observations of cat's eyes in the dark he deduced that their gleam was due to reflection of light rays from the pigmented retina (Tapetum) like light reflected from a lead-backed mirror (fig. 14). This coat of the eye, too, he thought, reflected light rays back towards the central line of vision.

The pupil remained a tantalising problem. At first Leonardo had looked upon it as a point of convergence of the light pyramid. He revoked this view when he noted the great variations in pupil size in light and darkness, and its variability as between man and nocturnal animals. On this subject he says: "The nocturnal animal can see better during the night than during the day. This happens because there is a greater difference between the enlargement and contraction of their pupils than in diurnal animals; for while the pupil of man doubles itself, the diameter of the pupil of the owl widens 10 times from its size during the day. Furthermore the ventricle in the human brain referred to as the imprensiva is more than 10 times the size of the whole human eye, and the pupil less than a thousandth part of the eye itself; while in the owl the pupil at night is much larger than the ventricle of its imprensiva in the brain. The proportion between the imprensiva and the size of the human pupil, the imprensiva being 10,000 times larger than the pupil, is far

*Figure 13*
The dioptrics of the eye. Some rays (including the central ray) pass through the lens, where the image, already inverted in its passage through the pupil, is reinverted. Other rays are reflected from the surface of the lens to the retina, whence they are reflected back (D, fol. 10*r*).

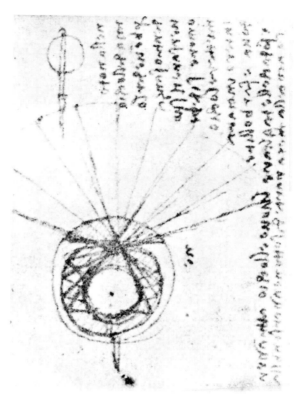

*Figure 14*
The reflection of light rays from the retina to the lens and optic nerve (K, fol. 119*r*).

greater in man than in the owl where they are almost equal. The man's imprensiva compared with that of the owl is like a great hall receiving light through a small hole compared with a small room entirely open. Indeed in the great hall there will be darkness at noonday, while in the small open one there will be brightness at midnight" (MS D, fol. 5*v*). This passage makes it clear that Leonardo saw vision as the result of the percussion of light, first on the eye, then on the optic nerve, up which its waves of percussion flow to make their impression on the ventricle of the imprensiva. The clarity and duration of the visual image are directly proportional to the intensity of illumination of the imprensiva; this in its turn is directly proportional to the base of the pyramid or cone formed by the pupil; this base, however, since the pupil contracts, is inversely proportional to the intensity of light falling on it. At each stage the power of percussion and vision is subject to the pyramidal law of perspective. This governs the diminution of size of the object and its loss of colour and shape with distance. Vision thus consists of a two-stage pyramidal system; one of perspective from the object to the pupil, the other from the pupil through the optic nerve to the imprensiva in the brain. Here the geometrical forms of the images carried by light have their existence and are combined with images from the other sense organs, the whole sensory input being forwarded to the senso comune where it enters consciousness.

47

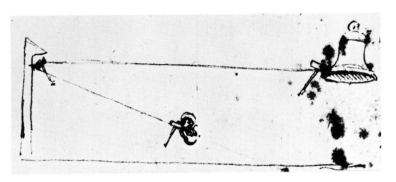

*Figure 15*
Sound is percussion of the air
which percusses the ear. "I
say that the sound of the echo
is reflected by percussion to
the ear, just as the percussions
made in mirrors by the images
of objects are to the eye"
(C, fol. 16*r*).

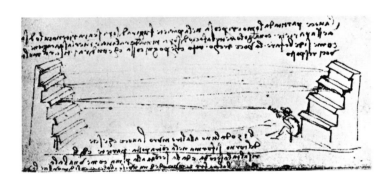

*Figure 16*
Multiple sound echoes
(B, fol. 90*v*).

## 5. HEARING

Leonardo by no means neglected the study of acoustics. The physical basis of hearing is percussion. "It is the cause of all sounds and the transmuter of various things . . . There is nothing of greater power," he writes (MS A, fol. 27*v*), and "the wave of the voice goes through the air as the images of objects pass to the eye." Sound is produced by a pressure wave, "by the friction of the rare against the dense" (F.B., fol. 31*v*). It consists of spreading waves of condensation and rarefaction. He notes how poor is the power of locating sound, and attributes this to sound not reaching the ear along straight lines only but also along tortuous and reflected lines. He appreciates that echoes are reflected from surfaces according to laws similar to those for the reflection of light; this he illustrates (fig. 15), representing the power of percussion of sound by hammers (MS C, fol. 16*r*). The ear, he makes clear, is percussed in hearing (fig. 16). The intensity of sound (fig. 17), like that of light, Leonardo relates to the size of the base of its pyramid in relation to the size of the ear (MS G, fol. 46*r*). Its decline is in pyramidal proportion to its distance from the ear, a point he illustrates very clearly in two figures on folio 79*v* of MS L (fig. 18), showing that two "small" sounds do not carry as far as one twice as large. The pitch of sound he correlates with the degree of condensation or pressure produced by, for example, a bird's wing or a human larynx. It is interesting to note that these variations in sensation he relates directly to external modifications of the stimulus, and they are in pyramidal proportion, that is, they follow the same law of perspective as vision.

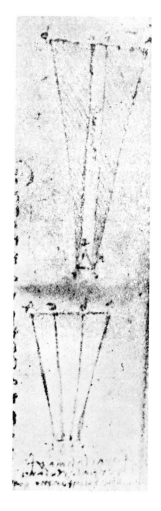

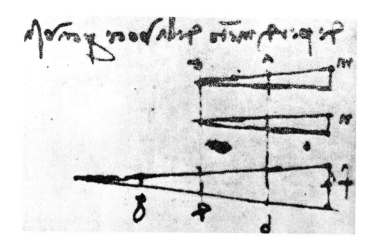

*Figure 17*
The intensity of sound; variation according to the pyramidal law. "Concerning the power of the voice. As many times as the voice ab, receives into itself the voice fn, so many times more powerfully will the ear, cd, receive the voice from ab;than from fn. If in fact ab,is infinitely greater than fn, the voice percussing the ear, cd, will be infinitely greater than that which would percuss it from fn" (G, fol. 46r).

*Figure 18*
The pyramidal diminution of sound with distance. "In the distance ab, the 2 voices m and n, diminish by a half . . . In the same distance the voice f, being twice m or n, has lost a quarter of its power. Here it surpasses by three times the power of the voice at g, which is equal to the voices m and n, at the distance ab" (L, fol. 79v).

In spite of all this interest in hearing, Leonardo's anatomical notes contain only one reference to the structure of the ear: "It would be sufficient merely for the voice to resonate in the arched recesses of the petrous bone which is within the ear without there being any other passage from the bone to the senso comune" (F.B., fol. 2r). He is here refuting the Aristotelian and Lucretian view that the senses operate and feel in the heart or on the surface of the body; at the same time he expresses the resonance theory of the function of the inner ear enclosed in the rocky "petrous" bone. This resonance he describes as the great function of the ear, the organ being what he terms "sensitive." He might also apply it to the imprensiva. "I apply the term sensitive," he writes, "to such an object which, while changing from its first state, preserves within itself an impression of the thing that moved it. The sensory impression is that of a percussion received upon a resonating substance such as bells, or like the note in the ear which indeed unless it preserved the impression

49

*Figure 19*
Mine-detecting
device resembling
the mechanism of
the eardrum and
ossicles of
the middle ear
(MS 2037,
Bib. Nat., fol. 14).

of the notes could never derive pleasure from hearing a single voice, for when it passes in a moment from the first to the fifth the effect is as though one heard these two notes at the same time and thus perceived their true harmony" (C.A., fol. 360r). This preservation of sound by the ear he likens to the after-image formed by the eye by a moving fire-brand. And musical harmony he finds "composed of the union of its proportional parts sounded simultaneously, rising and falling in one or more harmonic rhythms. These rhythms surround the proportion of the parts of the harmony as the contour lines surround the limbs from which human beauty is born" (Trat., fol. 16).

Instead of dissection Leonardo made models that illustrate, it would seem accidentally, his idea of the mechanism of the ear. The external auditory meatus Leonardo imitates thus: "If you place the head of a long tube in the water and the other end in your ear, you will hear ships at a great distance from you. You can do the same by placing the head of the tube on the ground, and you will then hear anyone passing at a distance" (MS B, fol. 6r). One is almost surprised to find that he did not apply this extension of the external auditory meatus, the stethoscope, to the human chest. He also devised a model that represents the middle ear, of which he seems to have been in fact quite ignorant (fig. 19). "If you wish," he writes, "to find out where a mine runs, set a drum over all the places where you suspect the mine is being made, and on this drum set a pair of dice, and when you are near the place where the mining is the dice will jump a little on the drum through the percussion given underground in digging out the earth" (MS 2037, Bibl. Nat., fol. 14r). The similarity of this mechanism to the ear-drum and its ossicles is too close to be missed.

In the third sketch (fig. 20) Leonardo defines his idea of the function of the internal ear as the production of resonance "in the arched recesses of the petrous bone." He observed that the peasants of Romagna make "large concavities in the mountain in the form of a horn. And on one side they fasten a horn, and this little horn becomes one and the same with the concavity already made, whence is made a great sound" (MS K, fol. 2r). This provided him with his concept of resonance of the internal ear; the resonating amplified sound waves are carried along the auditory nerve to make their impression on the imprensiva. Here they join with the other sensory percussion waves and are carried on to the senso comune.

50

*Figure 20*
Model of the mechanism of
the internal ear in the petrous
bone. The concavity in the
rock in the form of a horn.
"On one side they fasten a
horn, and this little horn
becomes one and the same with
the concavity already made, whence
is made a great sound" (K, fol. 2r).

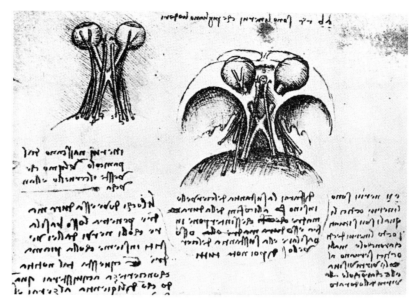

*Figure 21*
The olfactory nerves; the
optic nerves, chiasma, and
tracts (F.B., fol. 35r).

## 6. SMELL

Leonardo compares the senses of smell and sight in the following words: "Sight is exercised by all animals through the medium of light . . . the atmospheric medium which exists between the object and the sense incorporates in itself the images of things, and by its contact with the sense transmits the image to it; and if the object consists of either sound or odour, they send their spiritual power to the ear or the nose" (C.A., fol. 90r). Once more he stresses the analogous nature and mechanism of all the senses. In the case of smell Leonardo is struck by the great distances over which a scent maintains its power of stimulating the sense of smell. "Witness the musk," he writes, "which keeps a great quantity of air loaded with its odour, and which, if it is carried a thousand miles, will occupy the atmosphere without any diminution of itself" (C.A., fol. 270v, c). The "spiritual power" or nervous force of smell is conveyed to the olfactory nerve by "contact," that is, by percussion.

His anatomical studies of the olfactory organs revealed to Leonardo that the human nose is formed of "less ingenious instruments" for smell than those of many animals. He describes how in the lion "the sense organ of smell, forming part of the substance of the brain, descends into a large receptacle to meet the sense of smell which enters among a great number of cartilaginous cells or spaces with many foramina which go to meet the above-mentioned brain" (F.B., fol. 13v). The human olfactory nerve is beautifully illustrated (fig. 21) and referred to as carrying odours and smells; and its termination is shown to be in the imprensiva, alongside that of the optic tracts

51

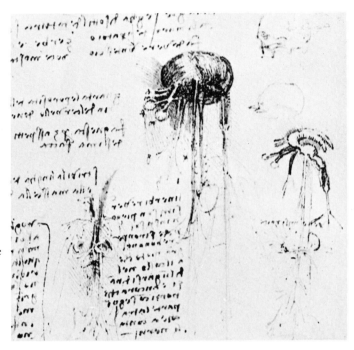

*Figure 22*
The termination of the olfactory nerves and optic tracts in the ventricle of the imprensiva ( Q. I, fol. 13*v*). See figure on right.

on folio 13*v* of Q. I. Thus the sense of smell is stimulated by the percussion of an odoriferous image on the olfactory nerve whence it is transmitted to the imprensiva (fig. 22), the central sensory reference station, before being passed on to the *senso comune*.

## 7. TASTE

Leonardo pays little attention to the sense of taste. Perhaps this is because he was convinced that chemistry plays little part in human physiology, and he found it difficult to see the relation of this sense to the stimulus of percussion. However, he notes that tastes, like the other sensations, are carried to the imprensiva. Because taste and touch arise directly from the body surface, he is of opinion that they cannot be inhibited or ignored so easily as the distance receptors.

## 8. TOUCH

Following Aristotle Leonardo makes touch a composite sense. "The sense of touch," he writes, "derives from the *senso comune*; one sees it extending with its power as far as the finger-tips. For as soon as the finger-tips have touched the object, the *senso comune* is immediately made aware of whether it is hot, cold, hard or soft, pointed or smooth" (C.A., fol. 270*v*, *b*). All these varieties of the sense of touch Leonardo finds to be accurately localised since they arise from direct percussion of the skin, without any external medium. "The sense of touch," he writes, "clothes all the skin of man. Touch passes through the perforated nerves and is transmitted to the *senso comune*;

52

*Figure 23*
The pyramidal concentration of the senses of heat and cold. "The heat of the sun which is found on the surface of a concave mirror will be reflected in converging pyramidal rays to a single point. As often as the point itself, ab, or cd, enters the base fg, so many times will the heat be more powerful than that on the surface of the mirror . . . In the same way many puffs from the bellows on the same point make extreme cold" (A, fol. 20r).

nerves spread out with infinite ramifications into the skin which encloses the limbs and viscera of the body . . . and being distributed over the tips of all the fingers they transmit to the senso comune the impression of what they touch" (F.B., fols. 1v and 2r).

The sense of heat (part of touch for Leonardo) receives much attention in relation to its physical laws; it is particularly compared with light. "The heat of the sun," he writes, "which is found on the surface of a concave mirror will be reflected in pyramidal rays converging at a point [fig. 23]. As many times as this point enters into the surface so many times will this point be hotter than the heat that is found on the mirror" (MS A, fol. 20r). Once more he brings into play the pyramidal law, this time as a quantitative measure of the concentration of a stimulus and sensation.

Cold for Leonardo does not consist merely of lack of heat; it is also produced by movement of the cold, dry element, air. For this reason he considers that puffs of air are felt as cold to the skin. Leonardo writes: "Just as the many rays of a concave mirror united in a point make extreme heat, so do the many puffs of air blowing on a point make extreme cold" (MS A, fol. 20r). Once more he brings his pyramidal law to bear on the relation of stimulus to sensation.

Leonardo's dissections of the nervous system revealed to him that all peripheral nerves join the spinal cord; along these, he reasoned, must pass those senses he called touch. How did they travel from the spinal cord to the senso comune? Since the fourth ventricle, the ventricle of memory, is situated at the top of the cervical spinal cord, he suggests that this may be the seat of the sense of touch. This suggestion is at variance with all his other statements about the destination of the sensory impulses which are described as going to the imprensiva and thence to the senso comune. It is the one inconsistent suggestion in his otherwise consistent pattern of sensory physiology.

## 9. PAIN

Leonardo saw pain as composed of two elements, sensitivity and heavy percussion. "Nature has given sensitivity to pain to such living organisms as have the power of movement in order to preserve the members that in this movement are liable to be destroyed" (MS H, fol. 60r). Plants that do not move do not percuss objects and so do not experience pain. "In the movement of man nature has placed all those parts in front which, on being percussed, cause a man to feel pain; so it is felt in the shins of the legs, forehead, and nose" (Q. VI, fol. 22r). This again is for the preservation of the body. The sensitivity factor in a man's experience of pain is stressed in the remark, "Where there is most power of feeling there of martyrs is the greatest martyr" (Trat., fol. 35r). The martyrdom of hanging such as he saw inflicted on Bandini Baroncelli, the assassin (fig. 24), was reflected in Leonardo's physiology of sensation by the remark, "The blow or percussion given to the cord in the neck [i.e., the cervical part of the spinal cord] redoubles the martyrdom of the hanged man" (MS A, fol. 31r). Believing as he did (and rightly) that the nerves of touch from almost the whole body were gathered together in the cervical spinal cord, percussion here must logically be the most painful of all percussions of the body.

On the same page Leonardo notes the destructive effects of heavy percussion by shock or blast waves. He describes how a heavy blow given to a rock standing in water stuns any fish under or near it which "come to the surface of the water as if dead." The reason is that the fish cannot move away from the percussion wave and so suffer damage from it as the wave penetrates them. "The pain they may feel," he adds, "is like the pain the hand gets if, whilst holding a stone, it is beaten by a hammer" (MS A, fol. 33r). He describes a similar wave of percussion from the blast of a cannon. "If you discharge a bombard in a courtyard surrounded by a wall, any vessel that is there, or any windows covered by cloth or linen, will be instantly broken . . . and the webs of spiders will fall down and the small animals will perish . . . and it will cause women to miscarry and also every animal that is with young, and the chicks will perish in their shells" (C.A., fol. 363v, d).

With this example we complete Leonardo's range of percussions of the sense organs of the body, from their finest and most delicate manifestation as the percussion of a ray of light to their most destructive form as blast from an explosion.

## CONCLUSIONS

The evidence is clear: Leonardo's physiology of sensation is thoroughly mechanistic. The whole process from the impact of stimuli on the sense organ to its appearance in consciousness in the senso comune is the result of movement and percussion. This movement and percussion Leonardo attempts to quantitate. His guiding rule in this effort, which rule he derived from observations of the wave motion of water and from many experiments in mechanics, is the pyramidal law. This he applies as strictly to the microcosm of the human body as he does to the macrocosm of the world.

*Figure 24*
Hanged body of
Bandini Baroncelli,
Bayonne, France.

*Figure 25*
Concentration of the powers of the
senses according to the pyramidal law
(see text; G, fol. 89v).

For Leonardo the intensity of any sensation is directly proportional to the size of the stimulus, as illustrated by the base of a pyramid; and this applies to all the senses equally. The more the pyramidal force of a stimulus is concentrated on to the sense organ, the greater its intensity or power. He summarises this quantitative relationship between stimulus and sensation in a note "On Power": "The same virtue or power is so much the more powerful as it is more concentrated. This is true of heat, percussion, weight, force, and many other things. Let us speak first of the heat of the sun which imprints itself in a concave mirror and is reflected by it in pyramidal figure, which pyramid acquires proportionately so much more power as it is narrowed . . . So also such other qualities as sweetness, bitterness, sharpness, roughness do the same, as has been stated above" (fig. 25; MS G, fol. 89v). Since this pyramidal law applies to all these various sensory images on their journey from the sense organ to the imprensiva, they arrive there carrying sensations proportional to the intensity of their stimuli. However, there are other modifying factors. Since the pyramidal decline of power is proportional to distance, the sense organ that is nearest the imprensiva will impart to it the most forceful percussion. Since this is the eye, the swiftest and most powerful sense of the body is that of sight.

All the percussion waves set up in the nerves by stimulation of the sensory end organs travel to the centre for receiving impressions in the brain, the imprensiva. Here they set up more vibrations; here lies the focus of the convergence of all the mechanical sensory impressions received on the surface of the body. Here selection by a process of the nature of resonance takes place. By this a harmony and rhythm of spatio-temporal wave patterns is transmitted to the senso comune. In this way the imprensiva organises the geometrical mass of sensory data into a suitable form for

conscious appreciation. Here in the senso comune these spatio-temporal patterns of movement make further percussions and come under the influence of "imagination, the rudder and bridle of the senses," and judgement. "The senso comune is the seat of the soul," writes Leonardo, "and the memoria is its monitor, and the imprensiva serves as its standard of reference" (F.B., fol. 2r). With their impact on the memoria sensory movements of percussion cease.

It will be seen that this physiological scheme of sensation retains a dynamic geometrical and mechanical relationship in space and time between the sensations perceived and the objective world of nature. In such a scheme the pattern created in the observer's mind corresponds in its spatio-temporal dimensions with the pattern of the external world. Thus in Leonardo's view man's mind really can enter into nature's mind to act as interpreter and expound the manifestations of her laws. This, as has been mentioned already, was Leonardo's declaration of faith in science. His sensory physiology enabled him to see his own mind in truth as a second nature; and it was thus he saw himself as able to represent the truth of nature in his painting.

The importance of this sensory corner of Leonardo's vast field of scientific endeavour is, I think, twofold. First, it throws light on Leonardo's own mental processes since it reveals how he himself thought he saw the world of nature. It amplifies his concept of what he calls experience, and clarifies such statements of his as "experience never errs; it is only your judgement that errs . . ." (C.A. fol., 154r). From Leonardo this, like many similar sayings, is a physiological as well as a philosophical assertion. The Treatise on Painting is particularly rich in references to his sensory physiology. Clarification of his concepts of many other biological problems can be achieved only by applying one of Leonardo's basic precepts of exposition. "Arrange it," he exhorts, "so that the book of the elements of mechanics with examples shall precede the demonstration of the movement and force of man and other animals, and by these you will be able to prove all your propositions" (B.M., fol. 145v). This method of presentation has been attempted in this paper.

The other source of the importance of Leonardo's work on the physiology of sensation lies in its relation to the history of medicine and science. Medical science has throughout its history advanced by applying the basic sciences to human problems. Leonardo not only created a great part of his own science of physics but, as we have seen here, he applied it consistently and quantitatively to the physiology of man. His sensory physiology, elaborated about 1495, initiated that struggle to understand our world of the senses in the form we still pursue today. That his conclusions are not without their anticipations of our present position gives us some measure of the power of Leonardo's scientific intuition; and it vividly reminds us of something we are in danger of forgetting, the reality of the creative art of science.

### REFERENCES

Heydenreich, L. H., *Introduction to the Treatise on Painting by Leonardo da Vinci*, trans. A. P. McMahon (Princeton, 1956).

Richter, J. P., *The Literary Works of Leonardo da Vinci* (London, 1883).

# Leonardo as a Writer

## by AUGUSTO MARINONI

THE FAME of Leonardo as a writer—if we can speak of real fame—remained for some centuries limited to the Treatise on Painting, which was in great demand and deeply appreciated by the artists of the sixteenth and seventeenth centuries. A medal struck about the middle of the eighteenth century can be considered a symbol and synthesis of this fame; it bears Leonardo's head on the obverse and a crown, a pen, and the words *scribit quam suscitat artem* on the reverse. This means that Leonardo was considered as great a writer and theorist on art as he was an artist. Yet when real men of letters, not artists, set about examining Leonardo's original writings with the intention of publishing them, their disappointment was keen. At first Ludovico Antonio Muratori and Antonio David, and later the professors of the University of Pavia, after examining Leonardo's papers, expressed their dismay at that chaotic mass of fragmentary notes which they judged absolutely unfit for publication. Antonio David, though convinced that Leonardo had written books and treatises, refused to identify them with those manuscripts. Muratori declared them "a barren field." Apart from the wonderful drawings, he considered the notes to be too few and, besides, not sufficiently explanatory. Later on, Padre Fontana, in his unfavorable report on Leonardo's writings, complained again of the lack of proof. In other words, if language is an instrument of communication, it cannot be said that Leonardo's language is so, according to Fontana, because it fails to communicate the author's thought. And this seems to be a completely negative judgment.

In the nineteenth century Venturi, Bossi, Manzi, Libri, and others showed greater confidence and even enthusiasm, but for the novelty of Leonardo's scientific thought more than his literary expression. Only in our century has Leonardo been held in increasing esteem as a writer, after the great romantic revolution had destroyed many formal prejudices and had predisposed men's minds to accept even a splintered and fragmentary work. The situation has even been reversed at times, because at the very point where Leonardo's expression fails to communicate his thought many have yielded to the fascination of the riddle and abandoned themselves to the most arbitrary conjectures.

The generation that lived in the last years of the nineteenth century and the first years of the twentieth bequeathed us a mythological image of Leonardo. Both the enthusiasm aroused by the discovery of the manuscripts, which had lain hidden and unpublished for so many centuries, and the ignorance of the actual state of medieval scientific thought contributed to the creation of this image. A deeper knowledge of the cultural environment in which Leonardo lived and worked, together with a deeper and more analytical scrutiny of the actual contents of Leonardo's writings, has brought about a revision of that myth. This revision, instead of destroying Leonardo's greatness, has freed it from many ridiculous misconceptions. If it is true, as Leonardo says, that love derives from knowledge, we think we love Leonardo more than he was loved by his blind admirers of the past, especially because, having a deeper knowledge of the man and his limits, we can base our admiration on surer foundations. Even from the literary point of view, Leonardo as a writer has been judged in different ways; some critics maintain he was the founder of Italian scientific prose, while others deny this. Some are inclined to consider him one of the greatest Italian writers, while others put him among the minor ones. I think it is possible to clear up this problem by carrying out an analytical examination of Leonardo's style.

We may consider as a starting point for our research the Codex B, which is the oldest of Leonardo's *Codici* that can be dated. In this Leonardo piles up, without any order, drawings of arms, machines, fortifications, civil and sacred buildings, accompanied by some short explanations and others less short; or he transcribes, with a summary, certain passages from the *De Re Militari* of Valturio. In all these writings there are very scanty traces of an attempt at style, of any particular attention to rhythm, to the sound of words, to their position in the sentence, or even to the syntactical structure of the period. The practical and utilitarian purpose of this type of writing, which aims at fixing rules and standards for the activity of an artist, only requires brevity and conciseness, and not always clarity since it is not intended for the common reader. The more usual form of expression is the independent clause, which is as simple as possible: "Il pié dalla punta al calcagno, entra due volte"; "A la Fama si de' dipigniere tutta la persona. . . ." The verb often has the peremptory form of the imperative or of the commanding future. The main clause is often connected with a subordinate conditional one which expresses the circumstance in which one must execute the order given. And this is precisely one of the most frequent syntagma used. (See fol. 17*v*, for example, for the five notes on the way to prune or grow trees; four notes out of five are written according to the pattern of the hypothetical period.) There is a prevalence of simple propositions, sometimes accompanied by one subordinate proposition. Generally no care has been taken to compose these simple periods into a harmonic whole. When the speech exceeds the usual limits of brevity, Leonardo does not think of varying the phrasing in order to avoid monotony, but, following the rhythm of oral speech, directed to a practical end, he links one proposition to the other with a sequence of "ands." (See fol. 37*r*, for example, and the description of a cannonball.) We can say that the typical phrasing of Leonardo in this sort of writing is generally linear, but disharmonious, that is, it is made up of one or more straight segments, one

after the other, which do not join together so as to form any design. The extremely simple vocabulary, too, is made up of the usual names of the objects described and of their parts, a language that, unaided by the imagination, remains purely technical. It is used by a craftsman who is writing for himself what are absolutely private notes.

Yet there are at least two points where Leonardo's words have an unusual depth and energy. In folio 4r he fights against the belief in *spiriti* or ghosts, and he sums up in a few lines a speech that will be developed more fully in another paper. Here we can trace unusual stylistic care. The sentences are simple and short, of the usual rectilinear type. Yet they are repeated three times, identical at the beginning and varied at the end, with a concentration of energy that shows itself in the rapid conclusion: "non pò essere voce dove non è movimento e percussione d'aria; non pò essere percussione d'aria dove non è strumento, non pò essere strumento incorporeo. Essendo così, uno spirito non pò avere né voce, né forma, né forza; e se piglierà corpo, non potrà penetrare né entrare dove li usci sono serrati." In this way the few uniform sentences have a unitary rhythmic and musical structure, which derives from insistent repetition and from parallelism of the opposed parts. Instead of developing the thread of his thought on a wide canvas with subtle and progressive argumentations Leonardo arrives at a vigorous and definite conclusion immediately. But, to tell the truth, he does nothing but fix the most important subjects of a theme which he intends to develop more widely. Therefore even here he is writing for himself.

The second point concerns one of the deepest themes of Leonardo's cosmology: the definition of Force. The definition is so solemn as to require the use of latinizing forms: "Forza dico essere una potenza spirituale incorporea e invisibile, la quale con breve vita si causa in quelli corpi che per accidentale violenza stanno fori di loro naturale essere e riposo." The same concepts are developed in the Codex Atlanticus (fol. 302*v*, *b*) in a still more interesting page. Force is defined in a series of bare sentences grammatically detached, yet connected by so insistent a rhythm as to transform them into a kind of biblical hymn, almost like the verses of a psalm. "Tardità la fa grande e prestezza la fa debole.—Vive per violenza e more per libertà.—Trasmuta e costrigne ogni corpo a mutazione di sito e di forma.—Gran potenza le dà desiderio di morte.—Scaccia con furia ciò che s'oppone a sua ruina.—Trasmutatrice di varie forme.—Sempre vive con disagio di chi la tiene.—Sempre si contrapone ai naturali desideri.—Da piccola con tardità s'amplifica, e fassi d'una orribile e maravigliosa potenza.—E costrignendo se stessa ogni cosa costrigne." It is not a logical discourse, but the enunciation of experimental facts that have, however, the solemnity of an epic poem and the strength of dogmatic truths. The impression is one, not of scientific prose, but of a sudden lyrical outburst.

In many pages of the Codex B Leonardo transcribes or summarizes certain parts of the *De Re Militari* of Valturio, which he read in Ramusio's bad translation. The quickening spirit of this book is clearly humanistic. Though the author intends to turn the military experience of the ancients to his contemporaries' advantage, the admiration and love for the classical world is so striking as to take the reader back through the centuries, as if the world had stopped its course in

59

that age. In every line the author talks of ancient writers and figures as if they were alive: Quintilian, Caesar, Vitruvius, Plutarch, Xenophon, and even the smallest facts concerning their lives and sayings are mentioned with eager curiosity. Leonardo read the book from a different point of view. In his letter to Ludovico il Moro he said he knew every aspect of military engineering, both on land and sea. Each paragraph in that letter corresponds to parts or chapters of the *De Re Militari*, and this may be sufficient to demonstrate with what deep interest Leonardo consulted that book. When Valturio speaks of a weapon he dwells on the etymology of its name, on the passages of the authors who give us information about it, on when and how it was invented, but he fails to describe the weapon itself in detail. On the contrary, Leonardo's first concern is to make a drawing of it, so taking the first step toward its concrete realization. Yet the immense humanistic vitality of that book is not completely lost. In no other manuscript of Leonardo do we find the quotations from ancient authors so numerous and so detailed; which leads us to suspect that at least for once Leonardo wanted to try the method of contemporary men of letters and "allegare gli altori" or adorn himself with other men's labors.

But Leonardo must have found the reading of this book difficult. The language in which it is written, though similar to that used by many translators in North Italy of that time, must certainly have appeared ugly and abstruse to a Tuscan with a scanty knowledge of Latin since it is a mixture of Latin, Tuscan, and northern words, without any rigid syntactical order. He must have found many words either completely new or unusual by virtue of their particular meanings and spelling. Leonardo already had the intention of becoming a writer himself, and, while reading that book, he must have realized the insufficiency of his own vocabulary, rich in technical words but poor in those abstract ones that all writers with a deep knowledge of Latin were continually transferring from the ancient language of Rome to their own vulgar tongue, so enriching and ennobling it. Leonardo thought it possible to obtain directly from these books, translated from the Latin, that lexical wealth which others were able to draw directly from the Latin language. And he began transcribing from these books thousands and thousands of words, which were in those days called *vocaboli latini* and which are Latinisms. The technical terminology that he had learned in the artisan shops was rich but tied to the everyday things. The *vocaboli latini* that Leonardo learned to "derive," as he called it, were more flexible and more suited to the expression of ideas and sentiments, that is to say, the objects of thought. A few years later he attempted a more radical solution of the problem, studying Latin directly from Perotti's grammar. He filled several pages of the Codices H and I with verbal conjugations, declensions, and syntactical schemes. But this attempt, which was soon interrupted, did not have any visible results.

The Codex Trivulziano, in which Leonardo made copious lists of about nine thousand *vocaboli latini*, was written a short time after the Codex B and shares a common characteristic: it contains a confused mass of personal notes, devoid of any literary value. Yet on folio 6r it gives us a famous evocative and enigmatic passage: "Muovesi l'amante per la cos'amata come il senso e la sensibile e con seco s'unisce e fassi una cosa medesima.—L'opera è la prima cosa che nasce dell'uni-

one.—Se la cosa amata è vile, l'amante si fa vile.—Quando la cosa unita è conveniente al suo unitore, li seguita dilettazione e piacere e sadisfazione.—Quando l'amante è giunto all'amato, lì si riposa.—Quando il peso è posato, lì si riposa.—La cosa cogniusciuta col nostro intelletto." The meaning of these seven propositions is not immediately clear. They are preceded by three words, which probably belong to this passage: "Sugietto colla forma." I think that the whole passage deals with the Aristotelian relationship between substance and form, that is, between power and act, from which motion derives. But it also deals with the Neoplatonic concept of "appetite," which, said Ficino, is an "inclinatio ab indigentia quadam adnitens ad plenitudinem." The appetite which drives the lover toward his beloved and the heavy object to come to rest is the same as that which drives the mind toward the joyful completeness of knowledge. This theory of ours has been formulated because we consider it to be implicit in the seven sentences of Leonardo; it is a theory that, were it actually developed by Leonardo, would involve the reader in the coils of his dialectics. But Leonardo, who is only speaking for himself, is not concerned with clearing up logical connections: he is only enunciating certain transparent truths with linear and parallel statements. But the parallelism and the symmetry of each part constitute a rhythmic, resonant, and musical link. Three consecutive sentences begin with the same word "when"; two end in the same way, with an undulating movement; and at once a sudden inversion of rhythm indicates that the conclusion has been reached. The dynamic contents are fixed and almost frozen in the rigid and categorical formulation of scientific laws.

Our mind turns at once to another passage, which in a very few lines would seem to sum up an immense speech: "De Anima. Il moto della terra contro alla terra ricalcando quella, poco si move le parte percosse. L'acqua percossa dall'acqua fa circuli dintorno al loco percosso. Per lunga distanza la voce infra l'aria. Più lunga infra'l foco. Più la mente infra l'universo. Ma perché l'è finita non s'astende infra lo'nfinito" (MS H, fol. *67r*). A philosopher, who died a short time ago, expressed his disappointment and perplexity on reading this note, which promises to deal with the soul but instead talks about physical tremors that shake the earth, move water, air, and fire, while the mind is at the same time taking in the whole of infinite space.

But Leonardo is perfectly consistent with his logical principles. He avoids all metaphysical discussion. It is not possible to give a definition of the elements; only their effects are known. And since the soul (or mind) is made up of the fifth element, it is compared with the other four and included in a scale that goes from the most solid and inert to the most mobile and ethereal. From this very simple comparison the nature of the soul can be clearly seen as pure activity, energy, and very rapid and unseizable motion. Here, too, Leonardo's real aims are implicit. If he were speaking to a reader, Leonardo would be more diffuse; but speaking to himself, he limits himself to registering certain indisputable physical phenomena, and says nothing about the deductions he wishes to draw from them. Yet the direction of his concealed thought, which hides itself behind these simple aspects of the natural world, is revealed by the rhythm of the sentences, which gets gradually faster to the point where it relaxes and finds its rest in the final conclusion.

So far we have examined how Leonardo put down on paper personal notes, which were not intended for a reader, notes which range from the most disordered and hurried to the deepest and most intense. They have a characteristic in common: the brief, concise, linear sentence, like the segment of a straight line. When the thought broadens out and is more deeply felt, these rectilinear sentences are set out parallel to each other, and join together to form one rhythmical, unitary group, charged with compressed energy. Their structure is no longer that of a continuous, logical discussion, but the musical structure of a poetic creation. However, even in Leonardo's manuscripts there are many pages that were evidently written for a reader to come. He decided to write several treatises on painting, on water, on anatomy, which unfortunately he was never able to finish. The Codex A, which was written a short time after the Codex B and Trivulziano, contains many passages of the Treatise on Painting. Many of them are bare rules for the painter, but many set out the reasons for those rules. Here Leonardo talks with his reader-pupil, without the strong conciseness of scientific definitions, and without the carelessness of hurried notes, but with an average tension, which neither avoids the anacoluthons of everyday speech nor leaves out those contemplative pauses when he dwells upon the most suggestive aspects of beauty. At those moments the rhythm of the word acquires a particular purity, which accompanies the trepidation of the soul. The words join together in uniform, rhythmical entities, which often coincide with lines from the Italian poetical tradition. "Poni mente per le strade,—sul fare della sera,—i volti d'omini e donne,—quando è cattivo tempo,—Quanta grazia e dolcezza—si vede in loro!"

Afterward, too, Leonardo happens to insert verse into his prose unconsciously. Some passages begin and end with resonant hendecasyllables. When in a moment of fervid enthusiasm he sees— unfortunately only with his imagination—the first aeroplane built by him rise and fly like a big bird from a hill in Florence, he expresses his joy in a series of hendecasyllables. "Piglierà il primo volo il grande uccello sopra del dosso del suo magno Cecero, empiendo l'universo di stupore, empiendo di sua fama tutte le scritture, e gloria eterna al nido dove nacque."

The Codex C has a particular interest for us. The perfection of its drawings and the care of the writing are certain proof that Leonardo intended to present his notebook to an important reader. Here the literary form must have received special attention, and it probably represents Leonardo's ideal at that moment. In fact we can see that all traces of hurry and improvisation have disappeared, and the style reveals a sustained confidence, which can only be seen at intervals in the preceding manuscripts. A peculiarity that strikes the reader is the frequent use of indirect constructions, which were adopted chiefly by Latin scholars. To give only a few examples, instead of writing "la quale fia causata dal lume più alto che largo," Leonardo writes "la qual dal lume più alto che largo causato fia;" instead of "del corpo ombroso piramidale posto contro a sé," he writes "del contr'a sé posto piramidal corpo ombroso." The affectation of putting the adjective before the noun is frequently repeated even in those cases where common usage prescribes the contrary. Consider also the use of latinizing words: *propinquo* instead of *vicino*, *circundare* instead

of *circondare, conducere* instead of *condurre*, etc. The use of these latinizing devices reveals Leonardo's purpose: he wants to attain to a nobler and more dignified style by slackening the rhythm. In fact the rhythm is no longer rapid and broken, as it is in the passages we have already examined, but calm, solemn, and above all "legato." This term is used deliberately in its musical sense because we can clearly see Leonardo's predilection for a particular type of melody: "la piramidal pura ombra dirivative," "Quel corpo parrà più splendido, il quale da più oscure tenebre circundato fia." The syntax of the periods remains extremely simple, but the modulation of the sentences, prolonged and amplified, takes on a sense of grandeur. The language is also ennobled by coupling the nouns with particular adjectives: "le usate tenebre," "le ombrose cose," "la pupilla tenebrata," "lo sopravenente splendore." Adjective and noun are musically joined in one ample modulation which echoes the sonorous sound of the great poetry of the fourteenth century. His long practice in the choice and derivation of words from the books of men of letters had certainly helped him in refining his language, which has now become nobler and more sensitive.

If in these passages of the Codex C Leonardo enlarges and ennobles his sentences with various devices, yet still retaining a very simple syntax, in the Fables, on the other hand, he makes strenuous efforts to abandon the linear form and to arrive at that complex articulation of periods which is obtained by employing many subordinate propositions, hierarchically arranged (according to their importance) around the main proposition. By adopting this structure writers such as Boccaccio and, later on, Bembo established the so-called round period. Yet in Leonardo's Fables we see a great number of subordinate propositions, but not the "round period." In fact these subordinate propositions are mostly of the same degree and of a simple type. The verb has the gerund form or is a past participle, and the propositions are joined together as if they were co-ordinate clauses. Consequently the structure of the sentences remains linear (for example: "Il misero salice trovandosi . . . e raccolti . . . apre; . . . e stando . . . e ricercando . . . stando . . . corse; . . . e crollato . . . parendoli . . . e fatto . . . rizzò"). We can conclude, therefore, that Leonardo's effort to arrive at more dignified literary forms is restricted to the simple proposition and is never realized within the complex structure of the period.

It is well known how writers at the time of the Renaissance were led by preference to use certain literary forms when expounding a scientific subject, forms such as the Treatise, the Discourse, the Dialogue, the Epistle. It is very interesting to notice how Leonardo tried to use each of these forms. Besides the Treatise, for which it is not necessary to give any examples, as far as the Dialogue is concerned, I shall merely quote the famous passage in which two interlocutors expound in turn the arguments "for" and "against" (*pro* and *contra*) natural law, according to which men unconsciously long for death (C. Ar., fol. 156*v*). As for the Epistle, we all remember the fanciful ones addressed to Benedetto Dei and to the Diodario di Soria in which he describes fabulous lands and monsters he has discovered—through his imagination. And by analogy we cannot but remember the Letters in which, some years later, Christopher Columbus and Amerigo Vespucci described their wonderful discoveries in the New World. As for the Discourse, the

examples are numerous, and it will be enough to remember those written against the "Abbreviatori," against the "Negromante" and the "Alchimista."

All we have said so far confirms the intention of the *omo sanza lettere* to devote himself to a vast literary activity. He tried to enrich his language with a mass of learned words taken from books. He tried without any great success to learn Latin. He introduced into his style some of the devices frequently used by the men of letters of his day. He experimented with almost every type of literary production then in fashion. But it is evident that these attempts were not made according to any organic plan or firm decision. His literary projects had ripened in Milan, at the court of Ludovico il Moro. After the fall of the duke the environment in which Leonardo had cherished his projects changed greatly. He began to live an unsettled way of life, frequently moving from one prince to another. Besides, the more he devoted himself to the study of nature, the more the matter of his observation grew in volume, and consequently the length of his treatises. He continued to collect thousands of preparatory notes, but, perhaps unconsciously, he gave up writing his book, whatever book it was to have been, and even the idea of a complete series of chapters. Neither his exacting nature nor the adverse events of his life can give a sufficient explanation of this renunciation. The real reasons are the very ones that establish his position in the history of science. J. H. Randall so sums them up: "Science is not oracular utterances, however well phrased: it is not bright ideas jotted down in a notebook. Science is systematic and methodical thought" and Leonardo "has no interest in working out any systematic body of knowledge." The real reasons derive from his cultural formation. In the artisan shops he learned, together with manual skill, the cult of experimental research, and he sharpened his spirit of observation. He realized, and openly declared, that the progress of science could not be guaranteed without the experimental method, and, polemicizing with men of letters and philosophers, he asserted the superiority of the painter above all other artists and scientists. He thought that his anatomical drawings not only surpassed but could eliminate and take the place of any treatise. He was convinced that it was not permitted for man to discover the nature of the soul or of the natural elements, but only to describe their behavior and mode of functioning in the physical world. But the men of letters and philosophers, whom he opposed and despised, knew how to set up and bring to an end a discussion, and how to write a book—something that Leonardo appears never to have learned.

In the Treatise on Painting Leonardo exhorts: "Se vuoi aver vera notizia delle forme delle cose, comincierai dalle particole di quelle, e non andare alla seconda, se prima non hai bene nella memoria e nella pratica la prima" (fol. 47). Even when writing he always composed the *particole*, the very small parts of his books, going over them again and again, always unsatisfied and incapable of ever putting them together. He thought of his books as of his final aim, but meanwhile he wrote only for himself, even neglecting certain attentions to style which we saw in the Codex C. It is significant that certain latinizing forms (such as the verb placed at the end of the sentence) are very frequent in the last ten years of the fifteenth century, but are very rare and almost dis-

appear in the later manuscripts (G, E). This habit of writing "by particles" certainly influenced Leonardo's style. Think, for instance, of the famous description of the Deluge, which is rich in splendid details, but without any central core, and not conceived as a whole, but developed only within short, interchangeable periods. This is a characteristic of a great number of Leonardo's pages, where the propositions, even in the longest periods, follow one another, but are not strongly linked together.

Nevertheless, his style has become much more refined in comparison with the Codex B and Trivulziano. He still piles up series of short, linear, parallel sentences, but sometimes he is able to link them together with a very lively rhythmic cadence, as when he describes the aspects of water, where his style reproduces the extremely changeable forms of water. "Questa l'alte cime de' monti consuma. Questa i gran sassi discalza e remove. . . . Questa l'alte ripe conquassa e ruina . . . salutifera, dannosa, solutiva, stitia, sulfurea, salsa, sanguigna, malinconica, frematica, collerica, rossa, gialla, verde, nera, azzurra, untuosa, grassa, magra. Quando apprende il foco, quando lo spegne . . . quando con gran diluvi le amplie valli sommerge" (C. Ar., fol. 57r). Even simple lists of titles appear musically linked, as in the "Partizioni" of the Deluge: "Tenebre, vento, fortuna di mare, diluvio d'acque, selve infocate, piogge, saette dal cielo. . . . Rami stracciati da' venti, misti col corso de' venti, con gente di sopra. . . ." The adjectives have become richer and more sensitive, and the phrasing solemn due to the nobility of the words and the purity of rhythm. Long and suggestive modulations, often easily divisible into rhythmical entities corresponding to the lines of Italian poetry, alternate with the excited energy of brief and concise sentences. "Mare, universale bassezza e unico riposo delle peregrinanti acque de' fiumi" (C.A., fol. 108v, b) ". . . con continua revolvizione per li terrestri meati si va ragirando" (C. Ar., fol. 236r). And often we are astonished at the precision with which the words adhere to the most complex objects of reality.

Leonardo's visual qualities, even as a writer, have always been praised. But he does not only grasp the proportion of forms, the splendor of surfaces, and the sweetness of shadows in the natural world. Beauty does not exist only in the harmonious correspondence of the parts but also in the quickness of actions, "la prontitudine delle azioni," as he states, translating Marsilio Ficino's words, "actus vivacitas et gratia quaedam in fluxu ipso refulgens." Leonardo differs from the writer of his time because of his deeper, inner adherence to the dynamism of universal life, which he feels in every place and in every being as a longing and a passion, as sorrow and happiness, triumph and tragedy. Let us read one last and not very well-known fragment. "La setola del bue, messa in acqua, morta, di state, piglia senso e vita e moto per sé medesima; e paura e fuga, e sente dolore. E prova ne é che stringendola, essa si storce e si divincola. Rimettila nell'acqua. Essa, come di sopra dissi, piglia fuga e levasi dal pericolo" (MS K, fol. 81r). A sense of continuous wonder at almost every word arrests the movement of the phrase to propel it forward again only after the pause. The movement of the hair in water is followed with such wonder because it reveals a mysterious world of invisible forces that give life both to man and nature. Leonardo's

poetry derives from this immense and harmonious vision of the universe.

We have tried to demonstrate here that Leonardo's poetry did not find a full and orderly expression in his writings, as he did not submit himself to a complete literary discipline. Therefore those who considered him as the founder of scientific prose or as a great writer used inexact terms. I think that the opinion of Attilio Momigliano is right: "Leonardo's fragments are for the most part the puffs of poetry, which arise and die out suddenly . . . he remained for the most part a poet in potential." But Leonardo was not only a writer, and if we catch these sudden puffs of poetry in his writings and connect them to those which burst forth from his pictures and drawings, we shall easily recognize the greatness of his spirit and receive the incomparable gift of his poetry.

# Leonardo da Vinci
# the Technologist:
# The Problem
# of Prime Movers

## by LADISLAO RETI

INVESTIGATIONS on Leonardo are far from being concluded. An immense task yet awaits the Vincians of today and tomorrow. I have no fear of exaggerating if I say that most of the studies published before 1936 in the most varied areas of science and engineering will have to be rewritten. The complete corpus of Leonardo's writings was simply not accessible before that date. Sir Kenneth Clark's Catalogue was finished in 1935; the edition of the British manuscripts, excepting the Leicester Codex (1909), was completed in 1936 (Codex Arundel, 1923–1930; Forster, 1930–1936).

The evolution of Leonardo's thoughts, correlated to a particular scientific or technological theme, cannot be studied through isolated samplings. He wrote for himself, not for others, so that, along with original conceptions, one meets with ideas stimulated by his readings and personal contacts. To form an objective opinion in these cases it is necessary to consult, compare, and analyze all the documents in existence. This has only become practicable in recent times now that the notebooks and drawings have been transcribed, edited, and reproduced. Access to the originals was always a privilege of very few students, and to read them directly is an arduous task demanding specialized linguistic and paleographic training.

Leonardo often revised his ideas but he did not, for that reason, destroy his former notes. That is why contradictory statements are to be found in the manuscripts. So we must study Leonardo's legacy as an entity, and, as far as this is possible, in chronological sequence. This last point was well taken into account in Anna Maria Brizio's book [1] in which, for the first time, a selection of

[1] *Scritti Scelti di Leonardo da Vinci,* a cura di Anna Maria Brizio (Turin, 1952).

Leonardo's writings was published in chronological order. Of course, dating may present serious problems, particularly in arbitrary collections like the Codices Atlanticus and Arundel, or the drawings at Windsor. After the fundamental study of Sir Kenneth Clark, his classic "Catalogue," we await with impatience the completion of the brilliant chronological lists of Carlo Pedretti.[2]

Even so, we cannot always know the evolution of any particular idea pursued by Leonardo. Too many of his writings are missing. The almost 6,000 pages that have survived after countless tamperings and losses represent only a fraction of the heritage once in Francesco Melzi's possession. What and how much has been lost of this accumulation of notes, or of the finished treatises—as far as Leonardo ever *finished* anything? He constantly refers to chapters of books which he says he had written, and it is difficult to assume that this was pure imagination.

When Cardinal Luigi d'Aragona visited Leonardo at Amboise in 1517, the cardinal's secretary, Antonio de Beatis, entered in his diary: "Besides Anatomy . . . he also wrote on the nature of water, on divers machines and other things, an infinite number of volumes that if published shall be very useful and pleasing."

Where are the treatises on the anatomy of man and of horse repeatedly cited by Lomazzo[3] and by Vasari,[4] and the book on painting and drawing that the anonymous Milanese painter referred to by Vasari[5] wanted to publish? Where is the original of the Codex Huygens?[6] Where are the sheets made for Gentile dei Borri on fighting between a horseman and a foot soldier?[7]

We know with certainty that sometime before 1800 there existed in the Biblioteca Nacional of Madrid a manuscript by Leonardo catalogued as "Tratado de Fortificacion, Estática, Mecanica y Geometria, escritos al revés y en los años 1591–93, 2 vol. Aa 19, 20."[8]

Very recently M. André Corbeau offered convincing evidence that Pompeo Leoni, whose ignorance and greed led to the dismemberment of a great part of Leonardo's heritage, assembled not only the Codex Atlanticus and the Windsor volume but two other collections of Leonardo's drawings as well, totalling 474 leaves. All trace of them after 1613 has been lost.[9]

The Treatise on Painting, a collection of texts extracted from Leonardo's original writings and compiled under the supervision of Francesco Melzi, constitutes dramatic evidence of the

---

[2] Carlo Pedretti, "Saggio di una Cronologia dei Fogli del Codice Atlantico," in *Studi Vinciani* (Geneva, 1957).

[3] Giampaolo Lomazzo, *Idea del Tempio della Pittura* (Milan, 1590), pp. 17 ff.

[4] Giorgio Vasari, *Le Vite de' più eccellenti Pittori. . . .* pt. 3 (2d ed.; Florence, 1568), p. 7.

[5] *Ibid.*

[6] Erwin Panofsky, *The Codex Huygens and Leonardo da Vinci's Art Theory* (London, 1940).

[7] Vasari, *op. cit.*

[8] *Raccolta Vinciana*, II (Milan, 1902), 89. The notice, based on Bartolomeo Gallardo, *Ensayo de una Biblioteca Española de Libros raros y curiosos,* was forwarded in 1897 by Prof. E. de Marinis to the Italian Embassy in Madrid, and at their request a search was carried out in the Biblioteca Nacional. However, the catalogue entry mentioned did not reveal a Leonardo manuscript. Instead a precious copy of Petrarca's *De Remediis utriusque Fortunae* and a no less important copy of Justinian's *Digest* were found. The director of the library studied the entries in former catalogues and came to the conclusion that the Leonardo manuscript had either been stolen or replaced by the works mentioned, sometime before 1800. Such substitutions were frequent at that time.

[9] *Raccolta Vinciana*, XX (Milan, 1964), 299.

point we have been discussing. In his introduction to the *Trattato*, in the edition of McMahon, Ludwig Heydenreich comes to the sad conclusion: "The fact that less than half of the chapters in the Codex Urbinas can be found among the still extant Leonardine manuscripts proves that substantial parts of Leonardo's literary legacy have been lost." [10]

I wanted to know how much "less than half" was, and by checking the concordance I discovered that out of 1,008 headings only 235 are traceable in the surviving originals. This means that more than 75 percent of the writings used by Melzi for his compilation are missing today.

Even so, that part of Leonardo's heritage which has been handed down to us, as if by a miracle,[11] is a precious testimony of Leonardo's thoughts and activities in the most diverse fields of human knowledge. In this corpus studies related to the technical arts seem to be predominant.

Varied as Leonardo's interests were, statistical analysis of his writings points to technology as the main subject. As was acutely pointed out by Bertrand Gille in a recent book, judging by the surviving original documents, Leonardo's métier was rather an engineer's than an artist's.[12]

However we may feel about this opinion, it is disturbing to take an inventory of Leonardo's paintings, of which no more than half a dozen are unanimously authenticated by the world's leading experts.

Contrast this evident disinclination to paint with the incredible toil and patience Leonardo lavished on scientific and technical studies, particularly in the fields of geometry, mechanics, and engineering. Here his very indulgence elicited curious reactions from his contemporaries and in the minds of his late biographers. They regretted that a man endowed with such divine artistic genius should waste the precious hours of his life in such vain pursuits. And, of course, as the well-known episodes of his artistic career testify, this exposed him not only to criticism but also to serious inconveniences.

But were Leonardo's nonartistic activities truly marginal?

Documentary evidence proves that every official appointment refers to him not only as an artist but as an engineer as well.

At the court of Ludovico il Moro he was *Ingeniarius et pinctor*. Cesare Borgia called him his most beloved *Architecto et Engengero Generale*. When he returned to Florence he was immediately consulted as military engineer and sent officially *a livellare Arno im quello di Pisa e levallo del letto suo*.[13]

Louis XII called him *nostre chier et bien amé Léonard da Vincy, nostre paintre et ingenieur*

[10] *Treatise on Painting (Codex Urbinas Latinus 1270) by Leonardo da Vinci*, trans. and annot. A. Philip McMahon, with introd. by Ludwig H. Heydenreich (2 vols.; Princeton, N.J., 1956).

[11] This is not a rhetorical flourish. The history of the manuscripts is full of dramatic episodes, from the misappropriation of Gavardi, the ordeal of Pompeo Leoni, the dangerous journey of the Napoleonic booty to Paris, to the Libri plunderings of the last century; cf. "The story of the manuscripts," by Elmer Belt in

*Manuscripts of Leonardo da Vinci*; Catalogue by Kate T. Steinitz (Los Angeles, 1948); and Augusto Marinoni, "I manoscritti di L. da V. e le loro edizioni," in *Leonardo—Saggi e Ricerche* (Roma, 1954), pp. 229–274.

[12] Bertrand Gille, *Les Ingénieurs de la Renaissance* (Paris, 1964).

[13] Luca Beltrami, *Documenti e Memorie riguardanti la Vita e le Opere di Leonardo da Vinci* (Milan, 1919), pp. 72, 80.

*ordinaire*. Even in Rome, despite the pope's famous remark on hearing of Leonardo's experiments with varnishes preparatory to beginning an artistic commission, Leonardo's duties clearly included technical work, as is documented by three rough copies of a letter to his patron Giuliano de' Medici.[14] Nor was his position different when he went to France at the invitation of Francis I. The official burial document calls him *Lionard de Vincy, noble millanois, premier peinctre et ingenieur et architecte du Roy, mescanichien d'Estat, et anchien directeur du peincture du Duc de Milan*.[15]

We can thus see that Leonardo had a lively interest in the mechanical arts and engineering from his earliest youth, as evidenced by the oldest drawings in the Codex Atlanticus, to the end of his industrious life. Thousands of his drawings witness to it, from fleeting sketches (though always executed with the most uncanny bravura) to presentation projects finished in chiaroscuro wash. Often these sketches and drawings are accompanied by a descriptive text, comments, and discussion.

The drawings and writings of Leonardo on technical matters, though scattered throughout the notebooks and especially in the Codex Atlanticus (a true order probably never existed nor did the author attempt to make one), represent an important and unique source for the history of technology.

This discipline, emerging slowly from the timid beginnings of the past, encounters an unusual and apparently insuperable obstacle: the extreme scarcity of direct documentary evidence. And if we can resign ourselves to accept the fragmentary and indirect character of the information about the technology of antiquity, it is with deep amazement that we are confronted by the scarcity of the evidence offered, not to speak of the Middle Ages, but for an age nearer to us, the Renaissance.

It is remarkable how few engineering notes and drawings have survived from those times. Several causes may have contributed to this regrettable fact.

First, their unimportance in the eyes of those who inherited them, even if conserved by the authors during their lifetime. A tragic case of this type is precisely the plunder and dispersal of the Leonardine heritage after the death of Francesco Melzi.

Second, the necessity of secrecy felt by the authors. Innovators and inventors were almost never protected by patents or privileges. Once divulged, the invention became public property and anyone could adopt it as his own with or without irrelevant modifications. Unanimous is the cry against imitators and plagiarists in the writings of Jacopo Mariano, called Taccola, Francesco di Giorgio, Francesco de Marchi, Ramelli, Leonardo, and many other excellent practitioners of the mechanical arts. In the Codex of Munich [16] Taccola tells us that Brunelleschi once said in Siena: *Noli cum multis participare inventiones tuas.*

[14] C.A., fols. 182*v*, 247*v*, 283*r*; English version in MacCurdy, *The Notebooks of Leonardo da Vinci* (New York, n.d.), II, 537, 543, 545.

[15] Beltrami, *op. cit.*, p. 156.
[16] Codex Latinus 197, fol. 228.

If a graphic record appeared imperative, the drawing was presented without description, and if the latter was indispensable, often the authors resorted to cryptography, as can be seen in the writings of Giovanni Fontana,[17] Bonaccorso Ghiberti,[18] and Leonardo himself. I do not refer to his mirror script that offered only a limited protection, but to the cases in which interpretation is hindered by the use of anagrams or code words.

A further motive which may have contributed to the disappearance of many precious sources of the history of technology has till now received too little attention: it was the contempt and disrepute into which the practitioners of technical arts fell at the end of the sixteenth century. We may wonder about the causes of this strange happening but the fact cannot be denied.

Brunelleschi's epitaph in the Cathedral of Florence praised not only the great builder of the cupola but also his *divino ingenio ab eo adinventatae machinae*. We have seen that Leonardo received the still honorable appointments of engineer and mechanician. But documents of the late sixteenth and the seventeenth centuries abound in references that hint at the rapid deterioration of those titles. In the introduction of the *Mechaniche* of Guido Ubaldo Del Monte, translated from the Latin by Filippo Pigafetta,[19] we can read: ". . . there will be some that esteem this word to be one of injury, because in many parts of Italy it is customary to call somebody a Mechanic out of scorn and abuse and there are others that take offense at being called Engineers; for this reason it will not at all be beside the point to remember that Mechanic is a very honorable word . . ."

Nor was the situation better in seventeenth-century England. Webster's dictionary records the meaning of the words *mechanic* and *mechanical* as "rude, common, vulgar, base," a meaning which is, of course, obsolete. Shakespeare uses it in several instances, for example, in *Julius Caesar* I, 1: "what, know you not being mechanical . . ." or in *King Henry IV*, Part II, verse 5: "by most mechanical and dirty hand."

A fair survey of Leonardo's technological activities and investigations, as they are revealed in the manuscripts, would fill at least a large volume. Indeed, a comprehensive work on this all-important part of Leonardo's life still awaits realization. There is no lack of good studies in this field, but they are fragmentary, limited, and incomplete.[20]

It is far from my intention and beyond my possibilities to discuss Leonardo's technology as a whole on this occasion. Enough is said when we remember that there is hardly a field of applied mechanics where Leonardo's searching mind has left no trace in the pages of his notebooks. To illustrate Leonardo's methods I shall limit myself to discussing some little-known aspects of how

[17] Cod. Icon. 242, Munich, Staatsbibliothek.
[18] MS Br. 228, Biblioteca Nazionale, Florence.
[19] Guido Ubaldo de' Marchesi del Monte, *Le Mechaniche tradotte in Volgare dal sig. Filippo Pigafetta* (Venice, 1581).
[20] Cf. Theodor Beck, *Beiträge zur Geschichte des Maschinenbaues*, 2d ed. (Berlin, 1900), and *Zeitschrift des Vereines Deutscher Ingenieure, passim*; Franz M. Feldhaus, *Leonardo der Techniker und Erfinder* (Jena, 1922); Arturo Uccelli, *Storia della Tecnica* (Milan, 1945); Carlo Zammattio, "Hydraulic and Nautical Engineering," and Giovanni Canestrini, "Leonardo's Machines," in *Leonardo da Vinci* (New York, 1956); Ivor B. Hart, *The World of Leonardo da Vinci* (London, 1961); etc.

*Figure 1*
MS H, fol. 43*v*.

he dealt with the main problem of technology, the harnessing of energy to perform useful work.

At the time of Leonardo the waterwheel had been improved and in some favored places wind was used to grind corn or pump water. But the main burden of human industry still rested on the muscle power of man or animal. Little thought was given to how this should be used. Animals were attached to carts or traction devices; fortunately collar harness was already in use, multiplying by five the pulling strength of the horse.[21] Men worked tools by hand, turned cranks, or operated treadmills. Of course, power could be gained, sacrificing time, with the help of levers, screws, gears, and pulleys. Little attention was given to the problems of friction, strength of materials, and to the rational development of power transmission. At least this is the picture suggested by studying the few manuscripts that precede Leonardo, devoted to technological matters.

Leonardo's approach was fundamentally different. He firmly believed that technological problems must be dealt with not by blindly following traditional solutions but according to scientific rules deduced from observation and experiment.

When Leonardo searched for the most efficient ways of using the human motor, the force of every limb, of every muscle, was analyzed and measured. Leonardo was the first engineer who tried to find a quantitative equivalent for the forms of energy available.

In MS H (written *ca.* 1494) on folios 43*v* and 44*r* (figs. 1 and 2) there are two beautiful sketches showing the estimation of human muscular effort with the help of a dynamometer. The force is measured in pounds which represent the lifting capacity of the group of muscles under scrutiny. In figure 1 no less than six different cases covering the whole body are examined, while in figure 2 Leonardo tries to compare the force of the arm in different positions and points of attachment.· Between the last two drawings a diagram shows the arm as a compound lever. In many other

[21] Lynn White, Jr., *Medieval Technology and Social Change* (Oxford, 1962).

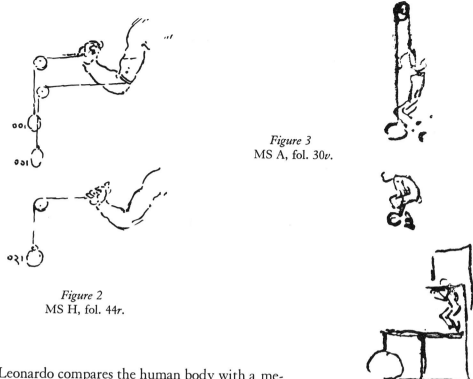

*Figure 3*
MS A, fol. 30*v*.

*Figure 2*
MS H, fol. 44*r*.

instances Leonardo compares the human body with a mechanical system, anticipating Borelli.[22] We shall see one of them on folio 164*r*, *a* of the Codex Atlanticus (fig. 15).

The interest of Leonardo in the maximum efficiency of muscle power is understandable. It was the only motor he could have used in a flying machine; a project that aroused his ambition as early as the year 1488 and in which he remained interested till the end of his life.

The efficiency of the human motor depends not only on its intrinsic strength but also on the ways the force is applied. Indeed, what is the greatest strength a man can generate, without the help of mechanical devices like levers, gears, or pulleys? In a very interesting passage of MS A, folio 30*v* (fig. 3), Leonardo answers the question:

A man pulling a weight balanced against himself (as in lifting a weight with the help of a single block) cannot pull more than his own weight. And if he has to raise it, he will raise as much more than his weight, as his strength may be more than that of another man. The greatest force a man can apply, with equal velocity and impetus, will be when he sets his feet on one end of the balance and then leans his shoulders against some stable support. This will raise, at the other end of the balance, a weight equal to his own, and added to that, as much weight as he can carry on his shoulders.

Masterly executed marginal sketches illustrate the three different cases. The problem has been already touched on folio 90*v* of MS B, where the following suggestion is made beside a simi-

[22] Giovanni Alfonso Borelli, *De Motu Animalium* (Rome, 1680).

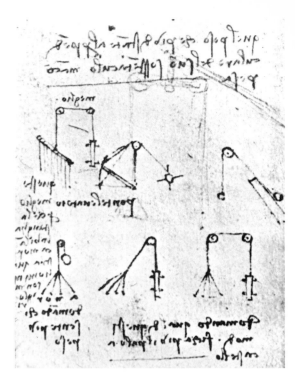

Figure 4
Belidor, *Architecture Hydraulique*, pt. 2, p. 128, pl. 8.

Figure 5
MS H, fol. 80*v*.

lar sketch: "See at the mill how much is your weight, stepping on the balance and pressing with your shoulders against something."

But Leonardo was always anxious to integrate theory with application. His own advice was: "When you put together the science of the motions of water, remember to include under each proposition its application and use, in order that this science may not be useless" (MS F, fol. 2*v*).

I should like to select, among many, a few cases in which Leonardo demonstrates the usefulness of his rules. One of them is pile driving for foundation work or the regulation of river banks. The simplest pile-driving machine consists of a movable frame, provided with a drop hammer raised by men pulling at a rope provided with hand lines. After being raised, the hammer is released by a trigger. The operation is repeated until the pile has been sunk to the necessary depth. In Belidor's classic treatise [23] we may see the figure of this age-old device (fig. 4).

Leonardo, often engaged in architectural and hydraulic projects, obviously had a more than theoretical interest in the operation. He starts analyzing the simplest case, a single man raising a hammer by pulling a rope, MS H, folio 80*v* (fig. 5). If the man pulls on the rope straight under the block, he can apply a force equal to his weight. But if the man takes a position farther away, he cannot use his whole weight and therefore his effort lacks efficiency.

But one man cannot raise the heavy hammer that drives down the large foundation piles. So it became customary to branch the rope holding the hammer in so many strands or hand lines as needed, having one man pulling at each strand. However, in accordance with the principle

[23] B. F. de Belidor, *Architecture Hydraulique* (Paris, 1737–1753), pt. 2, 128, pl. 8.

clearly enunciated by Leonardo, in this way the efficiency of each man's effort will be severely impaired. The *sonnette ordinaire* of Belidor operated with a drop hammer of 800 pounds and required a "brigade" of twenty men, that is, each man raised 40 pounds, a fourth of his own weight —a poor efficiency indeed.[24]

Belidor was well aware of the problem and observed, talking of the common pile driver: "In spite of having been used by so many skilled people for a long time, its shortcomings were only corrected a few years ago." The corrections proposed are the following:

*a)* substitution of the block on top of the frame by a larger wheel, allowing the operators to place themselves in a dynamically more favorable position;[25]

*b)* use of winches and capstans for raising the hammer;[26]

*c)* improvements on the catch or locking device of the hammer.[27]

Leonardo, 250 years before the great French engineer, arrived at exactly the same conclusions. On folio 80*v* of MS H (fig. 5) he examined the basic problems pointed out by Belidor.

As for the practical improvements, I should like to present a group of notes on this subject, from the Leicester Codex, folio 28*v*, which so far as I know have never been reproduced, commented upon, or translated. Marginal drawings (figs. 6 and 7) illustrate the text.

The very best way to drive piles (*ficcare i pali a castello*) is when the man lifts so much of the weight of the hammer as is his own weight. And this shall be done in as much time as the man, without burden, is able to climb a ladder quickly. Now, this man shall put his foot immediately in the stirrup and he will descend with so much weight as his weight exceeds that of the hammer. If you want to check it thoroughly, you can have him carry a stone weighing a pound. He will lift so much weight as is his own on descending from the top of the ladder and the hammer will raise and remain on top, locked by itself, until the man dismounts the stirrup and again climbs the ladder. When you unlock the hammer with a string, it will descend furiously on top of the pile you want to drive in. And with the same speed the stirrup will rise again to the feet of the man. And this shall be done again and again. And if you want to have more men, take several ropes that end in one rope and several ladders to allow the men to reach the top of the ladders at the same time. Now, at a signal from the foreman, they shall put their feet in the stirrups and climb the ladder again. They will rest while descending and there is not much fatigue in climbing the ladders because it is done with feet and hands, and all the weight of the man that is charged on the hands will not burden the feet. But one man shall always give the signal.

Pile driving by raising the hammer by hand is not very useful, because a man cannot raise his own weight if he does not sustain it with his arms. This cannot be done unless the rope he is using is perpendicular to the center of his gravity. And this happens only to one of the men in a crowd who is pulling on the hammer.

[24] *Ibid.,* p. 109.   [25] *Ibid.,* p. 110.   [26] *Ibid.,* p. 114.   [27] *Ibid.,* p. 184.

We can further observe in the sketches of the Leicester Codex that Belidor's first two improvements had already been considered by Leonardo: the substitution of a large wheel for the block and use of a capstan or a winch.

In 1782, more than 250 years after this lucid exposition, a great French engineer, Claude François Berthelot (1718–1800), happened to come to analogous conclusions. In his book [28] he proposed the same ingenious utilization of muscle power for activating a corn mill,[29] a water-raising device,[30] a crane,[31] and a pile driver [32] (fig. 8).

After describing his apparatus, Berthelot says:

> No mechanician ignores that the greatest power a man can apply is that of his own weight. He cannot produce a continuous effort of more than 20 lb. even if 24 lb. has been admitted. The weight of a man is estimated at 150 lb.: we can thus conclude that with this machine one man can produce the same effect as six men at the machines commonly used. We shall add that the men will suffer less fatigue in this maneuver than in any other of the kind, etc.

The only comment I should like to add is that on comparing the pile driver of Berthelot with that of Leonardo, the latter appears quite the more efficient, for obvious reasons.

A last word on the pile driver of Leonardo. He spoke of a hammer that is locked and unlocked by itself. In the pile driver drawn on folio 289r, e of the Codex Atlanticus (fig. 9) we can observe

[28] C.-F. Berthelot, *La Mecanique appliquée aux Arts, aux Manufactures, à l'Agriculture et à la Guerre* (2 vols.; Paris, 1782).  [29] *Ibid.,* I, 94.  [30] *Ibid.,* I, 96.  [31] *Ibid.,* I, 126.  [32] *Ibid.,* II, 68.

*Figure 6*
MS Leicester, fol. 28*v*.

*Figure 7*
MS Leicester, fol. 28*v*.

*Figure 8*
Berthelot, *La Mecanique
Appliquée*, vol. 2, p. 68.

*Figure 9*
Codex Atlanticus, fol. 289*r*, *e*.

*Figure 10*
Belidor, *Architecture
Hydraulique*.

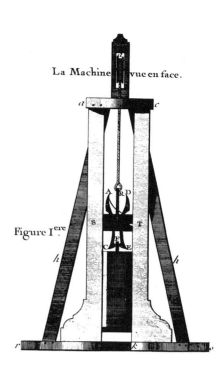

the kind of mechanism Leonardo was hinting at. It is amazing to verify the identity of this device with that of the mentioned, improved pile driver of Belidor (fig. 10). According to the French author, the machine had been invented by Vauloue, a London watchmaker, and used at the construction of the famous Westminster bridge, that is, in 1738–1750. The story is recorded also by Desaguliers.[33] Devices of this type are still used.

Many notes and sketches of Leonardo refer to the construction of canals, a subject that often turns up in the manuscripts. Of special interest is a homogeneous group of papers that, because of the correspondences existing in MS L, seem to belong to the short period spent in the service of Cesare Borgia (1502–03). Some of them may possibly be dated a little later, when Leonardo had settled in Florence, and could be connected with the famous project to change the course of the Arno and in this way destroy the power of the rival city of Pisa. The plan, too ambitious for the times, was abandoned in 1504. However, Leonardo must have toiled with the same ideas earlier during his first Milanese period, as is shown by some sketches in the Codex Forster.[34]

Canal digging is a complex operation. The soil must be first loosened, then excavated. The material must be elevated and transported or spread out evenly on the sides. Provision must be made for differences in character, composition, consistency, and water content. Eventually the pits must be drained and the banks secured against erosion and earth slides. A great deal of power is needed as well as the employment of appropriate building machines. Before the mechanization

[33] J. T. Desaguliers, *Course of Experimental Philosophy* (2 vols.; London, 1725–1727).

[34] Fors. III, fols. 17*r*–18*r*.

of the building technique, in the nineteenth century, only elementary tools and machines were in use, operated by man or animal.

I wish I could discuss in detail the writings and drawings Leonardo dedicated to excavation and canal building; some of them have often been cited and reproduced, but a systematic and complete treatment is still lacking. However, William Barclay Parsons [35] devoted many pages of his unique book to them and his conclusion is well worth special attention (p. 334): "They constitute a single intellectual achievement of high value. Had Leonardo contributed nothing more to engineering than his plans and studies for the Arno Canal, they alone would place him in the first rank of engineers of all time." Parsons believed that all those sheets belonged to the Arno project. We know that most of them were prepared during the period spent in the Romagna, very probably in connection with the port canal of Cesenatico.

My task, on this occasion, is only to point out how Leonardo tried to solve the problem of the prime movers required in building canals.

He began by analyzing the best ways of disposing men to work if this had to be done by hand. For those calculations Leonardo even constructed a kind of chronometer on the nature of which Augusto Marinoni tells us more.[36] He filled many sheets, extremely interesting in themselves, with calculations and sketches (e.g., C.A., fol. 210r, a), arriving at the conclusion that the only reasonable solution was to mechanize the whole operation. It was not only a matter of digging. The excavated material had to be cleared and transported a long way. For this purpose wheeled vehicles were considered next and rejected.

Leonardo did not underestimate wheeled vehicles. He notes that "the cart has the first place among all human inventions, particularly when it has the right proportions, although I have never seen such a one." But a cart is useful only on level ground; on steep runs the weight nullifies the effort of the animal. Besides, "to fill the carts requires more time than needed for the transport itself" (C.A., fol. 164r, a).

On many other pages of his writings Leonardo discusses the usefulness of wheeled vehicles and the best ways to improve their performance. During his appointment as engineer of Cesare Borgia he could not refrain from noting: "In Romagna, the realm of all stupidity, vehicles with four wheels are used, of which the two in front are small and two high ones are behind, which is very unfavorable to motion," etc. (MS L, fol. 72r).

The well-known folio 211r, a of the Codex Atlanticus shows the theoretical justification of this statement; less noticed are the beautiful sketches above the main drawing, where the influence of the relative thickness of the axle on the movement is measured by an amazingly modern-looking dynamometer. On folio 340v, d, of the same codex, a similar arrangement is suggested for the measurement of the force required in pulling a four-wheeled vehicle. Leonardo was to use

[35] William Barclay Parsons, *Engineers and Engineering in the Renaissance* (Baltimore, 1939).

[36] Augusto Marinoni, " 'Tempor Armonico' o 'Musicale' in Leonardo da Vinci," in *Lingua Nostra,* XVI (June 1955), fasc. ii.

*Figure 11*
Codex Atlanticus,
fol. 370*v, c.*

the same type of apparatus to gauge the force of a waterfall (C. Fors. III, fol. 47*r*) and to determine the power requirement of a grain mill (*ibid.*, fol. 46*v*), anticipating the classic experiments of Smeaton.[37]

After rejecting wheeled vehicles as unsuitable for excavation work and recognizing that a large and deep canal could not economically be dug by hand, Leonardo examined the possibility of substituting progressive hand shoveling from level to level by excavation machines combined with a system of cranes. Power was again his main concern.

To activate a crane, in addition to a horse-driven capstan, the only transportable motor available at the time would have been a treadmill, a machine that converts muscle power into rotary motion.

We can see the most popular form of this contrivance, the squirrel-cage type in which men walk on the inside of a drum, in several ancient monuments [38] and in many paintings and miniatures of the fourteenth to the seventeenth centuries.

Leonardo had an apparently intuitive abhorrence of this apparatus; from his youth onward he avoided it, using instead drums moved by men treading on the *outside* (e.g., a revolving crossbow spanner, C.A., fol. 387*r*; a drum blower, MS B, fol. 82*r*). But a mature and documented evaluation of both systems appeared later, precisely on the occasion of the canal-building projects.

On folios 164*r, a* and 370*v, c* of the Codex Atlanticus we find the discussion of the merits of the two systems accompanied by beautiful sketches (fig. 11). Leonardo explains that men walking on the inside of a drum can apply only part of their force because they can hardly reach one-third of the quadrant before slipping. Men treading on the outside apply the whole of their weight on a perfect lever system. "Therefore, the man that stays in *a* lifts ⅔ more than if he stays in *b*" (C.A., fol. 164*r, a*).

> If the men walk underneath the third of the lever . . . you throw away ⅔ of the time but do not reduce the expense. In my instrument I shall use, for each turn, half of the men, while the other half rest. And on each complete turn I shall change my men and this will give good service, gaining ⅔ of the time . . . Another fault (generally committed) is that the men used as counterweight are young and light; in my instrument I shall put only men weighing at least 200 pounds (C.A., fol. 370*v, c*).

[37] John Smeaton, *Experimental Enquiry* . . . (London, 1794).

[38] E.g., Roman hoists in *A History of Technology,* ed. Singer, *et al.,* II (Oxford, 1956), 637, 660.

*Figure 12*
Faustus Verantius,
*Machinae Novae.*

Another reason for Leonardo's preference was human safety, a factor generally of little concern in the past. He says:

> A wheel where you walk on the outside is more useful than one where the walk is in the inside, because in the latter there is danger of death while the first offers safety of life. I refer to the wheels used in lifting heavy loads. And this safety derives from the fact that if the wheel suddenly turns back, things in the inside would be battered. This cannot happen if the man works on the outside because by only lifting his foot from the wheel, he remains on the platform hanging from the rope by his hands (C.A., fol. 38*r*, *b*).

Leonardo did not invent the external treadmill; there are older examples as far back as Vitruvius. But he was the first to use the principle rationally and in accordance with sound engineering principles.

After Leonardo, the first scholar to analyze mathematically the efficiency of a treadmill was Simon Stevin, arriving at the same conclusions.[39] That the external treadmill was not in general use until the end of the sixteenth century is shown in the book of Faustus Verantius, datable around 1615, in which it was warmly recommended.[40] Verantius was pleased to declare himself inventor of this new kind of wheel because until then he had never seen or read of anything like one. Confronting Verantius' wheel (fig. 12) with those drawn by Leonardo, the direct derivation appears evident.

Folio 1*v*, *b* of the Codex Atlanticus (fig. 13) represents one of the huge engines that Leonardo wanted to power with a treadmill. Even if details are unclear, the wheel must be of the outside

[39] Simon Stevin, *De Weeghdaet* (Leyden, 1586), pp. 28–29; English trans. in *The Principal Works of Simon Stevin,* ed. E. J. Dijksterhuis, Vol. I, *Mechanics* (Amsterdam, 1955), 343–345.

[40] Faustus Verantius, *Machinae Novae* (Venice, ca. 1615).

*Figure 13*
Codex Atlanticus,
fol. 1*v*, *b*.

type because the spokes are so thick that there is no room for an internal walk. There are many remarkable engineering details in this excavation machine which I cannot deal with, but I shall return later to the curious telegraph-pole like devices that are regularly distributed along the rim of the semicircle of the excavation line and that, until now, have defied interpretation.

However, the increasing size of the complex machines created by the imagination of Leonardo required more power than that which could be supplied by the weight of a few men walking on a treadmill, even admitting the most rational mechanical arrangements. Leonardo was well aware of the situation, and wrote: "There you see the best of all motors, made by the ancient architects, that I cleaned from every fault and reduced to the ultimate perfection, with improvements that were not and could not be in its simple state. But I am still not satisfied and I intend to show a way of quicker motion of more usefulness and brevity" (C.A., fol. 370*v*, *c*).

To secure a higher power source Leonardo returned to the force of animals. Indeed he knew that animals of burden are capable of delivering a force surpassing many times that of a man and that they are able to endure heavy work for a longer period of time.

Again, in Leonardo's search for a maximum output, gravity is instrumental in the transmission of animal muscle power, rejecting the age-old traction devices applied to winches and capstans.

We can study Leonardo's improved excavation machines in several sheets of the Codex Atlanticus. Folio 363*v*, *b* (fig. 14) represents a double crane, with revolving derricks for lifting and transporting excavated material from the trench to the banks.

The excavated material is collected in boxes or buckets of special construction and elevated by the weight of an ox and a man that, after ascending the steps visible at the sides, place themselves on the platform that counterbalances the buckets. Once the material has been raised, the crane revolves and the bucket is emptied on the banks. Note the rational application of the so-called Chinese windlass system for gaining mechanical advantage, in the blocks that lead the ropes.

*Figure 14*
Codex Atlanticus,
fol. 363*v*, *b*.

A further improvement is suggested in the marginal sketch and notes on the lower right. A curved stairway is preferable to a straight one because it cuts down the distance from the bottom of the canal to the top of the bank. In fact, Leonardo says that for every thousand journeys, one and a third miles of walking can be saved.

The already commented-upon folio 164*r*, *a* of the Codex Atlanticus offers the final development of this idea. The stairway assumes the form of a spiral, following the face of the excavation curve (fig. 15). The platform with the animal descends exactly to the spot where the stairway begins. Leonardo, driven by his enthusiasm for the solution found, exclaims:

"Here, it would be impossible to load more quickly."

"Here, the traction could not be done with greater speed."

"Here, the motor for lifting from bottom to top could not exert a greater power in the same time."

"Here, the transverse pull, at the same distance from the axle, would not be easier."

And as a last concern of the conscientious engineer thinking of the added economic burden of the complex staircase, he says:

"There will be the expense for the woodwork but all of it can be used again in the building."

We found in this sheet the already-mentioned discussion on the merits of the internal treadmill (lower left), together with beautiful anatomical sketches illustrating the problems arising from the effort of pulling a burden uphill.

*Figure 15*
Codex Atlanticus, fol.
164r, *a*.

*Figure 16*
J. A. Borgnis, *Traité*, pl. 2,
fig. 16.

If anyone were to suggest discarding Leonardo's rational proposals directed at the full utilization of animal muscle power as fantastic and unpractical, let him be reminded that several centuries after Leonardo men like La Hire in 1699, Lambert in 1776, Prony in 1790, and the great physicist Coulomb in 1779 [41] again faced the problem of how human and animal power could be used most efficiently and came to the same conclusion as Leonardo. Figure 16 shows how Leonardo's idea appears in the famous treatise of Borgnis.[42] In 1835, following Coulomb's suggestions, the military engineer Captain Coignet constructed an elevating machine identical to that of Leonardo.[43]

Still, the ultimate perfection had not yet been achieved. There was too much human work in filling and emptying the buckets and, particularly, in the excavation itself, the breaking up and the shoveling of the soil. Let us see how Leonardo the engineer tackled these problems.

Amazingly modern systems for the emptying of the buckets are described and shown on other pages of the Codex Atlanticus. The box is discharged by hitting the ground as in folio 363r, *a*

[41] Cf. J. F. Montucla, *Histoire des Mathématiques* (2d ed.; Paris, 1802), III, 720–737.

[42] J. A. Borgnis, *Traité Complète de Mécanique Ap-* pliquée aux Arts (Paris, 1818–1823), "De la Composition de Machines," pl. 2.

[43] Feldhaus, *op. cit.,* p. 26.

Figure 17
Codex Atlanticus, fol. 363r, a.

Figure 19
Codex Atlanticus, fol. 370r, b

(fig. 17), or by releasing the bottom with a string (C.A., fol. 344r, a), or it is ingeniously over-turned with the least possible effort as in folio 294r, a. As for the mechanization of the excavation itself, Leonardo offered several solutions that command the admiration of the modern engineer. He devised wheeled scrapers that with the aid of a horse could dig and remove the earth (fig. 18). Their design contains all the main features of modern tools (C.A., fols. 294r, a; 389r, b; 389v, c).

Leonardo's aim, however, was total mechanization. He declared emphatically that in the making of canals "the most useful method would be one by which the soil, removed, would jump by itself quickly on the instrument that will transport it" (C.A., fol. 164r, a; C. Ar., fol. 127r–v).

To conclude this section let us look at how Leonardo fulfilled this fantastic requirement. In all the previously examined techniques the earth had to be broken up and placed in the buckets by hand shoveling. Now Leonardo first tried to find a machine that substitutes for the human digger. The first idea was to mechanize the hand tool. On the lower part of folio 370r, b of the Codex Atlanticus we can see a large shovel provided with digging teeth and moved by a system of levers (fig. 19). A similar instrument is illustrated on folio 76v of MS L (fig. 20). In both cases a poor performance is to be expected because the digging shovel falls from a relatively low height and its weight cannot be increased for lack of an adequate lifting power.

*Figure 18*
Codex Atlanticus,
fol. 294r, *a*.

*Figure 20*
MS L, fol. 76v.

A rational solution is proposed on the upper part of folio 370r, *b* of the Codex Atlanticus (fig. 21). Instead of a balancing shovel Leonardo designs a falling one. The proposal is backed by theoretical reasoning: "Among natural forces, percussion surpasses all others . . . because at every stage of the descent it acquires more momentum."

We see that Leonardo intended his new instrument to be operated with a digger instead of a drop hammer like a pile driver. The digger is lifted by men descending on a counterbalancing platform in exactly the same way as in the pile drivers already described.

Now, we can return to the beautiful drawing of Codex Atlanticus, folio 1v, *b*. The telegraph-pole like devices on the semicircular rim of the excavation are mechanical stab diggers (*Stech-ramme* in German) to be used in due time. Beneath each of those instruments there is a box or bucket, ready to receive the portion of soil detached at each blow of the digger. Amazingly, we see fulfilled the fantastic declaration of Leonardo: ". . . the soil, removed, would jump by itself quickly on the instrument that will transport it."

It is very interesting to note that many years before Leonardo had found another solution for the same technological problem, that of combining the digging, loading, and lifting of excavated material in one set of operations. The fundamentals are sketched on folios 17r and 18r of the MS Forster III, and explained on folio 240v, *b* of the Codex Atlanticus (fig. 22). A scraper provided with digging teeth moves horizontally against the lower part of the excavation border,

85

Figure 21
Codex Atlanticus, fol. 370r, *b*.

Figure 22
Codex Atlanticus, fol. 240v, *b*.

describing an arc. Flat lifting boxes are placed in the hollowed-out channel to receive the soil pushed down by the workers. The crane does the rest.

Describing his canal-building machines, Leonardo often launches into an imaginary dispute with the *contrario*, "the adversary," or criticizes the arrangements used before, proving that he had difficulty in convincing people of the advantages of his new systems. An extremely interesting annotation reveals how Leonardo expected to obtain a monetary reward from his inventions. The passage occurs in MS L, on folio 90r, and belongs without doubt to the Romagna period, according to the notes of the preceding and the following pages (especially fols. 88v and 93r). Leonardo gives himself some good advice (as he frequently does in his writings): "To secure my salary, do not accept a lump sum but have your foreman use my instrument in order to simplify all the superfluous and coarse inventions presently used." A very modern idea, like the present-day computors that are leased but not sold.

Let us now turn our attention to another important power source available in Leonardo's time: the energy stored in falling and running water. There are a great number of drawings and

*Figure 23*
MS Forster, I,
fol. 42v.

*Figure 24*
Giovanni Branca,
*Le Macchine,*
Rome, 1629.

descriptions related to waterwheels and water mills in Leonardo's manuscripts, just as they can be seen, though in lesser variety, in the writings of Francesco di Giorgio. But Francesco limits himself to the presentation of a number of well-drawn projects without analyzing their efficiency. Indeed, several could not have worked at all because of excessive friction or because they were based on the fallacious principle of perpetual motion. Francesco calls them "mills that operate with *acqua morta*."

It is very likely Leonardo had Francesco in mind, for he owned and annotated his manuscript,[44] when he irately exclaimed: "and the engineers who think to make dead water stir itself into life with perpetual motion . . ." (Q. I, fol. 13v). There are many other similar statements in the writings of Leonardo; to quote only one: "It is impossible to turn mills with dead water" (C.A., fol. 74r, a).

The delusion of perpetual motion, which haunted the technicians of all ages until very recent times, cannot be dismissed by *a priori* reasoning. Hydraulic perpetual motion arrangements must have been particularly deceptive because they may work—for a while. Look at one among the hundred devices of this kind examined by Leonardo, the one on folio 42v of Codex Forster I (fig. 23). The text says: "Screw *a* lifts water to screw *b* and screw *b* with the same water moves screw *a*."

There is a little feeding tank between both screws. Suppose now that in order to secure the regularity of the motion a larger tank is installed. At start, this tank must be filled with water and, rightly, the contraption begins to turn and screw *a* delivers water to the tank as anticipated. Of course, as the pumping screw cannot deliver as much water as the driving screw needs, after some time the machine comes to a standstill. This is the point where the ancient mechanics started to speculate: if they could build a "more efficient" driving screw, the problem would be solved! And for three centuries after Leonardo an immense amount of effort was wasted in dreaming up such perpetual motion devices.

[44] Francesco di Giorgio Martini, MS Ash. 361 (293), Biblioteca Medicea Laurenziana, Florence.

87

Leonardo knew better. He states categorically on many pages of his writings that "descending water will never raise from its resting place an amount of water equal to its weight" (C.A., fol. 147$v$, $a$).

He had a very clear idea about the virtues and the limitation of waterpower and he offered a precise definition of it in Codex Atlanticus, folio 151$r$, $a$: "Falling water will raise as much weight as its own, adding the weight of its percussion. . . . But you have to deduce from the power of instrument what is lost by friction in the bearings." The modern formula for evaluating hydraulic energy is $Ep = mg\,H$, that is, potential energy equals the weight of the water $m$, multiplied by $g = 9.81\ m/sec^2$, denoting the gravitational acceleration, multiplied by $H$, height of the fall. As "weight of the percussion" according to Leonardo's own words is proportional to the height, and therefore to gravitational acceleration ("among natural forces, percussion surpasses all others . . . because at every stage of the descent it acquires more momentum"), we have here stated for the first time the basic definition of the energy potential. And sound and practical advice is offered to the engineer for correcting the theoretical efficiency, by taking into account energy losses caused by friction.

And he knew that mechanical perpetual motion machines are just as useless: "O speculators about perpetual motion, how many vain chimeras have you created in the like quest? Go and take your place with the seekers after gold" (C. Fors. II, fol. 92$v$).

However, look again at figure 23. In it Leonardo shows, as in many other similar drawings, for the first time, a reaction turbine based on an inverted Archimedean screw. We are indebted to Carlo Zammattio for this important recognition.[45] Again Leonardo preceded by more than a hundred years Giovanni Branca [46] to whom the invention of those driving spirals is generally attributed (fig. 24).

On many pages of his notebooks and drawings Leonardo deals with hydraulic motors for a number of technological operations. A very interesting page is folio 355$r$, $b$ of the Codex Atlanticus on which he sketched three waterwheels to activate what appears to be a stone saw (fig. 25). The first is an overshot wheel that, connected by means of gears with a crank and connecting rod, induces a reciprocating motion. Below, two different solutions are offered with horizontal wheels as prime movers. This is no novelty, but the jet issuing from a forced conduit and acting tangentially is novel.

He confirms, on folio 63$r$ of MS H, that "the percussion of the water will be the greatest on the wheel if such percussion hits it at a right angle."

It is remarkable that in his mature technological projects Leonardo recurs to horizontal waterwheels to move heavy machinery, like the drawing and rolling mills that are illustrated in the paper of Bern Dibner. Leonardo failed to indicate in those projects how the perfectly drawn hydroturbine wheel was encased. He probably considered the matter obvious. Unfortunately the

[45] Zammattio, *op. cit.*, p. 482.　　　　　　　　[46] Giovanni Branca, *Le Macchine* (Rome, 1629).

Figure 26
MS Arundel, fol. 63v.

Figure 25
Codex Atlanticus, fol. 355r, b.

record of those ingenious machines has been lost. Most writers refer to the horizontal or Norse wheels as very inadequate prime movers, estimating their power output at one-half horsepower—a little more than the power of a donkey.

Fortunately the rediscovery of Juanelo Turriano's manuscript in the Biblioteca Nacional of Madrid can revise our opinion about the efficiency of those wheels.[47] It is very likely that turbine-like horizontal wheels and high-pressure impact wheels were already known in Leonardo's time, that is about 60 years before Turriano wrote his treatise.

One thing must be clarified on this occasion. The often discussed, reproduced, and reconstructed drawing on folio 63v of the Codex Arundel does not represent a hydraulic prime mover (fig. 26). Indeed, it is a turbine, but using Needham's felicitous expression, it is *ad aqueous* not *ex-aqueous*.[48] A waterwheel may be employed to derive work from moving water (as in a hydraulic turbine) or to apply work or move still water (as in a ship's propeller or a centrifugal pump).

[47] See Ladislao Reti, "A Postscript to the Filarete Discussion: On horizontal water-wheels and smelter blowers in the writings of Leonardo da Vinci and Juanelo Turriano," in *Technology and Culture,* VI (1965), 428–441.

[48] Joseph Needham, *Science and Civilization in China,* with the collaboration of Wang Lin, Vol. IV, pt. 2 (Cambridge, 1965), 412.

I agree with Carlo Pedretti [49] on the relation of this drawing to a group of sketches found in MS F (fols. 13r–v, 14v, 15r–16r). In those pages we meet one of the most brilliant technological ideas of Leonardo, the design of the first centrifugal pump. The principle of this instrument has been described in the already cited publications of Beck, Feldhaus, Hart, and Zammattio; I want to complete their exposition, showing the subtlety of Leonardo's technological genius.

On folio 13r (fig. 27) Leonardo presents the theoretical fundamentals of his invention. If water is stirred by a revolving movement, a whirlpool or vortex is produced in the form of an inverted cone. If by mechanical means such a vortex is artificially sustained, it appears possible to siphon water from swamps bordering the sea, even if the swamp is almost at the same level, the siphon effect becoming possible because of the depression created in the sea.

On this and the following pages Leonardo elaborates the idea, offering several very ingenious variants. The machine can be placed near the dividing shore or even mounted on a ship (fig. 28).

But the subtlety of thought, the ultimate elaboration of the idea, is to be found on the neglected folio 16r that reproduces an instrument comparable with the one depicted in the Codex Arundel. The text makes clear what Leonardo was after:

> $a, m, n$ is the vessel of the artificial whirlpool, with a diameter of 1½ braccia [1 Florentine braccio = ca. 23 inches] on top and ⅔ of a braccio on the bottom. The siphon's outlet enters in it at $a, b, c, d$. And the board that turns with the axle may have a greater velocity than the water that enters the vessel or the velocity could be the same, in order to have the movement accompanied and supported by the entering water. But if you want the board to revolve more quickly than the entering water, the effort will be greater, that is, the demand on the motor will increase. The faster the board turns, the greater will be the effort. But if the velocity of board and water are the same, there would be little or no effort, as I have proved in the 5th of the birds, on power and resistance; the power of the wing beating and the resistance of the air hit by the wings.
>
> The siphon must expel its water at the back of the turning board K. And this jet must be directed upward, following the obliquity of the vessel. Between the vessel and the board there shall be a spacing one finger broad and not more, in order to prevent impairing of the board's movement by the excessive weight of the water. The edge of the board must be oblique, as shown by the drawing.

Leonardo is suggesting here a remarkable technological development: a centrifugal pump moved by an outside force, where the incoming stream acting on the impeller reduces the effort of the main motor. He compares this case with that of the flight of birds: "When the bird finds itself within the wind, it can sustain itself above it without beating its wings, because the function which the wing performs against the air when the air is motionless is the same as that of

[49] Carlo Pedretti, "Saggio di una cronologia dei Fogli del Codice Arundel di Leonardo da Vinci," in Bib-liothèque d'Humanisme et Renaissance, XXII (1960), 172–177.

*Figure 27*
MS F, fol. 13*r*.

*Figure 28*
MS F, fol. 16*r*.

the air moved against the wings when these are without motion" (C.A., fol. 77*r*, *b*). There are numerous other examples from which it becomes evident that Leonardo recognized the universal validity of the law of action and reaction, known to us as the third law of Newton. In the realm of technology it was clear to him that a river mill is the opposite of a paddle boat, an Archimedean screw of a driving spiral, a centrifugal pump of a turbine.

We can observe the structural identity of the machines presented on folios 15*r* and 16*r* of MS F and on folio 63*v* of the Codex Arundel. If the smallest doubt remains about the legitimacy of this identification, let us compare notes. On folio 15*r* of MS F Leonardo defines his idea as *Giovamento da seccare li stagni che confinano col mare*, "method for drying up the swamps which border on the sea." On the Arundel page there is the observation *Mulina in stagni e in sul mare non si faranno, perche la fortuna riempie d'arena ogni canale che si fa in sua liti*, that is, "you shall not make mills

91

near swamps and the sea because the storms will fill up with sand every canal built on the shores." Leonardo means that his centrifugal pumps will be turned by mechanical means and not, as suggested on folio 13*r* of MS F, by a hydraulic wheel.

Even if different in structure, completely encased hydraulic turbines were drawn by Leonardo on folios 214*v*, *f* and 301*v*, *b* of the Codex Atlanticus, resembling an earlier one in MS B (fol. 26*v*). In all those cases the turbine was supposed to activate piston pumps.

Nor did Leonardo neglect the traditional vertical waterwheel that predominated as prime mover in a great variety of technical operations until the advent of the steam engine and the modern hydraulic turbines. But he was fully aware of its inherent weaknesses, analyzed and measured its performance, and attempted to improve it in several ways. Until Smeaton (around 1760), nothing like it was to be found in the annals of the history of technology.

There were three types of vertical waterwheels known: overshot, undershot, and breast wheels. Leonardo had something to say about each. He knew that water can transfer its energy by impact, as in the undershot wheels and the already described impact turbines, or by its descending weight in the overshot wheels.

For a long time after Leonardo, people were convinced that by letting the water fall from a height on the buckets of an overshot wheel its efficiency would improve by the added impact.[50] The matter must have been under discussion in Leonardo's time because he deals with the problem on several pages of the notebooks, and he concludes that "as the water falling on the water-filled buckets does not produce the impact that it would by hitting a hard surface . . . the advantage is doubtful" (C.A., fol. 337*v*, *c*). The advantage is denied categorically on folio 44*r* of MS F.

Experimenting with vertical waterwheels, Leonardo came to Smeaton's conclusions: the highest efficiency is obtained when the buckets are filled with water and the wheel turns by gravity. But this is a desideratum difficult to satisfy: on the down turn of the wheel the buckets start to lose their content long before reaching the bottom.

Leonardo tries to overcome the problem in several ways, all of them adopted centuries later. Folio 207*v*, *b* of the Codex Atlanticus (fig. 29) offers an interesting example of Leonardo's technological insight. On the upper part of the page he examines the superiority of the screw in comparison with the rack and pinion when used in lifting devices, and says: "Dealing with heavy weights, do not commit yourself to iron teeth, because one of the teeth may easily break off; you will use therefore the screw, where one tooth is bound with the other." As for the screw, "it shall be employed pulling not thrusting, because thrusting bends the shaft of the screw, while pulling straightens the bent one."

Following a hidden analogy, Leonardo turns his attention to the waterwheels. Speaking of the one depicted on the right, he says: "this wheel spills half the water that turns it." The wheel on

---

[50] See a typical example in Vittorio Zonca, *Novo Teatro di Macchine ed Edifici* (Padova, 1607), p. 21.

the left, based on an ingenious system of hanging buckets, often tried later, theoretically allows the full utilization of the energy potential. In MS B, on folios 33*v*–34*r*, and on folio 209*v*, *b* and *r*, *b* of the Codex Atlanticus, we find the elaboration of this basic idea. Here Leonardo tries to solve the difficulty by letting the buckets overturn at the end of their course with the help of a ratchet wheel.

Still another way of correcting the fault of the overshot wheels is visible on a sheet of studies for the famous *St. Anne with the Virgin and Child*.[51] A partial, external shrouding of the wheel provides for a constant waterhead over the paddles (fig. 30). On many other pages there are suggestions for improvements. Most characteristic is a design shown on folio 50*v* of the Codex Forster I (fig. 31). It represents a hydraulic wheel (probably ad-aqueous) where a number of individual

[51] Leonardo da Vinci, *I Manoscritti e i Disegni.* . . . "Disegni," fasc. vi (Rome, 1949), tav. ccxxxix, 1, British Museum.

buckets in the form of curved scoops are fixed on the rim. Each bucket has a ventilation hole. In 1863 Fairbairn,[52] talking about trouble with wheels that run submerged in the tailrace, wrote: ". . . in order to remedy it, openings were cut in the sole plates and small interior buckets attached inside the sole." Each bucket had a curved bottom wall. Fairbairn claimed a power increase of 25 percent resulting from this modification.

The inexhaustible mind of Leonardo offers more surprises. He experimented with partially submerged wheels having specially shaped buckets that entered the water with their edges (C.A., fols. 207r, b; 209r, a, etc.). He knew that maximum efficiency is obtained "when the flow of the water and motion of the wheel have the same direction" (MS H, fol. 63r, with figure of a breast wheel). In the early nineteenth century Fairbairn pointed out that breast wheels could be improved by immersing their bottom in the tailrace, where the flow would be in the direction of rotation.[53]

However, immersion of the wheel in the tailrace has several disadvantages and becomes disastrous if the water level of the race rises, as in the case of floods. Describing on folio 304r, b and v, d of the Codex Atlanticus a remarkable project destined to operate, in the same complex, not less than thirty-two grain mills moved by eight breast wheels, Leonardo designed an adjustable wheel-raising device.

Similar systems are known from the descriptions and figures that appear much later in the books of Ramelli[54] and Scamozzi.[55] Nothing like it exists in documents preceding Leonardo's writings; the first pertinent notice, after Leonardo, is found in Juanelo Turriano's manuscript datable around 1565.

What were all those wheels for? We are accustomed to associate waterwheels with corn mills or, at most, with iron forges, as seen in so many romantic paintings.

On an extremely interesting page of the Codex Atlanticus, folio 289r, e, the same on which Leonardo drew his automatic pile driver, there is a list of industrial activities that could be run on waterpower, if the Arno river were rectified. The list comprehends:

Saw mills
Fulling mills
Paper mills
Hammers (trip-hammers for forges)
Mills (flour mills)
Knife grinding and sharpening

Burnishing arms
Manufacture of gunpowder and saltpeter
Silk spinning of 100 women
Ribbon weaving
Shaping vases made from jasper
    and porphyry on the lathe.

[52] William Fairbairn, *Treatise on Mills and Millwork* (London, 1863), cited by Paul N. Wilson, "Water-driven Prime Movers," in *Engineering Heritage,* I (London, 1963), 31.
[53] Cited by John Storck and Walter Dorn Teague, *Flour for Man's Bread* (Minneapolis, 1952), p. 110.
[54] Agostino Ramelli, *Le Diverse et Artificiose Machine* (Paris, 1588), figs. 98, 99, 101.
[55] Vincenzo Scamozzi, *L'Idea della Architettura Universale* (Venice, 1615), pt. 2, p. 370.

An impressive listing, offering a hint about the most important manufacturing activities in Florence at the time of Leonardo. The "silk spinning mill of 100 women" may mean that the manual labor of a hundred women could be replaced by waterpowered engines or it refers to a factory where a hundred women were working at spinning equipment moved by the waterwheels. In any case, the list is striking and informative.

There is little to tell about the use of windpower by Leonardo da Vinci. Except for brief references interspersed in the manuscripts, sketches for a tower mill, together with an original braking mechanism, are found only in MS L (fols. 34v, 35v–36r, 90r–91r). The invention of the tower mill has been erroneously ascribed to Leonardo,[56] but those sketches are of interest because they may belong to the package of engineering "know-how" offered by Leonardo around 1502 to Sultan Bayezid II.[57] Windpower was never of actual interest in Italy, however, due to unfavorable meteorological conditions.

In contrast to the scarce interest of Leonardo in the utilization of windpower, heat and fire as possible sources of energy received his constant attention. Years ago I tried to collect and discuss all the pertinent references in the Vincian manuscripts,[58] and the late Ivor B. Hart examined them in a chapter of his last book.[59]

The invention of the steam engine marked the effective beginning of the conquest of energy. And, from the very beginning, the development of steam power was correlated with the evolution of the internal combustion engine. We are indebted to Professor Joseph Needham for a thought-provoking essay on the "Pre-Natal History of the Steam-Engine," [60] where the origin of every single part of the compound mechanism is discussed and traced (boiler, cylinder and piston, double acting principle, crank and rod transmission, etc.). It is remarkable that each of those elements was discovered long before Newcomen and Watt and used in several kinds of mechanical applications, generally in the East.

However, a distinct thread can be traced back from James Watt to Heron of Alexandria in the Western development of the steam engine. Watt's attention was first directed to the subject in the year 1759, by Dr. Robinson, a scholar in the University of Glasgow, and a few years later by Professor Anderson, who asked him to overhaul a model of the Newcomen engine. Newcomen was acquainted with the work of Savery and Papin, just as they were with the experiments described by Morland, the Marquis of Worcester, and David Ramsay.[61]

---

[56] Feldhaus, op. cit., p. 84.

[57] Franz Babinger, "Vier Bauvorschläge Leonardo da Vinci's an Sultan Bajezid II. (1502/3)," mit einem Beitrag von Ludwig H. Heydenreich, in Nachrichten der Akad. d. Wiss. in Göttingen (Jahrg. 1952), Nr. 1, pp. 1–20.

[58] Ladislao Reti, "Leonardo da Vinci nella Storia della Macchina a Vapore," in Rivista di Ingegneria

(Milan, 1956–1957), pp. 1–31.

[59] Hart, op. cit., pp. 249–250, 295–301.

[60] Joseph Needham, "The Pre-Natal History of the Steam-Engine," in Trans. Newcomen Society, XXXV (1962–1963), 3–58.

[61] Cf. L. T. C. Rolt, Thomas Newcomen, the Prehistory of the Steam Engine (London, 1963), pp. 17–41.

All of them, in their turn, were under the influence of an important group of scholars whose interest in the study of the behavior and dynamics of fluids (a discipline called, in the fashion of the time, "Pneumatics") was explosively stimulated by the printing of Heron's *Pneumatic* in 1575.[62] Pneumatics, after being merely a kind of a game and a curiosity, became a science with Galileo,[63] Torricelli,[64] Blaise Pascal,[65] Edm. Mariotte,[66] Otto von Guericke,[67] and especially Robert Boyle.[68] While in many other cases of technological progress parallel and independent developments were frequent, the story of the conquest of steam power runs in an unbroken sequence from Heron to James Watt.

A little-known factor in the unfolding of this exciting history was the contribution of Leonardo da Vinci. Leaving open the question of a possible direct influence, it is our duty to record his ideas and practical suggestions in this field.

Most of the writers on the history of steam power attribute to Cardan the fundamental statement that a vacuum is created by the condensation of steam. It is unaccountable how the obscure passage in the *De subtilitate*[69] was interpreted to the credit of Cardan.

More than fifty years earlier Leonardo had clearly made the same statement several times. For example, in MS E, back cover, we read: "When air is condensed into rain it will produce a vacuum, if the rest of the air does not prevent this by filling its place, as it does with a violent rush." Of course, Leonardo calls water "vapor" or steam "air," just as the later chemists called every kind of gas an air. But if we forgive Leonardo's faulty terminology, the meaning is clear.

To our greatest surprise, all the famous "theorems" of Salomon de Caus, which made him one of the founding fathers of the conquest of steam power, had been clearly enunciated by Leonardo, as shown in my cited publication.

Leonardo da Vinci attempted to determine the volume of steam obtainable by evaporating a given amount of water, long before Della Porta (1606), as can be seen in the familiar folio 10r of the Codex Leicester. Less known in the same Codex (fol. 15r) is Leonardo's description of other analogous experiments, revealing an amazing knowledge of the relation existing between volume, temperature, and pressure of vapors and gases. His approximate estimation of the quantity of steam evolved by the evaporation of an ounce of water points to the ratio 1:1,500. Besson[70] in 1569 still believed that the proportion was 1:10, a ratio raised to 1:255 in the famous experiments

[62] Hero of Alexandria, *Spiritalium Liber, Fed. Commandino e Graeco in Latin. conv.* (Urbino, 1575). For the avalanche of books on "Pneumatics" or "Spiritalia," see bibliography in my cited publication on Leonardo and steam power.

[63] Galileo Galilei, *Discorsi e Dimostrazioni Matematiche, intorno a due Nuove Scienze* (Leyden, 1638).

[64] Ev. Torricelli, *Opera* (Faenza, 1919).

[65] Blaise Pascal, *Nouvelles Experiences touchant la vuide* (Paris, 1647); *Traitez de l'Equilibre de Liqueurs* (Paris, 1663).

[66] Edm. Mariotte, *Traité du Mouvement des Eaux* (Paris, 1686).

[67] Otto von Guericke, *Experimenta Nova* (Amsterdam, 1672).

[68] Robert Boyle, *The Works* (London, 1744).

[69] Girolamo Cardano, *De Subtilitate libri XXI* (Lyon, 1551), 25.

[70] J. B. Besson, *L'Art et la Science de trouver les Eaux* (Orleans, 1579).

of Jean Rey.[71] It was not until 1683 that a better estimate—1:2,000—was made by Samuel Morland,[72] the correct figure being around 1:1,700.

Leonardo's best-known contribution to the history of the conquest of steam power is his famous "Architronito" (MS B, fol. 33r), a steam cannon. Needham remarked recently [73] that the "Architronito" was symbolic in the highest degree if we may look upon the piston as a tethered projectile. As for the attribution to Archimedes, I hope I have demonstrated convincingly in a recent paper [74] that the steam·gun is one of the most original ideas of Leonardo. Following older authorities (Valturius and Petrarca) he credited Archimedes with the invention of the ordinary gunpowder bombard. He merely did not realize that his own substitution of steam for gunpowder was a very significant additional invention.

A separate chapter in the history of harnessing steam power deals with the steam turbine. Even though Heron had already described a toylike device, embodying the principle of a reaction turbine, and Branca, in 1629, depicted an impulse turbine moved by steam, it would be inaccurate to affirm that the modern Parsons and De Laval turbines derive from those ancient prototypes. Practical steam turbines appeared long after the piston engines reached maturity.

However, François Arago, the great French scientist,[75] concerned with the part played by French inventors and particularly Salomon de Caus, in the history of the harnessing of steam power, confronted with Giovanni Branca's impulse turbine, declared: "Si, contre toute probabilité, la vapeur est un jour employée utilment à l'état de souffle direct, Branca, ou l'auteur actuellement inconnu à qui il a pu emprunter cette idée, prendra le premier rang dans l'histoire de ce nouveau genre de machines. A l'égard des machines actuelles, les titres de Branca sont completement nuls."

By this conditioned recognition Arago became a prophet *malgré lui*. Arago's hint of an unknown author, from whom Branca may have borrowed the idea, is suggestive and prophetic again. The unknown source of Branca was Leonardo da Vinci, who not only points in many places in his writings to the power of a gush of steam, but in the Codex Leicester, folio 28v, describes a steam-driven meat-roasting jack: "Water which is blown through a small hole in a vessel in which it is boiled, is blown out with fury and is entirely changed into wind, and by this means meat is turned to be roasted."

Also on several pages of the Codex Atlanticus (fols. 80r, b; 400v, a; 380v, a) Leonardo depicts cauldrons (eolipiles) in the form of a human torso, identical to that found in Branca's book. For Leonardo steam-driven turbines were only particular applications of a general mechanical principle based on the flow of any kind of fluid. A turbine with compressed-air impulse is presented in

[71] Jean Rey, *Essais* (Bazas, 1630).
[72] Samual Morland, *Elevation des Eaux* (1683).
[73] Needham, *op. cit.,* p. 227.
[74] L. Reti, "Il Mistero dell'Architronito," in *Raccolta*

*Vinciana,* XIX (1962), 171–183.
[75] D. F. J. Arago, *Eloge Historique de James Watt* (Paris, 1839), p. 20.

Codex Atlanticus, folio 13v, b, and a roasting jack, moved by a hot air turbine, in Codex Atlanticus, folio 5v.

The true history of the steam engine begins with a mechanical system comprised of cylinder, piston, and valves operated by the expansive power of the steam, by the atmospheric pressure generated by its condensation, or by a combination of both forces.

It is remarkable that the internal-combustion engine utilizing the same mechanical arrangement precedes historically the steam engine, though substantial practical application came much later. A common origin of both inventions is revealed in the evolution of the experiments of Huygens and Papin. Papin came to the idea of the atmospheric steam engine (1690) after Huygens' experiments (1673) with a piston, moved by the pressure of the air consequent to the explosion of a charge of gunpowder in the cylinder (atmospheric internal-combustion engine), failed to give consistent results.[76]

In several surveys of this important chapter of the history of technology, the abbé Jean de Hautefeuille (1678) is credited with the invention of the first gunpowder engine. This is a manifest error: the experiments of Huygens were known at least from 1673, even though he published them later. Besides, Hautefeuille's device is a water-raising box and not an engine.[77]

At this point I should like to deal with one of the most remarkable and original technological anticipations of Leonardo: the project of an atmospheric internal-combustion engine, activated by gunpowder, identical in every respect with those of Huygens and Papin.

In folio 16v of MS F there is a little-known and often misinterpreted sketch, depicting a mechanism "to lift heavy weights" (fig. 32). The caption reads: "To lift a heavy weight with fire, like a cupping glass. And the vessel should be one braccio [about 2 feet] wide and ten long, and should be strong. It should be lit from below like a bombard and the touchhole rapidly and immediately closed on top. The bottom, that has a very strong leather, like a bellow, will rise and this is the way to lift any heavy weight." It is very likely that for this experiment Leonardo used a true bombard, as indicated by the presence of a touchhole, the strength of the vessel, and its measure (1:10).

The only detail that differentiates Leonardo's machine from those of Huygens and Papin is the system adopted for raising the weight sustained by the piston. Huygens and Papin use a pulley and rope transmission (the same that Leonardo adopted in his experiments with steam!), while Leonardo preferred to attach a rod to the bottom of the piston.

Leonardo's apparatus bears an uncanny resemblance to the first steam hammer conceived by Nasmyth in 1839.[78] Indeed, the page on which Nasmyth sketched his first ideas has a curiously "Leonardesque" air (fig. 33). When Watt constructed the first model of his separate condenser

[76] Chr. Huygens, Oeuvres Complètes, Tom. VII, Correspondence (1670-1675) (La Haye, 1897); D. Papin, "Nova Methodus ad Vires Motrices," in Acta Eruditorum (1690).

[77] J. de Hautefeuille, Pendule Perpetuelle, avec un nouveau Balancier et la Mainère d'élever l'Eau par le Moyen de la Poudre à Canon (Paris, 1678).

[78] Reproduced in Engineer, LXIX (1890), 407.

*Figure 32*
MS F, fol. 16v.

*Figure 33*
Nasmyth, "Steam Hammer,"
*Engineer*, 1890, 69:407.

engine (1765), he adopted the inverted direct-acting cylinder system,[79] thus recreating a technological scheme elaborated by Leonardo 250 years before.

A number of reasonable questions advanced by several authors will be echoed at this point. Those marvelously modern-looking projects of Leonardo, do they have reality or are they to be considered as the unfulfilled dreams of an inventor? Are they original or do they come from a long tradition of engineering experience?

These questions can be answered both ways. Leonardo did find ample inspiration in the deeds

[79] H. W. Dickinson, *A Short History of the Steam Engine* (Cambridge, 1938), p. 70, figs. 11 and 12.

and writings of his predecessors in the technical arts,[80] and some of his projects were so advanced that they could not have been carried out, for lack of adequate technical support. Others, even if brilliantly conceived, were based on faulty theories and would not work (e.g., the use of syphons more than 30 feet tall).

There can be no doubt, however, that most of Leonardo's technical ideas were grounded in firm and actual experience, even if the corresponding historical records are meager. His canal-building activity in the Romagnas, while in the service of Cesare Borgia, must have been successful in view of his immediate appointment by the Signoria of Florence in a similar capacity after the downfall of his frightful patron. Leonardo's innovations and inventions in the field of mechanical engineering can be traced in the writings of a number of sixteenth- and seventeenth-century authors, especially Cardan, Besson, Ramelli, Zonca, Castelli, Verantius, De Caus, etc. It is useless to speculate about the fact that Leonardo's manuscripts were hardly accessible to those writers: his technological ideas, like those related to the arts, were already incorporated in the common knowledge of the epoch.

But arts and techniques can be easily lost when genius is not understood and assimilated. The technology of the sixteenth and seventeenth centuries was much inferior to the standards set by Leonardo; only at the end of the seventeenth century was there a renewal that led to the beginning of modern engineering. A thorough study of Leonardo's technical activities and ideas, even if presented in the disorderly state of the mutilated and plundered heritage, points to him, as Feldhaus has correctly remarked, as the greatest engineer of all times.

[80] As an interesting example, I shall quote my own study, *Tracce dei Progetti perduti di Filippo Brunelleschi nel Codice Atlantico di Leonardo da Vinci* (Florence, 1965), where an intimate relationship between a group of juvenile drawings of Leonardo and the lost projects of the hoisting machines used by Brunelleschi in the construction of the cupola and the lantern of the Cathedral at Florence is demonstrated.

# Leonardo:
# Prophet of Automation

## by BERN DIBNER

AUTOMATION is the most recently forged link in the chain of technological progress. It follows the mechanization of work, using the power of wind and water, the expanding energy of steam, the torque of electromagnetic motors and electronic controls. Our present concern is with automation and the vision of its potential, especially in the mind of Leonardo da Vinci who conceived and designed many devices that later entered into the fabric of progress.

With his unusual preparation in the working of the elements and forces in nature and with vision for combining simpler mechanical elements into complex machines, Leonardo helped to pioneer today's important technological development. We term automation the inclusion of devices in a machine to act in accordance with some preset index. It constitutes a higher order of machine complexity. Leonardo's study and command of the devices in use in his day made him a master of machinery. But in addition he was among the earliest who foresaw, in the production machine, elements to relieve the operator of the need for making judgments. Such machines made possible greater uniformity of the machine product and therefore greater reliability and lower cost. It was the essential step that led toward mechanization, the interchangeability of parts, and the threshold of the new industrial revolution.

In examining the many hundreds of drawings of machines and inventions of Leonardo, we must, for our purpose, select only those that have elements of automation in them. We shall currently disregard his compounding of simple prime tools which resulted in devices giving some mechanical advantage, improved accuracy, or magnified power. We shall hunt out those into which are incorporated devices designed themselves to control some work, coordinate some apparatus, or advance some process. We shall look at a few designs of Leonardo into which he introduced fittings that were to act in place of the eye or that would replace human judgment or the need for decision making. If Leonardo was truly a twentieth-century man living in the fifteenth century, we shall establish this by examining his contributions to automation.

From his writings it can be concluded that Leonardo gradually developed a mechanistic philosophy in viewing the world about him: he was aware of the regular rotation of the heavenly bodies, the life and interrelation of man and beast, the motion of wind, the flow of water, the pattern of growth of tree and plant. Therefore the concept of built-in controls—so highly developed in animal and plant—was everywhere indicating the concept of automation toward their inclusion into mechanisms. This concept was a proper challenge for Leonardo's incisive mind. A contrivance which had an automatic element in it was impressive and sometimes quite startling to his contemporaries and biographers.

Buried among the many notes and sketches are two mechanisms of unusually brilliant design which apply to our present study. Both concern grinding and polishing. The first illustrates a mechanism for grinding and polishing hollow cylinders (fig. 1). One sees the rough cylinder clamped by two hollow vise jaws held firm by adjusting wing nuts (which, to produce pressure, Leonardo should have shown on the inside of the studs). Partway into the bore extends the reamer, on the outer surface of which are cut grooves to hold the polishing or lapping compound of oil and emery. The top of the reamer or lapper rises through a complex and ingenious mechanism consisting of a spur gear, as seen, having an internal thread of high pitch. Into this thread is fitted a bolt having the matching outer pitch and a rectangular inner bore. The gear is confined by the two horizontal plates so it can only revolve but not move vertically. The threaded bolt within it rides up and down within the gear as it turns because it is confined by the rectangular inner shank within it. Our attention now shifts to the circular plate having a semicircle of gear teeth that engage the horizontal gear. Also to be noted is a vertical spring rod at the extreme left from the top of which a string passes through the stud and is wound upon a collar extending above the gear. The device is now ready to lap the cylinder bore. The large disc is turned, the teeth engage the gear, it revolves causing the bolt to turn and descend into the bore. But the disc teeth at the half-revolution and the gear become disengaged. The spring takes over and the taut string unwinds, causing a reversal in the gear motion and the bolt to ascend, thereby reversing the polishing motion. The top is reached, the disc teeth engage once more, and the cycle is repeated as long as the disc is revolved. The reamer thus turns and reverses as it moves up and down.[1] Excess lapping compound drips into the small dish beneath the bore.

But Leonardo was not one to waste a perfectly good half-cycle of rotation. He therefore sketched at the right a combination of two such grinding and polishing machines. In this arrangement one is spun during a half-cycle by the arc of teeth on one face of the disc, the second is spun by the arc of teeth on the other face.

Was this simply an exercise by Leonardo in clever mechanization and automation, or did it have a useful application? He had drawn many boring devices for earth, wood, and metal, but this highly refined mechanism seemed intended for special application. One such might be for the

---

[1] Leonardo's intent is quite clear, but the mechanism as shown is not fully functional.

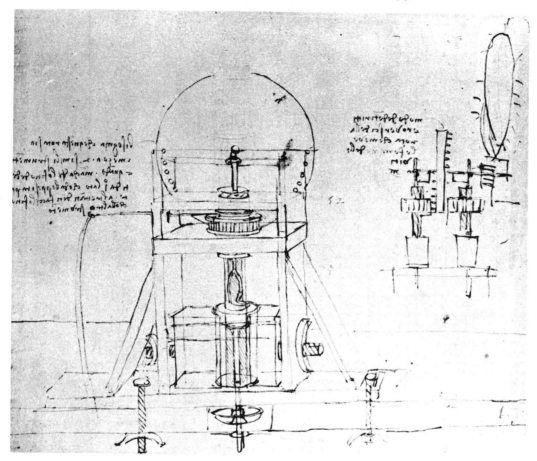

*Figure 1*
Cylinder grinder. A machine
for grinding and lapping a
cylinder bore, combining
rotary and vertical motion.
At the right, a sketch for
doubling the operation
(C.A., fol. 291r).

fabrication of bearings. With his concern with friction losses and the proper meshing of gears that depended on close tolerance, the need for accurate bearings became obvious. For greater accuracy, a mechanized rather than a manual bearing fabrication was called for, and Leonardo supplied it.

Another intricate machine was sketched by Leonardo and is referred to as a needle-grinding machine for mass production. Unfortunately, he did not go into much graphic detail of the parts that he combined to grind and polish his needles but, to tantalize us even more, he appended a production schedule of such promise that even a world monopoly of his device soon would have saturated all the markets.

103

The machine itself shows a turntable which as it revolves activates a small spur gear by a circle of strip cams (fig. 2). The gear turns a shaft which moves a leather belt passing through a control mechanism over two pulleys kept taut by a bolt. Somehow the many needles on the plate pass under the face of five such belts and are revolved, ground, and honed by a suitable abrasive of lead and emery. Leaving the exact mechanical details to our imagination, let us examine the breakdown of Leonardo's production figures. He wrote: "Tomorrow morning on January 2, 1496, I shall try out the broad belt. . . . A hundred times in each hour 400 needles make 40,000 per hour, and in twelve hours 480,000. But let us say 400,000, which at 5 soldi for each thousand gives 20,000 soldi, that is in total 1,000 lire per day for one man's work; and if one works for 20 days in the month, it is 20,000 lire a month and the yearly total becomes 60,000 ducats."[2] Not only is this a neat paper profit but it also highlights the incentive for designing needle-making machinery instead of attending to the weary business of painting altarpieces. The tenfold error in Leonardo's arithmetic would probably still not have dampened his enthusiasm as a needle tycoon.

Leonardo actually had little interest in money or money matters. He was often in debt from not having been paid by his patrons. His attitude to money and get-rich-quicks is more clearly shown in his note:

And those who wish to grow rich in a day shall live a long time in great poverty, as happens and will to all eternity happen to the alchemists, the would-be creators of gold and silver, and to the engineers who think to make dead water stir itself into life with perpetual motion, and to those supreme fools, the necromancers and the enchanters.[3]

What motivated Leonardo's interest in mechanisms and physical forces? Described by Vasari as a man of extraordinary strength, Leonardo was sensitive not only to line, form, and color but also to work, struggle, and pain. No one has described in word or picture the violence and havoc of war in clearer terms than has Leonardo. Whether in the excesses of battle or the more prosaic exertions of labor, the demands on the muscle of man and animal were never more clearly portrayed than in his anatomical drawings. Leonardo's sensitivity was possibly bred by an awareness of his illegitimacy. Not completely at home in the house where he was born (in 1452), his faculties were sharpened in the busy workshop of Verrocchio in Florence. He was constantly exposed to labor in foundry, quarry, arsenal, and forge, and the great demands on the bodies of men and beasts evoked in him ways of diminishing such strains. It has been told that he would buy in the marketplace caged birds which he would then release. Whether he was motivated by compassion or a desire to study the mechanics of flight is debatable. In his writings he refers frequently to those who labored or struggled while at work or in the demands of battle. As a designer of ordnance to the court of Lodovico Sforza, or as an engineer general in the armies of Cesare Borgia, Leonardo was exposed to the application of effort under maximum demand. To reduce physical

[2] C.A., fol. 318*v*.    [3] Wind. I, fol. 13*v*.

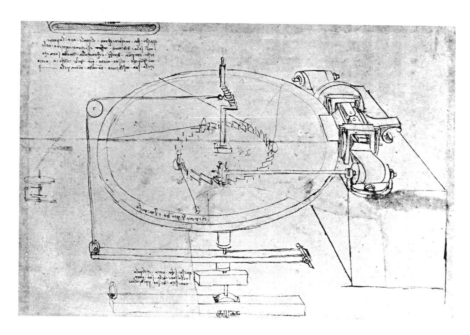

*Figure 2*
Needle grinder. A highly mechanized needle grinder and polisher capable of vast production capabilities, according to Leonardo's calculations. The location of five such systems around the circular table are indicated (C.A., fol. 31*v*).

labor was therefore an understandable purpose in his concern with implements and machines. He was always the experimenter, the explorer, and the innovator, whether it was in the techniques of painting, the scope and grandeur of city planning, architecture, or sculpture, or in the design of military equipment, in aviation, or in probing the depths of the sea. The trend to the new was equally evident in his machine designs.

His sharp and facile mind, his perceptive eye, and a skilled left hand rendered ideas and observations with clarity and beauty unmatched by any other observer or inventor. Expressing the spirit of renascence and extending it into the new fields of exploration and experiment, Leonardo scorned those who looked upon his lack of formal education. "They will say that because of my lack of book learning I cannot properly express what I desire to treat of. Do they not know that my subjects require for their exposition experience rather than the words of others? And since experience has been the mistress of whoever has written well, I take her as my mistress, and to her in all points make my appeal." Leonardo later added: "He who has access to the fountain does not go to the water pail." [4]

He sensed in nature the fundamental relationship of effect to cause and he searched for the cause in the shaping of all things that stimulated his awareness. In even the most complicated ma-

[4] J. Bronowski, in *The Renaissance* (London, 1961), p. 187.

chine available to him—the human body—he saw a complex of hinged levers moved by an intricate system of muscles anchored at the most efficient points and stimulated by vast networks of veins, arteries, and nerves, not too complex for him to study and to delineate as no man had done before him and few since. The dynamism of a world in motion became for him a task for organization by its qualities and numerical values. Like the soundest of scientists, he assigned numbers to things measurable and these were added, subtracted, and multiplied to tally with observed results. His respect for mathematics grew when applied to solve mechanical problems.

Leonardo's analytic mind treated the animate and the inanimate with equal judgment in their play one upon the other. The classic writers were no source of final authority for him; he had to begin fresh with his own observations, make his own measurements, and conclude with what was demonstrable. The more that his keen eye observed in the structure of a vine's tendril or the functioning of an internal organ, the more was he drawn into searching further into the complementary elements of the living world. Each minute capillary, each odd leaf, was one more element in a grand order which his universal mind tried to compose and arrange into systems actuated by measurable forces.

He noted that "there is no certainty in science when one of the mathematical sciences cannot be applied." [5] This habit of approach to mechanics, the translation and application of power, led his inventive mind from the applied devices of his time to their extension into the yet unapplied. He wrote with that quality of imaginative speculation that is so much sought in today's teachers, engineers, and research scientists. Without the help of the scientific principles that came later with Gilbert, Galileo, and Newton, Leonardo drew those guiding rules that he could grasp and formulate from the many problems that surrounded him. He was, as Ivor Hart observed, a scientific technologist rather than an empiricist. The evidence clearly indicates an empathy of Leonardo for engineering devices that moved and turned in accordance with laws that he felt he could understand and attempted to define. On reading Leonardo's notes, one soon absorbs his confidence in the meaning of results derived from experiment. This approach was novel even in the early 1500's. "Before making this case a general rule," he wrote, "test it by experiment two or three times and see if experiment produces the same effect." [6] In another note he cautions himself, "Remember when discoursing about water to use first experience and then reason." [7]

Leonardo's times preceded those of the factory system but encouraged the specialty shops in which a dozen or more men were employed at repetitive operations. These included the output of ceramics, textiles, hand tools, papermaking and printing, weapons and ordnance. The publisher Anton Koberger in Nürnberg employed over a hundred printers and typographers in the 1490's. The Venice Arsenale employed two thousand men and was the world's largest industry in the 1500's. The streets and shops of the Arsenale covered sixty acres, and more than a hundred galleys could be built or repaired in the docks at one time. However, this was the unique exception of the period. Labor was basically manual, but it was also supplemented by animal power

[5] MS G, fol. 95v.  [6] MS A, fol. 47v.  [7] MS H, fol. 90 (42)r.

106

and from wind and water mills. The success of each such enterprise encouraged others to seek improvements in the organization of skills and training and in better machines and devices to strengthen the economy and the quality of the products. Production tools, pumps, presses, and mills were designed by the early mechanicians and engineers, among whom Leonardo considered himself one. In manufacturing and trade the stimulus of reducing the actual labor content of an item so as to lower its price and make it salable in wider markets became apparent to those early managers of manufacturing enterprises.

As we marvel at Leonardo's design of machines and instruments equal to and more ingenious than those of his contemporaries, we become aware of the presence of a mind of extraordinary technical ability. His machines were more powerful than those in use in his day or even proposed by the best of his fellow engineers. His engines of war were more devastating and their elements were combined to be more efficient in their destructive purpose. But we, with the perspective of nearly 500 years, stand in awe not of his mechanical improvements but of his search into the ways of nature in an effort to discover and command her basic and inexorable laws.

When Leonardo left Vinci for Florence and joined the other apprentices in the studio of Andrea del Verrocchio, he was exposed to some of the most advanced technological practices of his time. Florence was then the center of the creative arts and crafts. To it were brought problems in architecture, in casting large memorials and candelabra in bronze, the fashioning of heavy religious structural and decorative elements requiring special jigs and tools. He was exposed to all of these problems. But the studio was no hideaway from the sterner problems of the day, for Florence was astrife with wars against Rome, and was torn by conflict among the dominant Florentine families and by struggles with other city-states. War and violence were ever present.

Approaching his thirtieth year, Leonardo began to search out new areas in which to apply his talents. He was kept aware of his limited formal training and lack of knowledge of Latin and Greek by those less gifted than he, and the growing cleavage between him and his fellow artists of Florence became disturbing. He wrote: "They go about puffed up and pompous, in fine raiment and bejeweled, not from the fruits of their own labors but from those of others; my labors they refuse to recognize. They despise me, the inventor, but how much more are they to blame for not being inventors, but trumpeters and reciters of the works of others."[8]

Leonardo began work as an artist with brush, crayon, chisel, and hammer. He was drawn into scientific investigation in search of the principles that controlled the essentials of art—anatomy of man and beast, geometry for composition, botany and geology for landscape, optics and perspective for background, architecture, fabrics, and armor for embellishment. His concern with sculptural casting, ballistics, and effective armaments drew him deeper into metallurgy, chemistry, and mechanics. His engineering duties exposed him to cartography, hydraulics, and strength of materials. His interest in mechanical flight drew him to pneumatics and meteorology. The shift from arts major to science major was gradual but constant. The quickened life of Florence in the

[8] C.A., fol. 117r.

third quarter of the 1400's provided the fast-moving panorama for his penetrating eye, which his hand reduced to some of the most stirring drawings ever made. Through these thousands of drawings and endless notes courses the search for common patterns of form and behavior which he saw as the rules of nature. No blade of grass was too insignificant, no object too sordid, no event too cataclysmic to engage his interest and invite its understanding. The result was thousands of manuscript pages of study and much preparation for more. Beginnings of encyclopedic plans, constant preparation to publish books in the physical and biological sciences as well as on painting and perspective, astronomy, architecture, and cosmology are strewn throughout his notes.

Leonardo lived in a period of constant wars between the city-states which made alliances with one another only to break them. The costs of war in manpower and materials remained heavy burdens on each city's economy. Pisa warred against Florence, Florence against Rome, Venice against Milan, Milan against Naples. A constant supply of arms had to be forged and more powerful engines of war became even more devastating, as gunpowder added its destructive dimension. Fort design and the concept of defense had to be restudied; improved tactics and mobility sharpened the efficiency of the new arms. Engineers were sought to provide the advantages of firepower over the weight of numbers and armor.

For a century prior to Leonardo's birth there was hardly a month of peace in warring Italy, which had involved the major cities, the Papacy, and the Empire. The introduction into Italy by the French in 1494 of iron cannonballs forced a further redesign of both fortress contours and gun design. The smaller dukedoms and city-states became more vulnerable to the heavier artillery and improved firepower, and they were thereby forced into alliances that led to the establishment of larger political units. Again technology altered social structure. Even Rome, Milan, and Florence were invaded and sacked by the armies of the French and Spanish kings. To this activity were added the demands and the rewards that followed the opening of the Far East and the New World and which forced new methods on the craft industries and new pressures on the merchants and adventurers.

As cities grew in size and power, so did the engineering services that helped feed them, clean them, and maintain the flow of goods, food, water, fuel, and building material for the houses, palaces, forts, and churches that distinguished city living from life on the land. As the cities grew larger and richer they became the greater target for the plundering lords and tyrants of other cities. If the realities of survival for Florence were the florin and the sword, so Milan and Venice leaned on improvements in ships, on weaving, dyeing, printing, and metalworking. These were the distractions from his art of which Leonardo was so well aware and in which he was immersed. There were fewer Mona Lisas and St. Annes because there were canals to be dug, guns to be built, and bridges to be designed.

By 1300 waterwheels were widely applied to the action of large furnace bellows, producing the higher furnace temperatures and the absorption of a higher percentage of carbon from the iron-making furnaces. Improved cast iron opened the markets for lower-priced cannon. Leonardo

was fully aware of the importance of machines and war engines to the heads of state in those turbulent times. He was twenty years old when he was admitted to membership in the Florentine Guild of Painters. Nine years later, about 1482, he sent that famous letter to Ludovico Sforza, later duke of Milan, offering his services. The letter reads:[9]

Having, My Most Illustrious Lord, seen and now sufficiently considered the proofs of those who consider themselves masters and designers of instruments of war, and that the design and operation of said instruments is not different from those in common use, I will endeavor without injury to anyone to make myself understood by your Excellency, making known my own secrets, and offering thereafter at your pleasure, and at the proper time, to put into effect all those things which for brevity are in part noted below—and many more, according to the exigencies of the different cases.

I can construct bridges very light and strong, and capable of easy transportation, and with them pursue or on occasion flee from the enemy, and still others safe and capable of resisting fire and attack, and easy and convenient to place and remove; and methods of burning and destroying those of the enemy.

I know how, in a place under siege, to remove the water from the moats and make infinite bridges, trelliswork, ladders, and other instruments suitable to the said purposes.

Also, if on account of the height of the ditches, or of the strength of the position and the situation, it is impossible in the siege to make use of bombardment, I have means of destroying every fortress or other fortification if it is not built on stone.

I have also means of making cannon easy and convenient to carry, and with them of throwing out stones similar to a tempest; and with the smoke from them of causing great fear to the enemy, to his grave damage and confusion.

And if it should happen at sea, I have the means of constructing many instruments capable of offense and defense, and vessels which will offer resistance to the attack of the largest cannon, powder, and fumes.

Also, I have means by tunnels and secret and tortuous passages, made without any noise, of reaching a certain and designated point; even if it is necessary to pass under ditches or some river.

Also, I will make covered wagons, secure and indestructible, which entering with their artillery among the enemy will break up the largest body of armed men. And behind these can follow infantry unharmed and without any opposition.

Also, if the necessity occurs, I will make cannon, mortars, and fieldpieces of beautiful and useful shapes, different from those in common use.

Where cannon cannot be used, I will contrive mangonels, dart throwers, and machines for throwing fire, and other instruments of admirable efficiency and not in common use; and

[9] *Ibid.*, fol. 319r.

in short, according as the case may be, I will contrive various and infinite apparatus for offense and defense.

In times of peace I believe that I can give satisfaction equal to any other in architecture, in designing public and private edifices, and in conducting water from one place to another.

Also, I can undertake sculpture in marble, in bronze or in terra-cotta; similarly in painting, that which it is possible to do I can do as well as any other, whoever it may be.

Furthermore, it will be possible to start work on the bronze horse, which will be to the immortal glory and eternal honor of the happy memory of your father, My Lord, and of the illustrious House of Sforza.

And if to anyone the above-mentioned things seem impossible or impracticable, I offer myself in readiness to make a trial of them in your park or in such place as may please your Excellency; to whom, as humbly as I possibly can, I commend myself.

Of the thirty-six abilities that Leonardo listed in the above summary, thirty concerned technology and only six were related to the arts.

Leonardo was thirty when he traveled north to Milan to join the court of Sforza. While Florence was mainly oriented toward literature, the arts, and trade, Milan drew the talents of scientists, mathematicians, and military engineers. Two industries—the fabrication of armor and of textiles—employed hundreds of hands, and both industries lent themselves to repetitive operations, mechanization, and mass production. It was to this progressive city and to a duke alert to the forward trends of his times that Leonardo turned. Milan had three times the population of Florence. Its architectural quality was that of strength rather than beauty, as in Florence. The arms industry of Milan kept over a hundred shops busy with the manufacture of weapons, armor, and ordnance. The din along the Via degli Armorai must have been quite welcome to Leonardo's ears. From that street ideas for new inventions came to his mind.

Leonardo's military activities at Milan were still in the period of transition from the archery stage to that of gunpowder. His designs of ballistic equipment therefore included ingenious innovations but many were still concerned with giant crossbows, rapid-fire catapults, and up-setting mechanisms to counter scaling ladders. As he applied his mind to artillery, there emerged weapons having design features of the late 1800's. Breechloaders, mobile and multibarrel machine guns, rapid-fire guns, shrapnel, and vaned missiles were additions to his arsenal of advanced designs. In powder-actuated artillery the rock or ball of the mangonel was no longer propelled by the energy stored in the bent bowspring or the twisted rope, but was contained in the explosive grains of gunpowder. Release of the vastly greater kinetic energy of the propelled shot now lay in the hand of the gunner, who simply touched a lit taper to the gun's touchhole. Chemistry was replacing stored muscle power. To apply and direct this vast new potential of destructive energy excited the inventive genius of Leonardo as had few other machines. Let us turn to one such example.

110

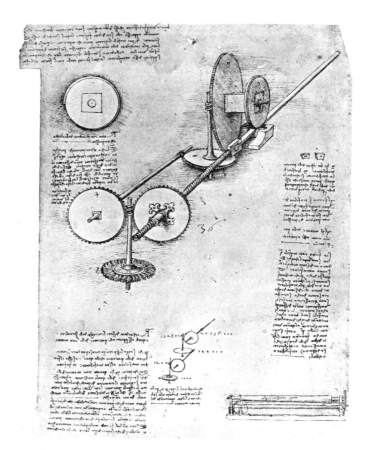

*Figure 3*
Swaging gun
barrel section.
A hydraulically
driven complex
for forming a
stave of a gun
barrel having
a heavier breech section
than that at the muzzle.
The power transfer diagram
has been worked out
at the bottom (C.A., fol. 2*v*).

The summation of Leonardo's solution to the manufacture of large artillery pieces was to concentrate on the production of the prime element that was to form the gun—a segment of the barrel, to be drawn by an assembly of shaping tools. The large gun that Leonardo had in mind was too large to be cast uniformly in a single pouring. The barrel was therefore to be formed by welding wrought-iron segments to one another, then banding them circumferentially by heavy wire or shrunk-on bands. To make such a construction feasible, the segments were all to have been smooth, even, and with a straight bore and a uniform taper. This precluded hand forging. A drawing mill to accomplish such a complex of specifications was designed by him and combined very advanced fabricating elements for simultaneously drawing and rolling the bars. In addition, Leonardo, with a masterly grasp for coordinating complex functions, left for us a drawing of such clarity that the sequence of operations shows up as neatly as in a single-line wiring diagram. One can readily count fifteen such links in the machine assembly! (fig. 3).

111

In his drawing, the first focus of attention is the prime mover, a reaction water turbine turning an upright shaft. At its top is a worm gear which commonly activates two large gears that turn in opposite directions. Following the left gear we see that it turns a long shaft which also has a worm gear on its far end. This worm gear meshes with a horizontal gear that has another vertical shaft and with yet another worm gear which now engages a large vertical gear. The heavy square shaft integral with the last gear is also fitted with a parallel vertical solid wheel on the rim of which is fitted a helicoidal cam or "snail" which, as it turns very slowly, increases its radius and thereby applies greater pressure on the "work," the cannon segment beneath it. To trace the elements of the system on the right one starts again at the prime mover, the turbine which, as it turns, revolves the first worm gear at the top of the shaft. This actuates the large vertical gear to the face of which is fastened an internally threaded hub surrounding a long threaded shaft terminating in a claw with a T-bar at the far end. Into this claw is inserted the knob of the cannon segment to be drawn. The segment was first prepared by rough hammering and shaping to the approximate section and length. In the first pass the roll formed the inner concave face of the bore. Subsequent passes formed the segment's sides which diverged radially. The final pass formed the convex exterior face and at the same time forced the bar into a gentle taper by pressure of the large roll and the cam face of its circumference. The front face of this roll is shown in detail at the top, left, where the heavy shaft, roll, and cam are also detailed. Leonardo described the cam as a "pyramid bent into a circle uniformly changing at a distance from its center." The bar during drawing was to be held in a block to avoid deforming the cross section, but Leonardo allowed "a good-sized crest to be left at the edges," which he proposed to use in hammering these edges together to weld the tapered segments into a complete cylindrical cannon bore. The difference in shape of the muzzle and breech ends of the bore are shown in the detail, right.

Leonardo's awareness of the relation of the speed of work to its magnitude is clearly demonstrated by a power-analysis diagram at the bottom of the page. Here schematically the power derived from the hydroturbine is traced upward with each multiplication of mechanical advantage as the power is transmitted from large turbine to small worm gear acting on a large gear. The faster revolving worm created in the slower revolving gear an increment in power in inverse proportion to its speed. Leonardo adds a figure to each element: the turbine is rated at 1,000, its worm 12,000, expressing a 12 to 1 ratio. The worm gear of the left bar has 12 times that, or 144,-000, and the vertical shaft worm 1,728,000. The final and slowest gear-cam unit is shown with the potential power of 20,736,000. Leonardo enunciated the ratio by noting that "the movement of the pinion and the surface of the wheel is as much more rapid than that of its axis as the circumference of the pinion is contained in the circumference of the wheel." [10]

Aware as Leonardo was of the negating effects of friction as well as of the value of ball and roller bearings, the above exercise in the design of a complex system of involved parts is representative of the most advanced practices in mechanisms and of automation. These are exemplified,

[10] MS A, fol. 57r.

respectively, by the one on the left sequence and the other on the right. His novel quantitative analysis of the power ratio holds greater significance than his indicated failure to apply any modifying factors such as the losses of power to friction.

His studies in friction led to his classification of it in three kinds: simple, compound, and irregular. The first was evident in dragging an object over a surface; the second, when the object was moved between two stationary surfaces; the third, as by a wedge between sloping sides.[11] His awareness and solution appear in ". . . which movement becomes more difficult in proportion as the surface is more scoured and rough. And in order to see the truth of this, move said weight upon balls on an absolutely smooth surface. You will see that it will move without effort." [12] His enthusiasm for roller bearings is often shown in his notes; he once called them "marvels of mechanical genius," [13] after observing how a cylinder on rollers continued to revolve even after the applied torque had stopped. To reduce friction at gear contact he designed gear teeth having roller bearings.

In a court where entertainment was as essential as war or administration, the inventive Leonardo built settings and staged surprise effects of great ingenuity. During a visit by the king of France, it is told that Leonardo designed and built an automaton in the shape of a lion which, at the proper moment, opened and poured a shower of lilies from its breast at the feet of the visiting monarch.

If any one characteristic is dominant in a person of so many interests, it is that of supreme independence. His loyalty to his patrons was never so deep that it could not be terminated or even switched when warranted. Not that he was weak or vacillating, he just did not permit such ties to hamper his freedom. Avoiding involvement, he was free to follow the unpopular, the skeptical, the bizarre. This path led to innovation. He was attached to no family, no church, nor permanently to any patron. He painted, sculpted, or engineered as required by each commission, reserving for himself the allocation of time to the project. Lorenzo de' Medici and Leo X were impatient with such independence; Ludovico Sforza and Isabella d'Este were more tolerant. Leonardo had so much to offer that his talents were always in demand. The sixteen-year period he spent in Milan is evidence of the latitude he enjoyed in the Sforza entourage.

On the question of the influence of Leonardo on his contemporaries, scholars have shown that in guiding talented pupils, maintaining studios, executing commissions, and establishing a style among the painters of Lombardy which is even today identified as Leonardesque, he remains one of the greatest artists of all time. As to his influence in the area of machines and inventions, we should not apply the standards of today's rush to publish to the experimenter and mechanician of the early 1500's. Leonardo published nothing in his lifetime, but he ordered many of his notes and papers for ultimate publication. As a line engineer in the services of the duke of Milan and through his appointments to Cesare Borgia and Francis I, his work on canals, in architecture, and in hydraulics brought him in direct contact with some of his technological peers. His exposure to

[11] MS E, fol. 35r.   [12] MS Fors., fol. 86v.   [13] MS I, fol. 57v.

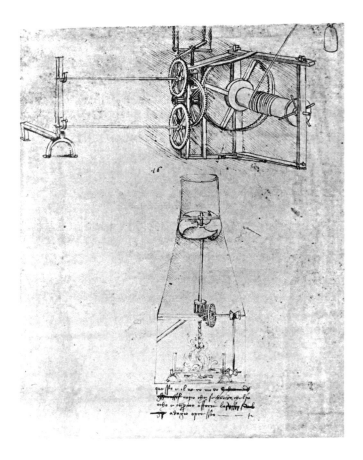

*Figure 4*
Roasting spit. The feathered
mechanized spit, top, rotates
the roast at uniform speed.
The air turbine, bottom, turns
the spit at a speed controlled
by the draft; the hotter the
fire, the faster the roast turns,
assuring more uniform
roasting (C.A., fol. 5*v*).

the active minds of the courtiers and scholars of Florence, Milan, Rome, and Amboise, his exposure to men of action, the movers and shakers of a turbulent age, must have included a marked exchange of ideas and designs.

Leonardo had known and was influenced by the convictions of Paolo Toscanelli on the feasibility of voyaging to "India" by sailing westward. The discipline and rigor of mathematical thought came to Leonardo through his years of contact and common labors with Fra Luca Pacioli, both in Milan and Florence. Leonardo's friendship with Marcantonio della Torre, thirty-one years his junior, helped to develop his anatomical insight. The young anatomist was trained at the famous school of anatomy in Padua, and together they performed dissections and supplemented each other's ideas on the structure and function of the organs of the body. Exchange of ideas in mathematics and crafts was also carried on in Milan with Faxio Cardano, father of the influential mathematician Girolamo, and with Bramante, painter and architect of St. Peter's in Rome. The wide spectrum of intellectual thought that shaped the Italian Renaissance stirred all about Leonardo. From each of the keen minds Leonardo drew the substance of their specialty and these specialties he wove into a pattern of repeating order which later evolved into our basic sciences.

*Figure 5*
Lathe. All the elements of a successful lathe are combined in this small sketch by Leonardo. Treadle operation frees both hands, crank and flywheel assure smooth and continuous rotation. Head- and tailstock center the workpiece (C.A., fol. 381*r*).

Of simple design and practical application was Leonardo's proposal for an automated roasting spit (fig. 4). The fowl was speared on the spit and placed on the bearings of the andirons before the fire. The pulley at the right was connected with the driving pulley over it by a belt. The upper pulley was set on a shaft with a crown gear which engaged a lantern gear. The latter shared a shaft, at the top of which revolved a rotary turbine impelled by the draft of the fire. As the turbine turned, its motion was transmitted by shaft, gear, and pulley to the fowl which turned as it roasted. The fortuitous element in the device was, as Leonardo stated, that "the roast will turn slow or fast depending on whether the fire is small or strong." Other roasters were driven by weights at uniform speeds but Leonardo's design had built in it the advantage that automatically the hotter the fire, the stronger the draft and therefore the faster the roast turned and was more evenly browned.

A significant advance in the history of the oldest and most important machine tool—the lathe —was due to Leonardo, who designed a lathe (fig. 5) which combined the treadle, compound crank, and flywheel. The treadle released both hands for tool manipulation, the compound crank translated reciprocating motion to rotary motion, and the flywheel inertia gave more uniform rotation, especially over points of dead center. Carlo Pedretti[14] dated this device *circa* 1480–1482, and Lynn White[15] records that the oldest extant lathe was that of the emperor Maximilian *circa* 1500. Unlike the older lathe motion induced only by treadle and overhead spring (which was a

[14] C. Pedretti, *Studi Vinciani* (Geneva, 1957).

[15] L. White, *Medieval Technology and Social Change* (Oxford, 1962).

*Figure 6*
Bolt cutter. The two outer precut bolts guide the yoke and cutter in threading the blank center bolt. By changing the gear combinations at the crank the thread pitch is changed (MS G, fol. 70*v*).

reversing action), Leonardo's combination of treadle, crank, and flywheel provided a continually rotating workpiece. The fixed headstock and tailstock, made adjustable by crank and threaded shaft, are clearly indicated.

The famous illustration of the thread-cutting lathe in Besson was published in 1579. Leonardo's simple thread-cutter design is of equal significance and is a century earlier. There were no interchangeable threaded parts in Leonardo's day because each implement and each part of it was fashioned specifically for that unit. The need for uniformity and interchangeability seemed clear to Leonardo, and that he strove for them is shown in the automatic screw-thread machine he designed (fig. 6). He arranged two matching threaded bolts on the outside of his device; one end of each revolved in a bearing, the other end was fastened into a gear. A crank was attached to the center gear. This center gear held the blank rod that was to be threaded similarly to the other two bolts. Straddling all three bolts was the cutter frame. The outer ends of it held threaded nuts that moved on the two outer bolts, the inner part of the frame held the cutter which bore down on the central blank. All that was left to be done was for an unskilled hand to turn the crank and extend

116

*Figure 7*
Reciprocating to rotary
motion. The left view is an
assembly, the right view an
"exploded" mechanism for
changing the rocking motion
of the upright lever to the
rotary motion of the shaft so
as to lift the weight. Note the
pawls on the rims of the discs
set on the heavy square shaft
(C.A., fol. 8*v*).

the cutter tool as the thread metal was cut away. The center bolt would thus match the two similar outer bolts, and so a series of interchangeable bolts was to be created.

A few items of special interest may be noted in Leonardo's sketch. To cut bolts of a different pitch the two outer gears were to have a correspondingly different diameter, such as those to be seen on the floor. Here Leonardo's backward alphabet is clearly seen, a, b, c, d. Also, note that the bolts have a similar pitch because both outer gears turn in the same direction at the same time. Note, too, that only one-half of the blank is threaded.

Several ingenious proposals for converting reciprocating motion to rotary were sketched by Leonardo, but one is outstanding, not only in the novelty of the assembly of elements but in the clarity of its presentation in an "exploded" view of the assembled parts (fig. 7). The assembled mechanism is shown in his sketch at the left. Its three essential units begin with the vertical operating lever at the right which is rocked back and forth so as to raise the stone suspended by a rope, the upper part of which is wound around the horizontal shaft in front. In between these two units can be seen an assembly of gears and plates detailed in their elements at the right. Again, one

117

begins with the right reciprocating lever which imparts its swinging motion to the square shaft. Upon this shaft are fixed two wheels which have pawls set into their perimeters, one facing up, the other down. These pawls engage ratchets fixed into the inner circumferences of two outer rings that rotate on the pawl-bearing discs. The ratchets, like the pawls, face up and down. The opposite sides of the rings are studded with gear teeth and both gear faces engage a common lantern gear that connects with a final shaft. When the initial lever is rocked, one pawl moves one gear, the other remains passive. When the lever moves back, the second pawl grips the gear and turns the shaft, the first becoming passive. No matter which gear is activated, the lantern gear still will be moved counterclockwise, and, as shown, the suspended weight will rise or equivalent work will be done. This mechanism could be used as a windlass, on a hoist, or in the several schemes Leonardo had for automotive vehicles. The process of motion exchange is reversible and provides a practical link between the two most common forms of motion, a welcome means for relieving animal muscle from such tedious work.

An application of this mechanism is indicated by Leonardo in a sketch for a paddle-driven boat that is moved by foot power (fig. 8). We see the ship's hull and the motive paddles. To the deck are hinged two treadles connected by a belt riding over a lantern gear. The teeth of this engage the teeth of a crown gear forming the inner disc of such a translating mechanism. The outer rim is ratcheted and a pawl engages the ratchet; it gives rotary motion to a ring having teeth on its outer rim. The teeth engage a gear on the paddle-wheel shaft. There is a matching mechanism on the ship's port side; the two in combination give the paddle shaft continuous rotary motion as the treadle moves up and down. The germ of the idea is seen rapidly sketched by Leonardo at the right.

The technology of manufacturing improved as the prime movers improved. Water mills were introduced in the later Middle Ages and they provided the power to grind corn, saw lumber, move bellows for hotter fires, which resulted in better metallurgy. Waterpower lifted triphammers and actuated the classic chain of five kinematic elements—the screw, the wheel, the cam, the ratchet, and the pulley. To these were added the crank and, later, the connecting rod. The mechanician of the mid-1400's had a sufficient range of tools to support amply the expanding needs of the explorers, colonizers, and exploiters who coursed the earth's newly revealed surface in the succeeding century. Soon the demand for skilled hands exceeded supply so that the innovator and inventor became then, as today, a much sought-for individual. Expansion of empires raised military needs and this further drained skills for the shops and manors, skills that were to be coaxed out of engines and machines. Leonardo's patrons were usually deep in military emergencies, and the survival of the city-states as well as the guilds depended on competitive economics. Machines improved the competitive edge. Mechanization was in the air. Leonardo was among the very few seer-mechanicians who sensed the future step—automation.

Leonardo's highly developed sense of precision is shown, not only by his attempts to attach numbers to variables that he investigated but also by his interest in instruments that registered

*Figure 8*
Foot-operated paddle boat. An application of the mechanism in fig. 7 to turn the paddles of a ship. The reciprocating action of the treadles is translated into rotary paddle motion (C.A., fol. 344*r*).

and recorded changes. He devised or improved a planetary clock to measure time, a hygrometer to measure the moisture of the atmosphere, an anemometer to register the varying force of the wind, and an odometer to record distance traveled. This need to measure sharpened his realization of the duality of nature's forces—of cause and effect, of pressure and resistance, of gain of moment at the loss of velocity. He phrased it specifically in a famous reference relating to his parachute design: "An object offers as much resistance to the air as the air does to the object." [16]

Leonardo's range of interest and study of mechanisms moved from simple adjustable cutters of prison bars to complex textile-weaving machinery. Theodor Beck in his general history of machinery,[17] published in 1899, illustrates and describes four hundred of Leonardo's devices (Leonardo was one of twenty mechanicians treated in this study). The extent of Leonardo's coverage of technical matters is shown by the 109 pages of notes transcribed and published by MacCurdy on motion, weight, impetus, percussion, and power. To these can be added other hundreds of pages of notes on warfare, flight, hydraulics, mathematics, and optics.[18] We have therefore to limit ourselves to only a very few of Leonardo's mechanisms to illustrate adequately the competence and genius of that pioneer in automation.

[16] C.A., fol. 372*v*.
[17] T. Beck, *Beiträge zur Geschichte des Maschinenbaues* (Berlin, 1899).

[18] E. MacCurdy, *The Notebooks of Leonardo da Vinci* (New York, 1939).

The file and the rasp are among the oldest of man's tools because they represent refinement of his oldest means for shaping wood, stone, or metal. Files are simple and handy, effective and versatile, but difficult to fashion. Leonardo turned his mind to simplifying production procedures in file making, and we here see an automated file cutter (fig. 9). Again, commencing with the source of power, we observe the crank which, when turned, revolves a shaft that sets three separate but coordinated events into motion. Nearest to the crank is a rope which is wound around the shaft; its other end goes over a pulley and a counterweight which, when released, sets the whole mechanism moving automatically. Next on the shaft is a lantern gear engaging a crown gear which revolves a threaded shaft moving within a block holding the file blank fixed by two hasps. Last on the shaft is a sprocket wheel, the prongs of which move a lug set into a small revolving shaft into which the long handle of a hammer is set. The length of the hammer handle is to give a sharp striking impact. The hammerhead ends in an oblique and rather sharp edge so as to drive a deep cut into the file blank. As the weight falls the lantern gear spins, the large gear turns, moving the block and file forward, while the sprocket prongs press on the lug to lift the hammer and let it fall sharply on the file blank, which has been edged forward by the turning threaded shaft. The file grooves and ridges are thus evenly spaced and automatically created. When the weight touches bottom, the hammer is held vertically to free the mechanism, and the weight is then raised by turning the crank. The two hammerheads detailed at the left were to indicate a way to produce crosscuts.

Automata were not new, even in Leonardo's day. In ancient times the need for the miraculous in the practice of certain religious cults had stimulated the design of magical devices that operated in some seemingly spontaneous manner long before such mechanisms found utilitarian application. Some were designed to simulate the motion of celestial bodies in their daily and extended rotations. In the 1300's clockwork for showing such astronomical motion, important feast days, and the time of day appeared in cathedral areas and at major town halls. To the astronomic and chronometric functions of the great clocks of Padua, Strasbourg, and Prague were added animated figures of saints, cocks, and angels. Further refinement of such parts produced mathematical and musical automata that were programmed by revolving drums, cams, and gears. The road broadened from Leonardo and his contemporaries through Pascal, Leibnitz, and Babbage into the age of computers and the introduction of electronic and transistor cybernetics. Helmholtz, in the middle of the last century, however, perceived in his own time the failure of attempts to endow automata with even some part of complex human behavior. Instead, he foresaw in the development of the machine a means of executing repetitively a single action endlessly and tirelessly, the work formerly done by thousands of human hands.

We have gleaned from the surviving pages Leonardo's designs and experimental approach to a wide variety of machines and devices, ingenious, novel, and, for his time, efficient. While some of the mechanisms show the work of earlier technicians, the majority are Leonardesque in their direct and bold solutions to the needs of the industry of his day. In his probing for a solution to

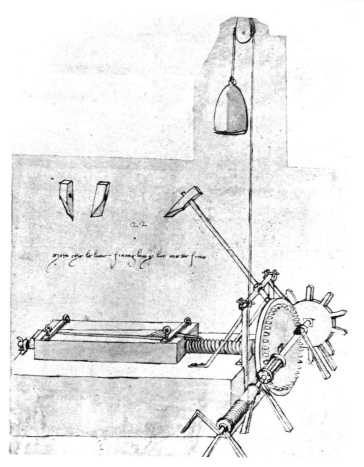

*Figure 9*
Automatic file maker. The
crank raises the weight and
readies the machine. When
released, the sprocket lifts and
drops the hammer on the file
blank as the bolt moves the
carriage and spaces the file
grooves evenly (C.A., fol. *6r*).

mechanical flight he was centuries ahead of the mechanics of his time. As an artist he left us the
Mona Lisa, the most famous of secular paintings, and the Last Supper, unmatched as a religious
composition. Outbalancing these supreme accomplishments in art are his devices for industry and
the crafts which have set new standards of inventive and mechanical genius.

Of the dozen elaborate machines that Leonardo designed for the textile industry one is rep-
resentative of his inventive approach. It is a flyer spindle (fig. 10). This is intended to wind a spun
thread evenly and automatically upon a rotating bobbin. Examining Leonardo's excellent draw-
ing, we begin with the operating crank. The crank turns the main wheel which carries a cord to
revolve a wheel riding on a rectangular shaft that turns the flyer spindle. The second main wheel
also has a cord for revolving the bobbin, but in counterrotation. We now examine the mechanism
for moving the shuttle back and forth as it winds the thread upon the bobbin. At the left of the
crankshaft is a worm gear that meshes with the larger spur gear having on its near face a semicircle
of teeth. This arc of teeth actuates the top lantern gear as it goes by, causing it to spin in one

121

direction. On the same vertical shaft is another lantern gear that spins in the opposite direction as the arc of teeth engages it. A rod protrudes on the common shaft ending in a fork that straddles a spool at the left of the shaft. This shaft extends through the several flyer and bobbin belt wheels and ends in the flyer from which the thread is distributed upon the bobbin. At the top left, Leonardo details the gear and lantern assembly that imparts the rocking motion to the thread guide. By the addition of a foot treadle to the crank both hands of the spinner were freed and the worker could be seated at the task.

There is little history and no theology or romance in the records that Leonardo left us, but much of reality in a world of sight and sound, of nature and thought. He was little concerned with the "why" of affairs but much with their "how." A machine to Leonardo was less a device to do a required task and more a means to demonstrate some mechanical principle or to extend man's limited abilities. Who among his contemporaries was ready to undertake flight by relying on his own devices? Yet he faced the question, can flight be made practicable? In his mind the sequence of order was to build from the specific to the general, from the device to the controlling law. Analysis, synthesis, abstraction, formulation, was the intuitive procedure of his mind. The soundness of his devices and the clarity of their rendering as working drawings have been unmatched in the history of technology. Having had no formal education, he was equally free of the preconceptions, prejudices, and the misinformation that had been drilled into the minds of so many of his contemporaries. He remained a nonconformist with few inhibitions to dampen a deep and rational curiosity about the world that surrounded him.

With the throbbing vitality of Florence of the Medici or of Milan of the Sforza it should not be surprising that in the five thousand extant manuscript pages of Leonardo one finds only half a dozen references to Vitruvius and Archimedes. Leonardo turned little to "authorities" and did so only for information, never for judgment. His tragedy was that, although he had so much to offer, by his failure to publish his own ideas and discoveries he did too little to influence the trend of scientific events in the four succeeding centuries after his death. To this might be added his failure to grasp the full significance of the voyages of discovery of his time: Amerigo Vespucci was a fellow Florentine only a year younger than Leonardo. In spite of his wide circle of contacts, Leonardo was essentially one who shared little with his contemporaries and his process of note keeping with its reversed script was a fortuitous asset. His notes were mainly memoranda to himself and his failure to publish probably held deep roots of distrust and misgiving.

The political instability in Milan which marked the end of the century found Leonardo leaving his adopted city and, in the company of Fra Luca Pacioli, returning to Florence, with a short stopover in Venice. His return to Florence after an absence of eighteen years was not a triumphant one: old friends were gone, the new stars in the firmament of art were reserved in their welcome; some, like Michelangelo, were openly hostile. The Medici had been banished, and the glow of the fire that had consumed Savonarola and the bonfire of the "vanities of the arts" had lingered on. The French conquerors were gone and the sinister presence of Cesare Borgia was beginning to be

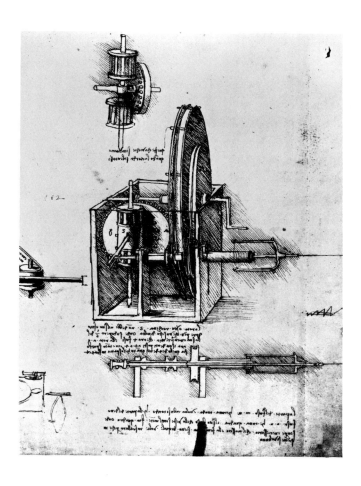

*Figure 10*
Flyer spindle. For
winding a thread
evenly upon a
bobbin. The crank
turns bobbin and
flyer in opposite
directions as the
mechanism at the left
(and above) moves
the flyer back
and forth
(C.A., fol. 393*v*).

felt. Cesare commissioned Leonardo as engineer general and commanded all the officials, civil and military, "to further any understanding he may find necessary." For a year Leonardo was concerned with problems of drainage, topography, geology, and canal construction. For the next dozen years his life was a restless one, changing as the political scenes of the northern cities of Italy changed. He returned to Florence where painting and scientific subjects shared his time. He then journeyed to Milan while the French still occupied the city, but here also political instability cut his stay to only a few years. He tried Rome but found unpleasant the carnival atmosphere of the reborn metropolis and the papal court's neglect of him. Leonardo's final journey took place in 1516 when he rode over the Alps in the entourage of Francis I, king of France, victorious over the forces of the pope and those of Milan. At St. Cloux, near Amboise, Leonardo made his final studies in architecture, canalization, and the sciences. There he died peacefully, on May 2, 1519.

*Figure 1*
Piero della Francesca. Madonna
and Child. Milan, Brera.

# Leonardo and Bramante: Genius in Architecture

## by LUDWIG H. HEYDENREICH

For eighteen years—from 1482 to 1499—Leonardo lived and worked in the service of the Sforza at Milan together with Donato Bramante, the greatest builder of his time.[1] We may say without exaggeration that in this period of contact between these two men of genius there matured some of the fundamental principles of what we call the classic phase of Renaissance Architecture.

In order to understand better the significance of the historical situation, let us try first to gain a general judgement of these two eminent figures in their approach to the art of building. Both had in common that they were from Central Italy. Leonardo came from Florence where during his years of apprenticeship the most famous monuments of Brunelleschi and Alberti were still in course of completion—the churches of S. Spirito and SS. Annunziata, the façade of S. Maria Novella, and the colossal cube of the Palazzo Pitti;[2] as a co-worker in Verrocchio's *bottega* Leonardo was present when his master set the golden ball on the top of the lantern of the Cathedral.[3] From his youth interested in all problems of the *Ars edificatoria*,[4] Leonardo had also a considerable knowledge of architectural practice and engineering;[5] so he felt able, as he puts it in

[1] Cf. F. Malguzzi-Valeri, *La Corte di Ludovico il Moro,* II: *Bramante e Leonardo* (Milan, 1915); L. H. Heydenreich, *Die Sakralbaustudien Leonardo da Vinci's* (Leipzig, 1929); C. Baroni, "Leonardo da Vinci ingegnere militare," in *Rendiconti Ist. Lombardo Scien. Lett.* (1937); J. P. Richter, *The Literary Works of Leonardo da Vinci,* II (2d ed.; London, 1939), 19–82; and O. H. Foerster, *Bramante* (Wien-München, 1956), p. 136.

[2] Leonardo stayed in Florence from *ca.* 1468 until 1482. For the state of the churches S. Spirito, S. Maria Novella, and SS. Annunziata within these years, see W. and E. Paatz, *Die Kirchen von Florenz,* I, III, V (Frankfurt, 1940–1953); for the Palazzo Pitti, K. A.

Busse, "Der Palazzo Pitti," in *Jahrbuch der Preussischen Kunstsammlungen* (1930), 51:110 ff.

[3] Cf. L. H. Heydenreich, "Spaetwerke Brunelleschi's," in *Jahrbuch der Preussischen Kunstsammlungen* (1931), 52:28.

[4] There are early sketches by Leonardo from the Florentine cathedral (C.A., fol. 17*v, a*), S. Maria degli Angeli, and S. Spirito (MS B, fol. 11*v*). Cf. Heydenreich, *Sakralbaustudien,* pp. 14, 17, 45.

[5] Cf. the recent, most illuminating study of L. Reti, *Tracce dei progetti perduti di Filippo Brunelleschi nel Codice Atlantico di Leonardo da· Vinci,* IV, *Lettura Vinciana, 1964* (Florence, 1965); and G. Calvi, *I manoscritti di Leonardo. . . .* (Bologna, 1925), pp. 36 ff.

his letter to the duke of Milan, "to satisfy in times of peace in the best way and in competition with anybody in the art of architecture, in designing public and private buildings, and in conducting water from one place to another." [6]

Bramante came from Urbino where he had learned his profession from the great masters of the palazzo ducale,[7] Laurana, Francesco di Giorgio, and—it is my personal conviction—to a large degree also from Piero della Francesca, the true creator of the *grandi forme* in painting and architecture:[8] the background of his altar-piece for S. Bernardino in Urbino is the anticipation of the classic style (fig. 1). Bramante had an extensive education at the court of Federigo da Montefeltro, and it is even probable that he met there Leone Battista Alberti, the close friend— "famigliare dilettissimo"—of the duke.[9] The small Cappella del Perdono, the private chapel of Federigo, a jewel of decorative architecture, might have been one of the first works of the young Bramante [10] (figs. 2 and 3).

On his way to Milan Bramante must have passed Mantua, where he saw the great designs of Alberti's churches, S. Sebastian and S. Andrea, and where he came in contact not only with Luca Fancelli but also with Andrea Mantegna.[11]

For both artists—Leonardo and Bramante—going to the north, the late Gothic scenery of Milan and Lombardy was entirely new and unfamiliar. Yet it was fascinating in its wealth of architectural structures and its pronounced taste for sumptuous ornamentation, which characterized, too, the somewhat unbridled decorative style of the first monuments of the early Renaissance as, for instance, the interior of the Portinari Chapel of S. Eustorgio and the Colleoni Chapel in Bergamo.[12] On the other hand, however, there were the solemn and dignified monuments of the romanesque period—S. Ambrogio, S. Eustorgio, or other churches in Monza and Pavia—which with their harmonic proportion of forms and spaces and, in particular, with their admirable per-

[6] For the letter, cf. Calvi, *op. cit.,* pp. 65 ff.

[7] For the biographical data of Bramante, see Foerster, *op. cit.,* pp. 20 ff.

[8] Cf. M. Salmi, *Piero della Francesca e il Palazzo Ducale di Urbino* (Florence, 1945).

[9] On L. B. Alberti's relations to the duke of Urbino, see G. Mancini, *L. B. Alberti* (2d ed.; Florence, 1911), p. 479. In a letter to Cristoforo Landino, written 1475, Federigo reminds us of his friendship with the great artist-humanist: "Nihil fuit familiarius neque amantius amicitia qua Battista et ego eramus conjuncti"; cf. *Federigo da Montefeltro. Lettere di Stato e d'Arte* (Rome, 1949), p. 102, no. 87.

[10] Cf. P. Rotondi, *Il Palazzo Ducale di Urbino,* I (Urbino, 1950), 357 ff.; and Foerster, *op. cit.,* pp. 70 ff. When Leonardo visited Urbino in 1502, he drew a small sketch of the chapel in his note-book (MS L, fols. 73*v*–74*r*); probably he regarded it as one of the works of Bramante which he intended to list as we may deduce from the words "edifici di Bramante" on the

cover of the same note-book. See C. Pedretti, "La Cappella del Perdono," in *Raccolta Vinciana* (1964), 20:263 ff.

[11] Mantegna was the chief counsellor of the Marquis of Mantua, Ludovico Gonzaga, in all questions of art, as was Piero della Francesca at the court of Urbino. Cf. P. Kristeller, *Mantegna* (Berlin-Leipzig, 1902), pp. 190 ff. Mantegna's advice was also frequently asked in matters of architecture; and C. Cotta-Fava, "Nuovi documenti," in *Atti e Memorie R. Accademia Virgiliana di Mantova* (1939), 25:197 ff. For Mantegna as architect, cf. G. Fiocco, "La casa di Mantegna," in *Rivista d'Arte* (1929), 11:291 ff.; Mantova, in *Le Arti* (1961), 2(1):141 ff.

[12] A good survey is offered in the corresponding chapters in the *Storia di Milano* (1955–1956), VI, v, 611; VII, v, 601 ff. Cf. also J. Ackerman, "The Certosa of Pavia," in *Marsyas* (1950), 5:23 f., and "Ars sine scientia nihil est," in *Art Bulletin* (1949), 21:84.

*Figure 2*
Bramante. Cappella del
Perdono.

fection of vaulting, must have corresponded also to the severe standards of the two men from
Central Italy.[13] But first of all there was one experience of highest significance for both of them,
the confrontation with the huge monuments of late Roman Byzantine tradition—S. Lorenzo,
S. Simpliciano, S. Satiro, and, as a later descendant, S. Sepolcro (fig. 4).

The contact with this thesaurus of forms and motifs in their new environment must have been
the subject of continuous discussions and exchanges between Leonardo and Bramante in so far
as both felt inspired in regard to their own artistic endeavours and aims. Both had equal interests,
but a different approach to the architectural problems of their time: Bramante was the great

[13] The great esteem for the monuments of the Ro-
manesque period can be observed everywhere in Italian
Quattrocento architecture; they were valued as the last
survival of the antique practice of building and largely
used as models for the new style, not only in Tuscany
but also in Venice and Lombardy.

127

*Figure 3*
Bramante.
Sketches of details.

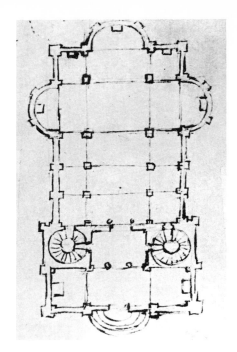

*Figure 4*
Leonardo. Plan of
S. Sepolcro, Milan.

"moulder," the efficient performer of works, while Leonardo was the reflective mind, who grasped every phenomenon under mere abstract aspects. So practice and theory completed each other in the thought of the two artists, and we may try now to examine in detail how this co-operation worked out and what results it produced.[14]

Bramante was eight years older than Leonardo, the one being at the end, the other at the beginning, of his thirties when they met (about 1482). Certainly Leonardo felt a great esteem for Bramante, who had already spent two years in Milan and was then working on the church of S. Maria presso S. Satiro, a fascinating project for Leonardo because it showed that feature of genius which made obvious to him the masterliness of his senior companion [15] (figs. 5–8).

Between 1479 and 1481 there had been built, as an addition to the little pre-Roman, centralized church of S. Satiro, an oratory in honour of a miracle-working picture of the madonna: S. Maria presso S. Satiro. Bramante was the architect; essentially his plan was nothing less than a very intelligent amplification of the scheme of Brunelleschi's Pazzi Chapel, a rectangular hall formed of a central, domed square with barrel-vaulted bays to left and right. Thus an impressive

[14] There are some documents that refer directly to this co-operation. Both artists are quoted as "ingenarii et pictores ducali" in a contemporary list of employees of the court. Cf. L. Beltrami, *Documenti,* no. 66; see also C. Baroni, *Leonardo ingegnere militare, loc. cit.* Their contact is furthermore proved during the competition for the *tiburio* of Milan Cathedral (see below) and in connection with their judgements on the model of the Cathedral of Pavia (1490). They must have attended together, too, the academic meetings mentioned by Luca Pacioli in the foreword of his *Divina Proportione.* Cf. L. Beltrami, *Documenti,* no. 82.

[15] For the dates of S. Maria presso S. Satiro, see *Storia di Milano,* VII, 641 ff.; Baroni, *Bramante,* pp. 21 ff.; and Foerster, *Bramante,* pp. 90 ff.

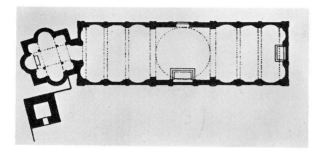
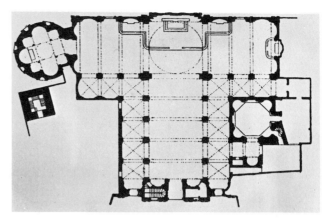

Figures 5, a and b
S. Maria presso S. Satiro,
original and amplified plans.

spatial composition came about which is dominated by the contrast between the central dome and the two equal barrel-vaulted arms. The monumentality of the interior is enhanced by a simple yet consciously studied articulation of the walls; the row of shell-hooded niches along the walls—a very brilliant variant of the flat niches in the choir of the Sagrestia Vecchia and the series of chapels in S. Spirito, Florence—is Albertian in its simplicity; the great shells recall the niches of S. Marco in Rome, the splendid coffered barrel-vault S. Andrea in Mantua. The space thus created is of great and distinctive beauty; on one narrow side it leads into the little sanctuary of S. Satiro (fig. 5a).

While the oratory was being built the idea arose of enlarging the church into a basilica. In 1482, after the necessary area had been purchased,[16] the new project was begun. The change of plan was unusual and bold; what had been the oratory became the transept of a church with a very short nave and aisles; consequently the façade was turned to the south and the new choir to the north. The amplified church was almost finished in 1486, because in that year Amadeo was put in charge of the execution of the façade under Bramante's supervision [17] (fig. 5b).

The present interior of S. Maria presso S. Satiro was very much disfigured by the later raising of the floor and the utter neglect of the walls and vaulting. Yet the grandeur of the initial conception can still be felt at first sight. The prevailing impression is the horizontal spread; the weighty barrel-vault spans a broad, short nave; the massive pillars with their attached pilasters look almost like walls, so that the dark, low aisles hardly appear in the general spatial effect. What dominates the whole is the hall of the nave, and thus even here, in a formal idiom deriving from Alberti and Piero, a constant feature of Lombard architecture is retained: its broad and comparatively low proportions (figs. 6 and 8).

[16] Bramante's signature appears as one of the witnesses on the document of purchase; cf. Foerster, *op. cit.*, p. 90.

[17] Cf. Foerster, *op. cit.*, p. 91; however, only the plinth of the façade was built: the rest was not completed until 1871.

*Figure 6*
S. Maria presso
S. Satiro, interior.

The quiet terra-cotta ornament harmonizes with the simple structural elements of the pillars and pilasters; the capitals are richly varied, even to figured composite formations. One remarkable detail, to my mind, is the seven flutings that Bramante has given pilasters, another Albertian motif.[18]

Bramante's stimulating invention culminated in the famous illusionistic chancel. The exigencies of the site left no room for a choir in the church, and thus the first example of Renaissance illusionistic architecture came into being.[19] From the entrance to the church—the station point—the observer imagines he sees a fully developed rectangular chancel as part of the structural system of the nave; its barrel-vault seems to prolong the vault of the nave beyond the dome. The principle of a scenic illusion to be obtained from a definite station point has been carried out with perfect consistency. True, the rules of perspective had been applied now and then in architecture before; the best-known examples are Rossellino's lay-out of the Piazza of Pienza and the disposi-

[18] About the unusual motif of pilasters with seven flutings, cf. L. H. Heydenreich, "Die Cappella Rucellai von S. Pancrazio in Florenz," in *De Artibus Opuscula XL. Essays in Honor of Erwin Panofsky* (New York, 1961), p. 226.

[19] Cf. H. Kauffmann, "Ueber Rinascere, rinascità und einige Stilmerkmale der Quattrocentobaukunst," in *Concorida Decennalis. Festschrift der Universität Köln* (Köln, 1941), pp. 141 f. and *Storia di Milano,* VII, 643 ff.

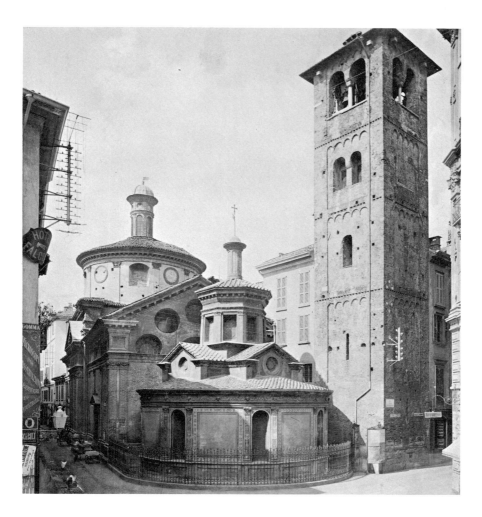

*Figure 7*
S. Maria presso
S. Satiro, exterior.

tion of the court-yard in Urbino.[20] Illusionistic interiors, on the other hand, were rather usual as background in relief sculpture [21] and in the art of intarsia.[22] But to transpose this principle to real architecture by creating a wholly feigned part of a building was an entirely new and very bold idea. The rich and yet restrained decoration underlines the simple greatness of the spatial structure.

[20] E. Carli, *Pienza* (Pienza, 1966), pp. 45 f.; L. H. Heydenreich, "Pius II. als Bauherr von Pienza," in *Zeitschrift für Kunstgeschichte,* 1937, 6:105 ff. and G. Marchini, "Il Palazzo di Urbino," in *Rinascimento,* 1958, 9:43 ff.

[21] For instance, Donatello's relief at Padua: The Miracle of the Ass in Rimini; cf. H. W. Janson, *The*

*Sculpture of Donatello* (Princeton, 1957), I, pl. 296; also, Kauffmann, *op. cit.,* p. 141.

[22] See the brilliant essay of A. Chastel, "Marqueterie et Perspective au XVe Siècle," in *Revue des Arts,* 1953, 3:141 ff., and his *Italie 1460–1500, Renaissance Méridionale* (Paris, 1965), pp. 245 ff.

*Figure 8*
S. Maria presso
S. Satiro, interior.

The exterior, too, is of great beauty. The new facing of the small pre-Romanesque building of S. Satiro is a masterpiece of Quattrocento restoration; every detail speaks of the intuitive reverence that Bramante felt for this monument of the past (fig. 7).

No reproduction can render the simple dignity of the choir front on the Via Falcone. Here, for the first time, a classical language of form was found for brickwork; it was based on the application of simple but carefully calculated proportions and groupings. The treatment of the wall surface with its panels sunk between the pilasters is of great refinement, and the attic zone is beautifully enlivened by its moulded frames which vary in size according to the structure of the

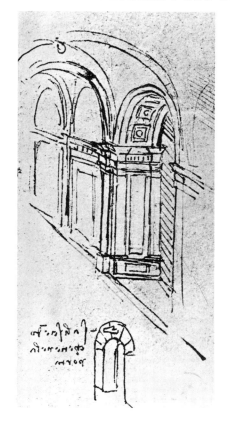

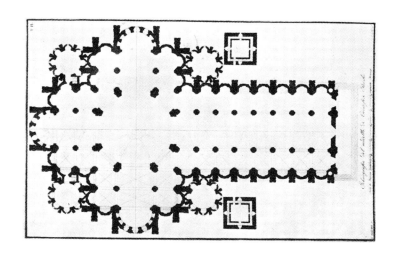

*Figure 10*
Plan of Cathedral of Pavia.

*Figure 9*
Leonardo. Drawing of
vaulted wall. MS B, fol. 15r.

wall below them. In the zone of the pediment and architrave
the quiet and delicate ornament reflects the spirit of Urbino.

Though the church of S. Maria presso S. Satiro is small, both its interior and exterior have a
monumentality that is achieved solely by the purity of their constituent elements. In this, his
first work, Bramante already gave evidence of his perfect mastery of his art, which is further
confirmed by his magisterial solution of the very complex architectural problem it presented.

We do not know of any direct reaction of Leonardo in respect to this masterpiece of Bramante,
and so it seems rather audacious to suggest that Leonardo—as a passionate theorist in perspective
and an expert in the art of relief sculpture, too—might have had perhaps some share in the elabo-
ration of the feigned choir.[23]

In any case, a small drawing of a vaulted wall in the MS B (fig. 9) proves with its mere Bra-
mantesque elements that Leonardo understood and appreciated his new forms of simple articula-
tion.[24]

[23] Cf. Leonardo's remarks on the sculpture in relief
in the Proemium to his Treatise on Painting, ed.
Ludwig, nos. 37, 40, 42.
[24] MS B, fol. 15r (Richter, *op. cit.,* II, Pl. XCIII).
The drawing, once erroneously brought into connec-

tion with the atrium of S. Maria alla Fontana (built
after 1507 and certainly not from a design of Leo-
nardo!), belongs to the first Milanese period of Leo-
nardo.

*Figure 11*
Cathedral of Milan.
Exterior.

In 1487 Bramante was summoned to Pavia in order to give his judgement about the model for the new cathedral that Cardinal Ascanio Sforza, the brother of Ludovico il Moro, intended to build.[25] The minutes of the meeting speak of a "plan prepared in the last few days," so that considerable alterations to the original design may be taken for granted. Yet it seems doubtful to me that we can recognize the hand of Bramante in the building as it was erected and in the surviving model. Cardinal Ascanio Sforza was an ambitious patron. It looks as if he wished—after having rejected a first design that was based on the Hagia Sofia in Constantinople—to see united in his cathedral the best of all architectural ideas that had been tried out in the most important buildings of the recent past. The huge octagonal domes that had been built at Florence, Bologna, Siena, and finally at Loreto, with the object of enriching the basilican plan with a dominating central motif, were prototypes for the cathedral of Pavia just as much as the elaborate naves with chapels which were to be seen in S. Spirito in Florence or at Loreto. It is obvious that the great theme of the centralized basilica was to appear in its most modern variation; the ground-plan of the model shows clearly how abstract and intellectual the conception actually was; the corner sacristies make the plan look like a piece of geometrical ornament (fig. 10).

It will probably never be possible to estimate the extent of Bramante's share in this peculiar

---

[25] For the Cathedral of Pavia, see *Storia di Milano,* VII, 642 ff., with quotation of all documents; F. Gianani, *Il Duomo di Pavia* (Pavia, 1930); Baroni, *Bramante,* p. 53; and G. Panazza, *Leonardo da Vinci a Pavia* (Pavia, 1952), p. 67.

*Figure 12*
Brunelleschi's dome,
Cathedral of Florence.

plan. When Leonardo and Francesco di Giorgio Martini were also invited to Pavia in 1490 as advisers, a model (by Cristoforo Rocchi) was already in existence; it subsequently underwent many alterations, but they were probably restricted to details of form or proportion; as a whole the plan bears all the marks of a basic idea which was consistently adhered to in the execution. Bramante's influence on the project may perhaps be recognized in the severe and simple forms which distinguish the mighty substructures of the crypt and the lowest storey of the exterior. In comparison with the complicated structure of the model, they bear the mark of moderation and of restriction to simpler structural units. The idea of a composite, centralized, and basilican plan probably corresponded very largely to Bramante's conception of an ideal architecture. A reflection of the intense preoccupation with new forms of religious building of the time can be seen in Leonardo's architectural drawings, which will shortly be discussed. But before doing so, we have to mention another architectural commission that brought Leonardo and Bramante in direct connection.

Between 1487 and 1490 there took place the great competition for the dome of the cathedral of Milan, and we know from the documents of the *Opera del duomo* that Leonardo intended to participate.[26] He was paid for a model in 1487, which he soon withdrew, however, in order to make

[26] Cf. C. Boito, *Il Duomo di Milano* (Milan, 1889), pp. 227 ff. L. H. Heydenreich, *Sakralbaustudien,* pp. 25 ff. and L. Beltrami, *Leonardo da Vinci negli Studi per il Tiburio della Cattedrale di Milano* (Milan, 1903).

135

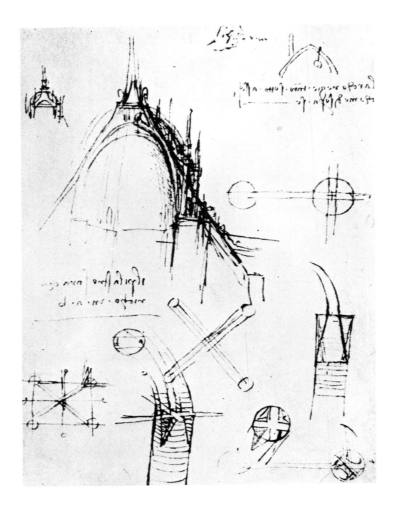

*Figure 13*
Leonardo. Design for cupola
for Milan Cathedral.
Codex Trivulziano, fol. 22*v.*

some corrections. He worked on a new design, but at the end (1490) he retreated suddenly and definitively from the competition, so that his second model was never presented to the jury. Let us look for a reasonable explanation of this somehow surprising decision.

In the case of the dome of the Milan cathedral it was a question of finding a way to cover the crossing of the colossal late Gothic structure, fitting organically into the Gothic pier-system and at the same time harmonizing with the rich decoration of the interior and the exterior.

The solution that was found and carried through after long and intensive discussions shows that the *Opera* decided to choose a construction that would be suitable to the Gothic body of the church: the *tiburio* as it was built is nothing else but the transformation of the usual medieval

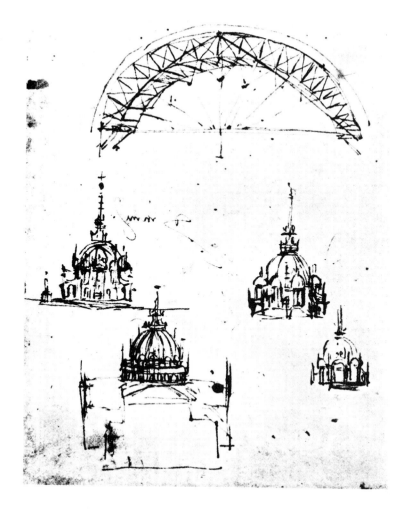

*Figure 14*
Leonardo. Design for
cupola. Codex Atlanticus,
fol. *266r.*

Lombard crossing-tower into late Gothic forms (fig. 11). Now, it is very interesting indeed to learn that the *Opera* with that decision followed the advice of Donato Bramante.

Bramante was the chairman of the jury and his written report on all presented models has been preserved.[27] His main demand was that, besides the firmness of the construction, the conformity (*conformità*) of the building should be maintained. In other words, he applied the ancient Vitruvian canon to this Gothic construction; hence Bramante voted—a very illuminating proof

---

[27] Cf. *Annali della Fabbrica del Duomo di Milano* (Milan, 1877–1855), III, 62 and Heydenreich, *Sakralbaustudien,* pp. 26 f.

*Figure 15*
Leonardo. Sketch of
a centralized church.
MS B, fol. 18*v*.

*Figure 17*
Leonardo. Design for bridge
over the Bosporus.
MS L, fol. 60*v*.

*Figure 16*
Medal (1505) commemorating
Bramante's first design for
St. Peter's.

of consequent Renaissance reasoning—for a *tiburio* in Gothic style, which in principle corresponded to the existing form.

Now Leonardo's idea in regard to the *tiburio*, as we see from his numerous sketches, was quite different: he planned a real cupola in the Tuscan style, based on Brunelleschi's majestic dome of Florence (fig. 12). From the technical point of view, his design was a very ingenious invention of a double-shelled construction, but it did not make the least concession to the Gothic body of the building [28] (figs. 13 and 14).

[28] Heydenreich, *Leonardo da Vinci,* p. 87.

138

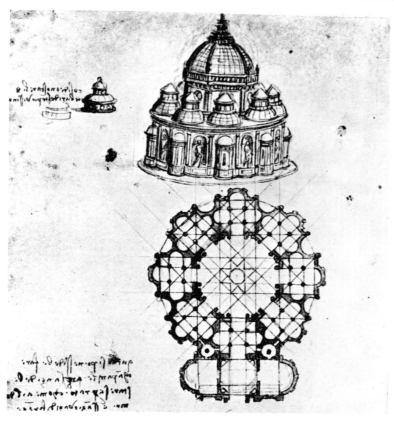

*Figure 18*
Architectural designs.
MS 2037, fol. 5v.

I suppose that it was Bramante himself who persuaded Leonardo to withdraw his model which, despite its extraordinary qualities, contradicted in every regard the principle of *conformità*. But likewise I am convinced that Leonardo's designs of domes as such must have interested Bramante greatly and provided the germ for his own future thoughts about this great theme.

If we look at the dome of an ideal plan of Leonardo for a centralized church, drawn in the 1490's (fig. 15), we realize how much it resembles Bramante's future design of his first project for St. Peter's—as it is preserved in the famous medal of 1505[29] (fig. 16).

And so we arrive at the essential point of our question—the examination of Leonardo's architectural studies as a whole under the particular aspect of their relation to Bramante.

Leonardo studied architecture all his life; he never built anything, yet his wide experience and

[29] Leonardo's drawings: MS B, 18v (Richter, *op. cit.*, II, Pl. LXXXVII, 2). For Caradosso's medal of St. Peter's, see Foerster, *op. cit.*, pp. 228, 237.

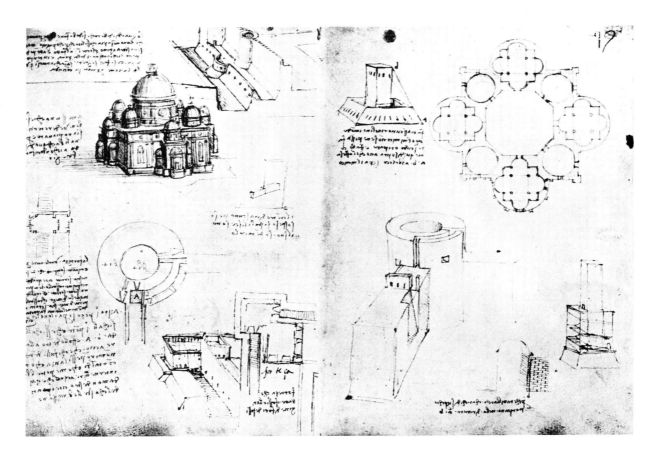

*Figure 19*
Architectural designs.
MS B, fols. 18*v*-19*r*.

knowledge of the subject brought him great fame. For lack of space I can just mention the most important dates.[30] He was often called as an expert. His advice was sought for the rebuilding of Pavia Cathedral (1490) and for damages in the fabric of S. Francesco al Monte in Florence (1500). In 1502 Cesare Borgia appointed him chief-surveyor (i.e., in architecture and engineering) for his territory, the Romagna; at that time he also designed a gigantic bridge over the Bosporus for Sultan Bajazid II [31] (fig. 17). In 1506 the lord-lieutenant of the king of France, Charles d'Amboise, put him in charge of the design for his residential villa at Milan, including a large garden: we owe to Carlo Pedretti knowledge of the precise location of this projected palace and its general lay-

[30] For more complete information, see L. H. Heyden-reich, *Leonardo Architetto* (Florence, 1962), pp. 5 ff.; L. Firpo, *Leonardo Architetto e Urbanista* (Turin, 1963), *passim;* and C. Pedretti, *A Chronology of Leonardo da Vinci's Architectural Studies after 1500* (Geneva, 1962).

[31] Cf. F. Babinger and L. H. Heydenreich, *Vier Bauvorschläge Lionardo da Vinci's an Sultan Bajadiz II* (Göttingen, 1952); and F. Stuessi, "Leonardo da Vinci's Entwurf für eine Brücke über das Goldene Horn," in *Schweizerische Bauzeitung* (Zürich, 1953), 8:21.2.

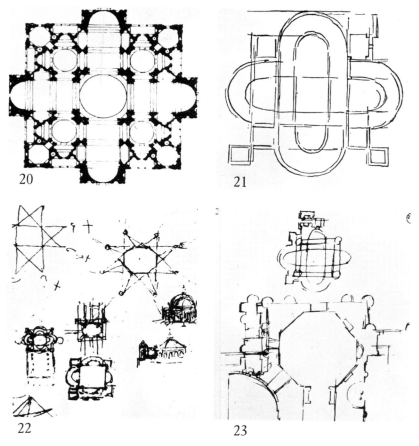

*Figures 20–23*
Bramante's first plans
for St. Peter's.

out.[32] Pedretti has also presented evidence to suggest that Leonardo created designs for the villa of Francesco Melzi in Vaprio d'Adda.[33] In Rome Leonardo studied antique monuments and sites such as the Roman harbour of Civitavecchia;[34] for the Medici he worked on a project for the enlargement of the family palace at Florence, another discovery of Pedretti,[35] to which I shall return. And at the end of his life, in France, he was occupied with the design of a great palace that was to have been built for Francis I's mother at Romorantin.[36] None of these projects was ever

[32] Cf. Pedretti, *A Chronology*, pp. 37 ff. C. Pedretti, "Il Neron di Sancto Andrea," in *Raccolta Vinciana* (1960), 18:65 ff. See also *Raccolta Vinciana* (1965), 20:408 ff.

[33] Cf. Pedretti, *A Chronology*, pp. 66 ff., and his "Leonardo da Vinci e la Villa Melzi a Vaprio," in *L'Arte* (1963), 62:229 ff.

[34] L. H. Heydenreich, "Studi Archeologici di Leonardo a Civitavecchia," in *Raccolta Vinciana* (1934),

14:39 ff.; and Pedretti, *A Chronology*, pp. 84 ff.

[35] *Ibid.*, pp. 112 ff.

[36] L. H. Heydenreich, "Leonardo da Vinci Architect of Frances I," in *Burlington Magazine* (1952), 94:282 ff.; and Pedretti, *A Chronology*, pp. 139 ff. In a book of forthcoming publication Pedretti shows that remains of the foundations of the Leonardo construction are still visible in the park of the old chateau, west of Romorantin.

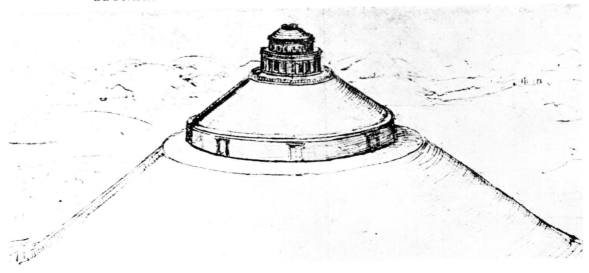

*Figure 24*
Design for a mausoleum.

realized and so there is no building which we can confidently regard as Leonardo's own work.

On the other hand his sketch-books and single sheets abound in architectural drawings from every period of his life, and many reasons suggest that Leonardo had the intention of combining these studies in a kind of treatise on architecture, which in its reconstructible parts shows that it would have been a mere pattern-book with a maximum of drawings and a minimum of words [37] (figs. 18 and 19). The thus collected material of ideal plans for central and basilical churches presents a complete schedule of all possible space-combinations—a collection of architectural types which could hardly be more characteristic and more instructive.[38] They reflect exactly and extensively the ideas and problems that he had in common with Bramante; they display the endeavours to transform the rich and complex forms of the medieval buildings in Lombardy into new, more coherent, and rational organisms by means of his own Tuscan feeling for clarity and structural logic. Not one drawing of Bramante's Milanese period has been preserved, and so Leonardo's studies may serve us as testimonials, too, for the way of development that led Bramante from his Milanese works to his *ultima maniera*, in which—with St. Peter's as well as his other buildings in Rome—he set the standards for all architecture in the classic style for centuries to come.

[37] Leonardo's architectural drawings are of the utmost value because the essential forms of orthographic and perspective projections of the Renaissance were laid down for the first time. In addition to the various types of ground-plan diagrams, they illustrate the various manners of perspective rendering of interiors and exteriors down to the section and perspective. Cf. Heydenreich, *Leonardo Architetto,* pp. 10 ff.

[38] Cf. L. H. Heydenreich, "Considerazioni intorno a recenti ricerche su Leonardo da Vinci," in *Rinascita* (1942), 5:167 ff.

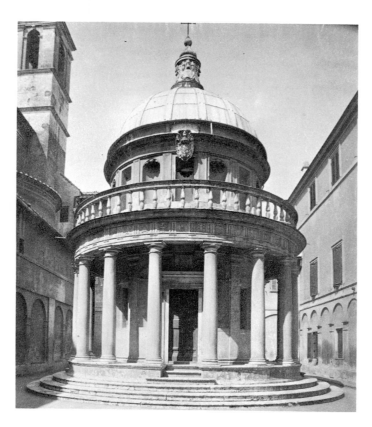

*Figure 25*
Tempietto di S. Pietro,
Montorio.

Bramante's first plan for St. Peter's was still largely based on the experience he had gained in Milan [39] (figs. 20–23). Its richly ornamental composition was essentially a derivation of the spatial system of S. Lorenzo, transposed into the rationalized structure of the Tuscan school. Leonardo's studies—pillar-constructions in the type of Brunelleschi's S. Maria degli Angeli on the one hand and the variations of the plan of S. Lorenzo in Milan on the other—demonstrate this transformation almost completely (fig. 22).

Bramante's "parchment plan" is more or less a kind of abstract ideal scheme without any relevance to its practical execution; the pillars are far too thin to guarantee the stability of this gigantic complex. Within the progress of the project two problems appeared: first, the necessity of modifying the plan to a realizable design; second, the demand to join the mere centralized church, as it was originally planned, with the old basilical scheme. These two changes—the

[39] Cf. D. Frey, *Bramantes St. Peter-Entwurf und seine Apokryphen* (Wien, 1915), p. 6; F. Graf Wolff-Metternich, "Gedenken zur Baugeschichte der Peter-skirche im 15. und 16. Jahrhundert," in *Festschrift für Otto Hahn* (1954), II, 6 ff.; and Foerster, *Bramante,* pp. 225 ff.

*Figure 26*
Leonardo. Sketches of
architectural details.
Cover of the Treatise
on the Flight of Birds.

strengthening of the four main pillars and the enlargement of the centralized building to a basilica of five naves—were the themes of the famous preparatory study for the so-called second plan of St. Peter's.[40] The sheet is known under the name of its signature "Uffizi number 8" and is one of the most beautiful and expressive architectural drawings ever made (fig. 23). Now, on the upper and lower margins we observe two small auxiliary sketches which represent, no doubt, rapid draughts of the Cathedral and of S. Lorenzo in Milan. These sketches, tiny as they are, are not at all accidental or incoherent; they have, on the contrary, a great significance because they prove that the artist recalled just these two buildings when he studied the particular problems of St. Peter's: S. Lorenzo indeed offered the best motif of inspiration for the amplification of the ground-plan by adding the hemispherical circuits, and for the problem of joining five naves with a domed square the Milanese cathedral shows a comparable structure.

In this brilliant solution of an extremely difficult problem of construction we recognize again a genius in architecture. No one but Bramante possessed such experience and such power of invention; so the existence of the two Milanese buildings on the drawing seems to speak in favour

[40] Cf. L. H. Heydenreich, "Bramante's 'Ultima Maniera': Die St. Peter-Studien Uff. 8 und 20," in *Essays on* *Art and Architecture in Honour of Rudolf Wittkower* (London, 1966), I.

144

*Figure 27*
Palladio's sketch of Bramante's
house, Rome.

of his still fervently discussed authorship, and this so much the more as we may perceive here a
last resonance of Leonardo's and Bramante's common past in Lombardy.[41]

There was still one further contact between the two, in the year 1513, when Leonardo came
to Rome.[42] Leonardo saw the Roman works of his old companion; first of all the immense pillars
and arches of the growing new St. Peter's, which meant to him the realization of an architectural
idea, theoretically prepared in his years of companionship with Bramante at Milan. A group of
sketches, jotted down on a sheet during his Roman visit, proves that Leonardo studied the same
problem as Bramante—the transformation of S. Lorenzo in Milan into a rationalized structure
and the combination of a centralized choir with a longitudinal church [43] (fig. 22). Leonardo saw,
too, Bramante's Tempietto of S. Pietro in Montorio, which gave him the inspiration for his de-

[41] L. H. Heydenreich, "Zur Genesis des St. Peter
Plans von Bramante," in *Forschungen und Fortschritte*
(1934), 10:365 ff. See also F. Graf Wolf-Metternich,
"San Lorenzo in Mailand, St. Peter in Rom," in *Kunst-
chronik* (1962), 15:285 ff.

[42] For the dates of Leonardo's stay at Rome, see W.
von Seidlitz, *Leonardo da Vinci* (2d ed. Wien, 1935),
pp. 372 ff.; and Pedretti, *A Chronology,* pp. 77 ff.

[43] There are several sketches of S. Lorenzo by Leo-
nardo: C.A., fol. *7v, b* (1490–1495), section in perspec-
tive. A "rationalized" version of the ground-plan of S.
Lorenzo is the "Teatro da Predicar" on fol. 55*r* of MS

B, where also the amplification to a basilical type is
intimated by some thick strokes, as it is worked out on
MS B, fol. 35*v* (both 1490–1495). In C.A., fol. 271*v, d,*
the plan of S. Lorenzo and its dome is drawn again; C.
Pedretti made the most interesting discovery that these
sketches belong to the same sheet of paper that contains
the studies on the Roman harbour of Civitavecchia and
must have been drawn therefore at the same period,
i.e., 1513–1514 at Rome; see Pedretti, *A Chronology,*
pp. 84 ff. No doubt, Leonardo drew these sketches
under the impression of Bramante's studies for St.
Peter's. Cf. Heydenreich, "Bramantes 'Ultima
Maniera.'"

*Figure 28*
Leonardo. Sketch of a palace.
Codex Atlanticus, fol. 217*v*.

sign of a mausoleum; I am convinced that this drawing must be his, were it only for the strangeness of the theme [44] (figs. 24 and 25). He saw, finally, Bramante's palaces and found there again a correspondence of ideas: in his study of a villa on the cover of the Treatise on the Flight of Birds he had drawn in 1505 an order of double-columns, which is very close to the motif of Bramante's house at Rome (no longer extant, but preserved in the drawing of Palladio) [45] (figs. 26 and 27). Certainly Leonardo was impressed by the clear simpleness and monumentality of these Roman palace buildings. His tiny sketch of a palace, which he drew in connection with his designs for Romorantin, was surely influenced by his Roman experience [46] (fig. 28).

First of all, however, Leonardo must have admired another very ingenious and very beautiful creation of Bramante in Rome—the Cortile del Belvedere. We owe to James Ackerman the discovery and brilliant interpretation of Bramante's concept [47]—the ideal reconstruction of the antique garden villa on the same site where it was supposed to have been. The fresco in Castel S. Angelo, rediscovered and identified by Ackerman, shows the grandeur of the project. There can be no doubt that Leonardo's ideas for terrace gardens and the building prospects, as he drew them in his studies for the Medici palace in Florence, for Romorantin, and probably, too, for the Villa

[44] Cf. Heydenreich, *Leonardo Architetto,* p. 15, figs. 29–30.
[45] Cf. Foerster, *Bramante,* p. 204, figs. 85–86.
[46] C.A., fol. 217*v*, right lower corner.

[47] J. Ackerman, "The Belvedere as a Classical Villa," in *Journal of the Courtauld and Warburg Institutes* (1951), 14:70 ff., and J. Ackerman, *Cortile del Belvedere* (Vatican, 1954), pp. 133 ff.

146

*Figure 29*
Castel S. Angelo, Rome.
Fresco of the Belvedere.

*Figure 30*
Project of Villa Melzi
(Reconstruction by Pedretti).

Melzi, were widely influenced by this contact with Bramante's *maniera romana*[48] (figs. 29–31).

I shall go so far as to say that Leonardo, who through all his life never drew one single monument or single element of antique architecture, while the sketch-books of his contemporaries— Francesco di Giorgio Martini, Giuliano di Sangallo, and others—are filled with such copies and studies, discovered the values of ancient monumentality through the classic style of Bramante;[49] especially he grasped the feeling for the *grandi forme* which is to be felt in his last designs for Romorantin. His late sketch of various types of portals touches even the anti-classic element that characterizes the Bramante school[50] (fig. 32). There is no literary document that gives us any in-

[48] Pedretti, in *L'Arte* (1963), 62:229 ff., fig. 8.     [50] C. A. fol. 279*v, a.*
[49] Cf. Heydenreich, *Leonardo Architetto*, pp. 14 ff.

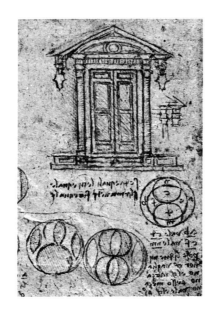

*Figure 31*
A Medici palace, Florence. Codex Atlanticus, fol. 315*r, b.*

*Figure 32*
Leonardo. Drawing of portal. Codex Atlanticus, fol. 297*v, a.*

formation about the personal relations between the two eminent men. From Bramante we do not possess a single utterance of his own, whilst Leonardo mentions Bramante's name only twice, and very briefly in his notes.[51] But through the link of their common thoughts and through the link of their genius, both were closely related and so we must see their work in the form of mutual completion.

[51] *Ibid.,* fol. 225*r, b (ca.* 1495); we find the note "gruppi di Bramante" which means knot ornaments; on the cover of Leonardo's note-book, MS L (1503–1504), is written "edifici di Bramante"; cf. our n. 10 above, and N. De Toni, "Saggio di Onomastica Vinciana," in *Raccolta Vinciana* (1934), 14, nos. 200–201. Another reference to Bramante is in MS M, fol. 53*v:* "modo del ponte leuatoio che mj mostrò donnjno." Cf. Pedretti, *A Chronology,* p. 81, n. 9.

# Belt 35:
# A New Chapter
# in the History
# of Leonardo's
# Treatise on Painting[*]

## by CARLO PEDRETTI

A<small>N ENTRY</small> in Leonardo's last will, dated at Amboise the 23rd of April 1518, reads as follows:

Item. The aforesaid Testator gives and bequeaths to Messer Francesco Melzi, nobleman of Milan, in remuneration for much appreciated services done to him in the past, each and all of the books the Testator has at the present time, and the instruments and portraits pertaining to his art and calling as a painter.

[*] This paper is reproduced here as it was given at the symposium, revised but not expanded. I have not added footnotes either, because the type of presentation does not call for them. But I must specify that the newly discovered document, which records the finding of the archetype of Leonardo's *Trattato della Pittura* in the Library of the Duke Francesco Maria II della Rovere at Castel Durante in 1631, is in the Archivio Notarile of Urbania, Rog. Giovanni Basilischi (354, vol. 12), and is dated June 6, 1631: *Gli infrascritti saranno i libri manoscritti et de disegni e scritture trovate nella libreria del già J.ᵐᵒ Francesco M.ᵃ della Rovere ecc.* The Codex Urbinas is listed on folio 91 recto as "Il Lionardo da Vinci della Pittura." I am indebted for this informa-

tion to Monsignor D. Corrado Leonardi, who has included it in his "Storia di libri e di Biblioteche ecclesiastiche urbaniensi," in *Atti e Memorie della Deputazione di Storia Patria per le Marche,* Serie III, Vol. III (1964), 71–101. Monsignor Leonardi has also published the document concerning the presence of the Codex Furini (copy of Belt 35) in the library of Count Ubaldini in Urbania, up to 1816 (*op. cit.,* p. 73).

I should like to thank Professor Alessandro Parronchi for his assistance during my researches in Florence in the summer of 1965, and Signor Renzo Cianchi, Bibliotecario della Biblioteca Leonardiana, Vinci, for a wealth of information about the former owner of Belt 35, Prince Giovanni Bardzky of Fucecchio.

This is the source of an information given by the Florentine Anonimo Magliabechiano in his short biography of Leonardo, *ca.* 1540:

> And he left by testament to Messer Francesco da Melzo, a nobleman of Milan, all of his cash money, clothes, books, writings, drawings and instruments and portraits pertaining to his art.

We cannot say that, after his death, Leonardo was soon neglected in Italy. As we have just seen, even his testament was known in Florence. As soon as Francesco Melzi had returned to Milan (in 1523 he is already reported there) he began to show the inherited Leonardo papers to his fellow painters. And he himself began that compilation from Leonardo's notebooks which was planned to be published as Leonardo's Book on Painting. The project almost reached the verge of realization: the archetype of the Treatise on Painting now preserved in the Vatican Library has all the characteristics of a manuscript ready for the printer. The first thirty folios were even gone through by an editor, who made significant corrections in the spelling of words to make the Leonardo text conform with an almost pedantic Italian that was becoming fashionable toward the middle of the century. For an unknown reason Leonardo's *Trattato della Pittura* was not published in the sixteenth century. Melzi's compilation was found a century later in the library of the duke of Urbino. But long before, manuscript copies of an abridged version of that compilation were already circulating in the workshops of the painters. And it was eventually one of those copies that was published in Paris in 1651. The history of the influence of Leonardo's theory of art begins officially with the appearance of this publication. But such influence was negligible—I am tempted to say that it was more in terms of Poussin's illustrations to Leonardo's *Trattato*. Or, at least, from that time onward, it was not greater than that of Alberti's *della Pittura*, a new edition of which was published together with the Leonardo *Trattato*. Indeed one can speak of a much more significant influence of Leonardo's theory of art in the sixteenth century, proceeding directly from him and from his literary remains made available to artists by Francesco Melzi and others. But where exactly did this influence originate? To the two centers of obvious pertinence, Florence and Milan (in both of which, incidentally, Leonardo himself operated), we must add Urbino, where Melzi's compilation eventually landed. And, to carry our topographical inventory a step further, we shall see that such centers as Bologna and Naples may also be included.

In the Elmer Belt Library of Vinciana there is a manuscript copy of the abridged version of Leonardo's Treatise on Painting, designated as Belt 35. I cannot think of a better way to begin my story than by examining this manuscript. Belt 35 is the only sixteenth-century copy that can now be dated with certainty and that can be identified, not only as a source of later compilations but also as a copy of an even earlier source still in existence today. This, in turn, allows us to move the origin of the unabridged archetype, the Codex Urbinas 1270, as far back in time as has hitherto been unthinkable, probably shortly after Leonardo's death, between 1520 and 1525.

Belt 35 has an anonymous look. It has a simple title page: Discorsi Di Lionardo Da Vinci

Sopra La Pittura. There is no name of the compiler, nor any date. The overall aspect of the manuscript is very close to that of Codex Barberinus 4304, and one may think at first that this is yet another copy of the celebrated abridged compilation in the Vatican Library. This, however, is not the case. The drawings in Belt 35 could not have been copied from those in the Codex Barberinus simply because one of them—the figure of a horse which illustrates chapter 263—is not found in the Barberinus. And again, the diagrams in Belt 35, folio *73v* and *79r* have letters that in the Barberinus are omitted.

Moreover, Barberinus is of an altogether different category: it has the chapters numbered and captioned, whereas in Belt 35 the chapters are only numbered and all the captions are listed in the table of contents. One of these captions in Belt 35 reads: "355. Del fare una pittura d'eterna uernice," and in the same caption in the Barberinus the word "eterna" is left out. Obviously a copy does not introduce drawings and words which are not found in the alleged source.

We shall see that Belt 35 has certain characteristics of text and illustrations which permit us to establish the category to which it belongs, but first we have to consider all sorts of exterior evidence. The manuscript itself reveals immediately a few clues to its identity. Originally it was not so anonymous as it looks today. The evidence of its origin must have been concealed on purpose. And so a stamp on the end flyleaf has been partly erased, leaving, however, a few letters still legible: Stud[io Legale?] Fucecchio. Fucecchio clearly stands for a locality in Tuscany. On the rear endpaper a nineteenth-century signature, H. Bardzky, is the only evidence left of the name of a former owner. Prince Bardzky was an officer in the Napoleonic army, who established himself in Leghorn, marrying the daughter of a lawyer of Fucecchio. In 1802 he had a son, Giovanni, who lived in Fucecchio and died in his villa of Pratobello near Lucca in 1870. Giovanni was sent to law school but after the death of his father he undertook the study of art and literature, first at the Academy in Florence, and then in Rome and Naples. It is not known when he came in possession of Belt 35, and where the manuscript went after his death. However, the recent history of the manuscript does not add anything to our knowledge of its early origin.

The ownership entry in Belt 35, folio 4r
(author's tracing, approximately 60% of original size)

But an important hint was yet to be found on folio 4r: again an inscription that had been carefully erased (fig. 1*a*). So little of it was left that it has escaped the attention of all those who have examined this manuscript in recent times. And yet the little that is left is enough to restore a sixteenth-century ownership entry: *Questo libro è di Giovanni di Simone di Francesco Berti Fiorentino e de' suoi Amici* (This book belongs to Giovanni di Simone di Francesco Berti of Florence and to his Friends).

151

*Figure 1a*
Belt 35. Title page and fol. 4*r*,
with the erased ownership
entry.

Who was this Giovanni Berti of Florence? The answer comes from another manuscript copy of Leonardo's Treatise on Painting, a manuscript compiled by the Florentine painter Francesco Furini (1600–1649) and later in the possession of Vincenzo Viviani (1622–1703) a pupil of Galileo (and one is reminded of Galileo's statement: "Others have access to all Leonardo's precepts, and yet they would not know how to paint a stool"). The Codex Furini, which is now in the Biblioteca Estense at Modena, to which it came from the Campori library, opens with a statement written by Furini himself and dated the 2nd of August 1632 (fig. 1*b*). It is here that we meet Giovanni Berti again. Furini's note reads as follows:

This is a record of how the present precepts by Leonardo da Vinci were lent to me by Signor Simone Berti gentleman of Florence, who is exceedingly devoted to design and in this

152

*Figure 1b*
The Furini MS, copy of
Belt 35. Editorial note
dated 1632.

a pupil of mine; and these precepts were copied by Signor Giovanni Berti my teacher, on account of the great affection that he had for the art of design, as one can read in a note by Signor Giovanni in the above-mentioned book of precepts; and conforming to the delight that he [*Signor Giovanni*] says to find in the art of design, he had the drawings which are necessary to illustrate the Leonardo precepts done by the teacher (of this noble profession) Maestro Gregorio Pagani, Florentine painter; which figures I myself copied in the present manuscript, just as the text [*of the Berti manuscript*] was copied at my request by Cosimo Corti, clerk of Florence cathedral, at the price of 24 lire which I paid to him in this day and year. And he declared to be satisfied, in the presence of Lionardo, Ferroni, Giovan Battista Galestruzzi, and Giovanni Risi and others.

*Figure 2*
Inventory of the Library
of Nicolò Gaburri, 1722.
Florence, Biblioteca
Nazionale Centrale,
Cod. Magl. Cl. XVIII,
no. 3.

This record, which sounds almost like a legal document, tells us the story of Belt 35. Our manuscript was compiled by Giovanni Berti, teacher of Francesco Furini, and has the figures by Gregorio Pagani, Florentine painter. Simone, son of Giovanni Berti and a pupil of Francesco Furini, lent our manuscript to Furini who had it copied by a clerk of Florence Cathedral. Furini himself copied Pagani's drawings. It is a simple story that speaks of the eagerness with which the Leonardo *precetti* were sought out and copied by painters in the sixteenth and seventeenth centuries. But this is not all the story. Furini says that Giovanni Berti copied Leonardo's precepts from another source and that it is in a note in his manuscript (that is, in our Belt 35) that Gio-

154

*Figure 3*
The Gaburri inventory. The item 13 describing the Pagani MS of Leonardo's Treatise on Painting, now identified with Belt 35.

vanni states that the drawings were made by Gregorio Pagani. Later I shall answer the question: What was the source of Belt 35? First we have to consider another question: Where is the note by Giovanni Berti, a note likely to be dated, just as was dated the one which Furini placed in his copy? The Furini manuscript, as others from this early period, shows that it was customary for such records to be written at the beginning of the manuscript, just before or after the title page. As we open our Belt 35 we see that only a flyleaf precedes the title page, but in between the flyleaf and the title page we see the stump of a missing sheet. This was probably the sheet on which was written the note by Giovanni Berti, the note with the precise record about the origin of this

155

manuscript. As the note was probably too long to be erased, the entire sheet was cut off. The only evidence left, the ownership entry on folio 4*r*, had to be erased as carefully as possible since it was not possible to remove the page with the Leonardo text. There is another way to see that a folio is missing. In fact, as we check the foliation backward we notice that the folio with the beginning of Leonardo's text is numbered 3, and that folio 2 is the title page. Thus there must have been a folio 1 which can only be the missing one.

I do not know whether I am reading too much into bibliographical hints. It could be claimed that this blank flyleaf has clear marks produced by the words of the facing title page; but this can also prove that the sheet in between disappeared in the not recent past. And if we look carefully we notice that this blank leaf not only has the impression of the facing title page but also that of less conspicuous lines of handwriting, about twenty of them, which can only have been produced by something that is no longer facing it.

With this ends the first part of my story of Belt 35, a story based on external evidence. Next question: How can we date this manuscript? Nothing, or at least nothing yet, is known of the activities of the Berti family, although it is likely that at least Giovanni was active in the sixteenth century. The answer to our question comes from another source, and by pure chance. In the summer of 1965 I was exploring archives and libraries in Florence in connection with projects that had nothing to do with Leonardo's Treatise on Painting. One project was to find records of the celebrated Cooper engravings after the Codex Huygens, which Gaburri received in 1730 as a present from Mariette. Not only is no one, after Mariette, ever recorded as having seen such engravings, but no one has ever suspected that they were after the Codex Huygens, the manuscript now in the Morgan Library, published by Panofsky in 1940. My search for the Gaburri set of the Cooper engravings was unsuccessful. But as I went through Gaburri's inventories in the Biblioteca Nazionale at Florence, in which are recorded such possessions of his as a codex Resta and other drawings now in the British Museum, I found under the date 1722 the record of a manuscript copy of Leonardo's Treatise on Painting (figs. 2 and 3): *Discorsi di Lionardo da Vinci sopra la Pittura, Manoscritto raro, col frontespizio fatto a penna, e acquarelli; Originale di propria mano di Gregorio Pagani Fiorentino, fatto nel 1582.*

The date in this document is somewhat ambiguous. It does indeed look like a "1542" and I must confess that this is the way it appeared to me first. But Gregorio Pagani (fig. 4), said in Gaburri's note to be the author of the compilation, and not only of the drawings, was born in 1558 and died in 1605. How could he compile this codex in 1542? And again, how could Gaburri make a mistake in transcribing a date? But in fact he transcribed it correctly: what looks like a "4" is actually an "8," a "recumbent eight" as it was used in the seventeenth and eighteenth centuries, especially in epigraphy, perhaps reminiscent of the symbol that was used sometimes in Roman epigraphy to indicate the One Thousand: ∞ . That this is so is proved by a comparison of this date with the numeral 14 of the next item, which makes clear how the compiler writes a "4." Finally, at the end of this item there is a date, 1688, which leaves no doubt as to the identification

*Figure 4*
The author of Belt 35,
Gregorio Pagani (1558–1605).
Self-portrait in the Uffizi
Gallery, Florence.

of the "recumbent eight" in the date of our entry. This entry is a document recording the existence in the eighteenth century of a manuscript copy of Leonardo's Treatise on Painting. But where is this manuscript now? Is it lost, or is it only its identity that is lost? We already know the answer, as we think back to the Furini manuscript. Since Gregorio Pagani was mentioned by Furini as the author of the drawings in our Belt 35, why could not our Belt 35 be the manuscript formerly in the Gaburri collection? And in fact it is. The missing sheet that once faced the title page becomes even more eloquent. The note written by Giovanni Berti on that sheet, as mentioned by Furini, is in fact the note in which Gaburri must have read the name Gregorio Pagani (to whom he attributed not only the drawings but the entire compilation), and a date: 1582. And just as it was easy for him to copy a date, so it was easy for him to transcribe the title page: *Discorsi di Lionardo da Vinci sopra la Pittura*, which is exactly the title of our Belt 35.

According to Gaburri's entry the manuscript had also watercolors. Pagani's drawings in Belt 35 are line drawings. Perhaps there were watercolors attached to it, which might have been removed when the manuscript was bound in the present nineteenth-century binding or before.

In spite of all these mutilations, Belt 35 has now a story that reaches as far back as 1582. We shall now turn to the examination of its text and complement its story with internal evidence.

157

*Figure 5a*
Furini MS. Note of
Errata as in Belt 35.

Let us go to the end of the manuscript. The table of contents is preceded by a note headed "Errori" (fig. 5*a*), which is more than a note of *Errata*. It tells us something more about the origin of the manuscript. It reads as follows:

Here follows the Second Part, which serves as a Table of Contents for one who wants to find the precepts according to their numbers. And we must inform the reader that in copying the preceding text we made a mistake in numbering, because numbers 165 and 166, each appears twice, and so number 168. And between numbers 180 and 185 there are some which are exchanged and others which are given twice, as is also the case with number 195. And because it was so in the manuscript from which this copy was taken, we made the same mistakes in numbering. All because we did not want to deviate from the source we have been using.

This editorial note appears again in the Furini manuscript which is in fact an exact copy of our Belt 35. And the Codex Corsini, which was considered so important as to be made the head of a

group, can now be recognized as a derivation from Belt 35. The compiler changed the chapter arrangement in a few points, but his source is obvious. At the end of his compilation he started copying the first lines of the editorial note headed "Errori," then he crossed them through realizing that in his revised compilation that note was no longer necessary (fig. 5b). It is likely that more manuscript copies originated from our Belt 35. But how can we identify the source of Belt 35? The only known manuscript to have 368 chapters are the Magliabechiano-Gaddi 372 and the newly reported Riccardiano 2136. Both contain in addition to Leonardo's Treatise on Painting excerpts from Vignola's *Perspective* which was published in 1583. The excerpts from Vignola in

159

the Riccardiano 2136 seem to be by the same hand as the Leonardo text, and one may conclude therefore that the manuscript can date from any time after 1583. On the other hand, by 1562, when Vignola published his *Regola dei cinque ordini di Architettura*, he was already working on his *Regole* of perspective, and it is possible that excerpts from it were circulating long before their publication, which was done posthumously in 1583 with a commentary by Egnazio Danti, mathematician at Bologna. And I must say, parenthetically, that Danti was aware of the existence of Leonardo's Treatise on Painting, as he writes in his preface to Vignola's work, "We also have such rules ordered in compendium by Leon Battista Alberti, Leonardo da Vinci, and Alberto Durer." Indeed these copies of the Leonardo *Trattato* can be dated before 1583, in fact before 1582, because one of them can be identified as the source of Belt 35.

According to the editorial note in Belt 35, the mistaken numbering of the chapters reproduces exactly the mistakes found in the source. It just happens that both the manuscripts I mentioned before, the Riccardiano 2136 and Gaddi 372, contain such mistakes, and so either one can be the source of Belt 35. But it is easy to find out that Gaddi was copied from Riccardiano because it introduces slight alterations in the text and illustrations, sometimes carrying out corrections suggested by the compiler of the Riccardiano. Thus Gaddi is the source of Belt 35. And in fact Belt 35 in turn slightly modifies texts and figures as found in the Gaddi, not in the Riccardiano.

The place we have found for our Belt 35 calls for a general revision of the chronology and categorization of the apographs dating before the 1651 publication. These early apographs, which must be arranged over a period of a hundred years, cannot simply be gathered in one group. Each manuscript was copied from another, and perhaps their prototype is no longer available, but the existing manuscripts (twenty-five, with possibilities of further additions) can be arranged in categories and thus in more accurate chronological sequence. At least there are means to prove that one manuscript cannot come before another. These means are designated as "tests."

One such test, which I introduced in 1953, has become the celebrated "egg test," and it may be used to prove whether a manuscript copy is made before or after the first printed edition. The chapter in point exists in Leonardo's original Ashburnham MS 2038, folio 17*v*. Leonardo explains why a painting should be viewed from a fixed opening, and gives the example of an oval, which would properly appear round the moment it is viewed from the correct viewpoint, according to a principle of anamorphosis (fig. 6*a*). Leonardo does not write "oval," but he draws an oval object, accurately shaded. His pictographic system is faithfully followed by the compiler of the Codex Urbinas (fig. 6*b*): the egg appears after the words "così fatti" (objects made in this way). The manuscripts of the abridged version which precede the first printed edition also include the little diagram of the egg, although not always properly understood. Finally the egg is dropped after the words "così fatti" and the words "a questa similitudine" are changed to "a similitudine di un uovo" (like an egg). The manuscript copies with this rendering are probably derived from the printed edition.

160

*Figure 6a*
The "Egg Test." Leonardo.
MS Ash. 2038, fol. 17v.

*Figure 6b*
Codex Urbinas
1270,
fols. 49v-50.

But the "egg test" is not simply an auxiliary in the game of sorting apographs in two groups. As the egg was dropped gradually, there are renderings which are closer to the prototype, that is, to the Codex Urbinas, and renderings which are closer to the printed edition. Intermediate steps are of importance to suggest a chronological sequence. We shall present only a few examples.

In the Pinelliano, which is probably the earliest abridged copy in existence, the diagram after the words "così fatti" appears more like a scribble, as if the copyist had misunderstood its meaning; but a clear diagram of an egg appears after the words "a questa similitudine" (fig. 7a). The codices which were claiming the earliest position because of the rendering "operatore" instead of the mistaken "imperatore," that is, the Ottoboniano 2984 and Casanatense 5018, have the same double rendering of the egg (fig. 7b). In the Scorzini manuscript of the Raccolta Vinciana a space

161

*Figure 7a*
The "Egg Test." Codex
Pinellianus D 467.

*Figure 7b*
Codex Ottobonianus
2984.

*Figure 7c*
Codex Scorzini, Raccolta
Vinciana.

is left after the words "così fatti" and the diagram of the egg is added later on the margin with a reference to the word "similitudine" (fig. 7c). And so for a moment there are actually two eggs (as in the Pinelliano), the first one, misunderstood, changed to a scribble that resembles an O with an accent. In Belt 35, as in the Riccardiano and Gaddi, the egg after the words "così fatti" does look like an O with an accent, but the second egg is not added, as will be the case with the Laurenziano Ashburnham 1299. I have kept the Barberino for last on purpose to show, by means of the egg test, that it cannot be dated before any of the manuscripts mentioned thus far. Both eggs are dropped. The first one is replaced by an "Et" (and), which is probably the result of the misunderstanding of the accented O, reminiscent of the diagram of an egg. Thus Barberino is just one step before the printed edition.

Several such variations in the text may be found, but even a few "tests" are enough, provided that they are used consistently. Of course, one can make "tests" with the illustrations too (figs. 8–10). But the drawings should be considered in the same way as the text, for their variations, that is, and not for their quality. The comparison of manuscripts in terms of the artistic quality of their drawings, an obviously subjective approach, is of little or no value in the determination of their chronological sequence.

CODEX URBINAS 1270
*ca.* 1525–1530

Unknown prototype of the abridged version from which two types stem: one reflecting accuracy in the illustration and one reflecting accuracy in the text

Pinelliano D 467

Riccardiano 2136

Laur. Ash.
1299

Gaddi 372

Lanino
before
1583

Casanatense
5018

BELT 35
1582

Ottoboniano 2984

Ricc. 2275
(Della Bella)
1630

Casanatense
968

BARBERINO
4304

FURINI
1632

Magliabechiano
XVII, 28

Nani
(Morosini)
ca. 1640

OTHERS:
Turin,
Recanati,
&c.

CORSINI 402
(Saltarelli)

Pal. 962
(Lessi)
18th cent.

Chart of a conjectural reconstruction of the chronological sequence of the key apographs of Leonardo da Vinci's Treatise on Painting

163

## CONCORDANCE: BELT 35—DELLA BELLA

Della Bella: total number of chapters, 377. The chapter numbers conform to those of Riccardiano 2136, Gaddi 372, and Belt 35 up to 166. Beginning with 167 corrections are introduced. The resulting total, 377, is exactly the total of chapters that Riccardiano, Gaddi, and Belt 35 would have had, had their numbering carried through correctly.

| Belt 35 | Della Bella | Belt 35 | Della Bella |
|---|---|---|---|
| 165 | 165 | 179 | 187 |
| 166 | 166 | 180 | 188 |
| 165 | 167 | 181 | 189 |
| 166 | 168 | 182 | 190 |
| 167 | 169 | 183 | 191 |
| 168 | 170 | 184 | 192 |
| 168 | 171 | 185 | 193 |
| . . . | . . . | 186 | 194 |
| 180 | 183 | . . . | . . . |
| 181 | 184 | 195 | 203 |
| 182 | 185 | 195 | 204 |
| 183 | 186 | . . . | . . . |
| | | 368 | 377 |

As a result of these "tests," the Codex Pinellianus is now given the first place in this sequence because of its drawings that are the closest to those of the Codex Urbinas (some of them are no longer found in the subsequent copies) and for characteristics of text as well. This early place can be claimed for it in spite of the misspelling "imperatore" for "operatore." In fact the codices with the right spelling (Casanatense and Ottoboniano) cannot be earlier than the Pinelliano for a number of reasons resulting from an analysis of their text and illustrations. It is likely that from the unknown prototype of the abridged version two types originated—one reflecting accuracy in the illustrations and one reflecting accuracy in the text. And we may conclude that no manuscript of the second type has survived which can be dated as early as the one of the first type which in fact survived, that is, the Pinelliano. From the Pinelliano stems the Riccardiano 2136 and Gaddi 372, and finally our Belt 35.

As a curiosity item in this filiation of the manuscripts, we can mention another Codex Riccardiano, the celebrated manuscript compiled by Stefano della Bella in 1630, and published in 1792. It is now clear that the source of the Della Bella manuscript was of the same category as Belt 35, if not Belt 35 itself, that is, with chapters misnumbered so as to make a total of 368 chapters. Della Bella carried out the corrections suggested by the editorial note of Belt 35, with the result that the number of chapters in his copy is, as one would expect, 372. This is shown in the attached table of concordance.

It may seem hard to believe that if the abridged version of Leonardo's *Trattato della Pittura*

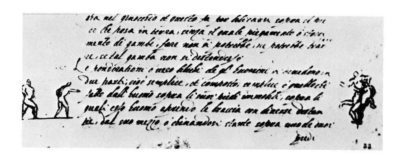

was already well known in the second half of the sixteenth century no record of it should be found in the literature of art of the time. Vasari ignores the existence of it. He only records Leonardo's autograph writings on a painting that a Milanese painter, who intended to publish them, showed him on his way to Rome.

Cellini, of course, in the same year as Vasari (1568), speaks of Leonardo's writings on perspective which he intended to publish ("le quali trassi da vn suo bellissimo discorso: che poi mi fu

tolto insieme con altri miei scritti"), but we know that the Cellini manuscript, which he acquired in 1542, was not an apograph of the Treatise on Painting but something like the Codex Huygens, if not that codex itself.

However, the first printed information about the existence of Leonardo's Treatise on Painting dates from the sixteenth century. In Borghini's *Riposo*, which was published in 1584, there is a short biography of Leonardo based on Vasari, but with a new information at the end. After having mentioned Leonardo's book on the anatomy of the horse and that on the anatomy of man, Borghini states: "And he wrote some exceedingly beautiful precepts on the art of painting, which writings, to my knowledge, have not yet appeared in print."

At least three manuscripts, the Riccardiano, the Gaddi, and Belt 35, were known in Florence at the time of Borghini. That was also the time of the institution of the Florentine academies, the literary one founded in 1541 by Grand Duke Cosimo I and the Accademia del Disegno, founded in 1562.

In the publications relating about the activities of the Accademia there is hardly a hint that can be interpreted as an awareness of the existence of Leonardo's *Trattato*. Michelangelo's derogatory remark in his letter to Varchi of 1549 merely alludes to Leonardo's *Paragone*, which he must have known of from the time of his acquaintance with Leonardo himself, early in the sixteenth century. Varchi speaks of Leonardo in his *Oratione* for the funeral of Michelangelo, in 1564, but he merely follows Vasari. More significant is again a remark by Cellini in his *Discorso* printed in Tarsia's *Oratione*, which also appeared in 1564 and in which Donatello, Leonardo, and Michelangelo are considered "the true painters" who "in their speeches and in their writings have reached the conclusion that painting is nothing but the shadow of its mother the sculpture." No such statement is found in the abridged version of the Treatise on Painting, but a similar one was published as Leonardo's by Lomazzo in 1584. And Giovio in his short biography of Leonardo had already reported about Leonardo having stated that painting must be founded on modeling. However, in the library of the Florentine Accademia del Disegno I have found a sixteenth-century copy of the Treatise on Painting which can be classified as belonging to the same family as the Riccardiano, the Gaddi, and Belt 35.

In spite of its early origin and of its presence in an academy, the abridged version of Leonardo's Treatise was becoming known quite slowly. Annibale Carracci (1560–1609) regretted that he had not read Leonardo's precepts on painting when he was young, declaring that they would have saved him twenty years' work. Thus in 1580 he had probably not yet seen an apograph of the *Trattato*. But as he got into the decoration of the Farnese palace, around 1600, he must have already known of Leonardo's chapters on human motion, for Bellori refers to his figure of Polyphemus as a suitable illustration to one of those chapters. And Domenichino's Farnese emblem of the Virgin with the Unicorn again echoes Leonardo, not by way of the *Trattato* this time, but in the pose of the Virgin which is that of the Louvre St. Anne. We know that Domenichino's teacher of perspective, the painter Matteo Zaccolini of Cesena (1590–1630), was

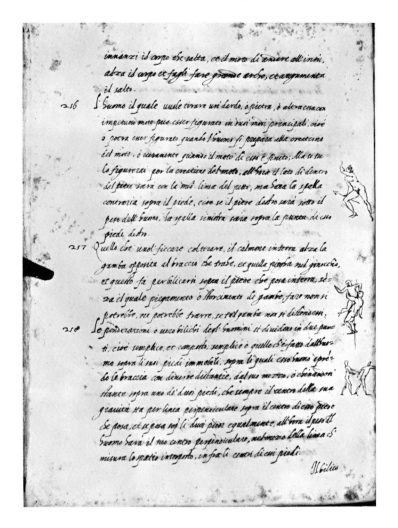

one of the first Leonardo scholars to carry out extensive studies on the *Trattato*, writing commentaries to it, unfortunately lost, with so fervent a spirit of emulation as to adopt Leonardo's own mirror writing. The mania of the Vinciani has indeed an early origin!

It is known that Leonardo's *Trattato* eventually reached Bologna, for it is said that Guido Reni (1575–1642) owned a copy of it. Guercino got a complimentary copy of the first edition of it, and in the publications of the Bolognese academicians from that time on one can always find references to it.

Milan was a special case. It was there that the original manuscripts and drawings in the possession of Francesco Melzi could be seen. Gerolamo Cardano must have been acquainted with those manuscripts, for he paraphrases some of Leonardo's notes on painting in his *De subtilitate* of 1551. And Gian Paolo Lomazzo, in 1584, could publish extensive excerpts from Leonardo's writings, including some that are no longer in existence. And there was, of course, more Leo-

167

nardo material available in Milan besides that in Melzi's possession. Vasari says that around 1530 Guglielmo della Porta was studying "the things of Leonardo," and it is known that Guglielmo owned the Codex Leicester.

It was in Milan that Melzi compiled the Codex Urbinas, from which the abridged version of the Treatise was to originate. Nothing is known of this codex until 1631, when it was listed in the inventory of books in the possession of Duke Francesco Maria della Rovere, who died in 1630. We do not know whether the manuscript was accessible before that time; that it was in the library of Castel Durante, and not, as commonly believed, in that of Urbino makes it even less probable. However, the dukedom of Urbino was a very active cultural center. Records have been found recently that the Codex Furini, which was copied from our Belt 35, was once in the library of Count Bernardino Ubaldini and it was listed in 1768 in the catalogue of the public library of Urbania, from which it disappeared in 1816.

It is clear that Leonardo's Treatise on Painting was circulating all over Italy. Everywhere there was a school of painting a copy of Leonardo's *Trattato* was likely to be present. Venice, of course, is close enough to Milan to have firsthand information on Leonardo material, and Leonardo himself was in Venice. In 1660 a Venetian, Marco Boschini, praises Du Fresne's edition of Leonardo's treatise:

> Quel Monsù Rafael d'Vfresne degno
> D'ogni honor, d'ogni gloria, e riuerentia,
> Che hà messo in stampa con gran diligentia
> Del Vinci con la vita anca el dissegno.

This is more significant as Boschini, with the sharp and colorful dialect of his lively polemic against Vasari, is all the time poking fun at Vasari's heroes, in particular at Leonardo, to whom he dedicates a long, derogatory poem.

Federico Zuccaro, president of the Roman Academy of Design, refers to Leonardo's autograph writings on the subject of human motion as treated in the Codex Huygens. In Naples a manuscript of Leonardo is recorded in 1566 in the library of the duke of Amalfi. And I am not going to repeat the well-known story of the activity around Cardinal Barberini in Rome from after 1630, with Cassiano dal Pozzo his secretary becoming instrumental in having a copy of the Leonardo Treatise finally published in Paris in 1651, with Poussin's illustrations.

I may still mention, however, that even before this *editio princeps* excerpts from Leonardo's Treatise were beginning to appear in print. In 1625 there appeared in Florence the Treatise on Perspective by Pietro Accolti, *Lo Inganno degl'Occhi*. Accolti was a teacher at the Accademia del Disegno. At the end of his book he publishes a *Discorso*, a speech addressed to the young academicians and painters. This *Discorso intorno al Disegno* (and one is reminded of the title of Belt 35) encompasses in nine pages the material of the abridged version of Leonardo's Treatise on Painting. It is a further abridgment, a paraphrase of Leonardo's precepts. Their sequence is

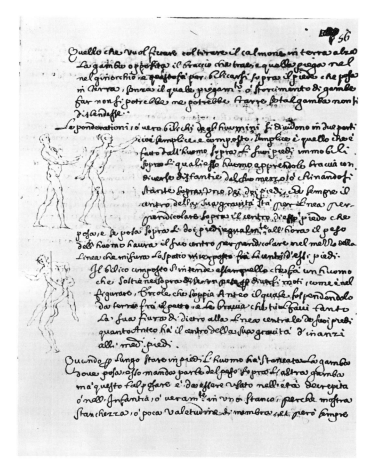

*Figure 10*
The "Hercules and Anteus Test." Codex Corsini 402, derived from Belt 35. The two groups are again placed one above the other, but in reversed sequence.

retained, but examples from contemporary productions are introduced, along with the learned touch, here and there, of a quotation from Horace or Cicero. As Accolti brings his examples in he gives us a measure of what was probably the influence of Leonardo's Treatise on Painting in the sixteenth century. And so the Bath of Diana by Passignani exemplifies the precept about the representation of female in the nude. Gian Bologna's Rape of the Sabines illustrates the precept of representing persons of different age and sex. (And we may well point to Leonardo's Leda as the prototype of the *figura serpentinata*.) Finally, the precept on how to represent children and old men is illustrated by a painting of Barocci at Arezzo. Federico Barocci was in contact with Gregorio Pagani, the author of the drawings in our Belt 35. Very probably he was acquainted with Leonardo's Treatise on Painting, and it is even possible that he had seen the Codex Urbinas at Castel Durante since he was born at Urbino; or that he had seen Leonardo's writings in Milan since he was there between 1592 and 1608. One is tempted to say that his splendid color technique and the use of colored shadows came from the precepts in Leonardo's Treatise on Painting.

The *Discorso* by Pietro Accolti published in 1625 can thus be considered as the first edition of

Leonardo's Treatise on Painting, although Leonardo's name is not given. This accounts for our difficulty in tracing the influence of Leonardo's Treatise in the sixteenth century: many are the painters who are acquainted with it, but no one acknowledges it. As it was copied time and again, not by professional copyists but by the painters themselves, it was at least read and understood, and perhaps it had in this way a greater influence than it would have had, had it been printed.

With the date 1651, the date of the *editio princeps*, the early history of the *Trattato* ends. By that time the abridged version had already reached Spain, where for a time the great bulk of the Leonardo manuscripts was found. Vincenzo Carducho, who reports about the Leonardo manuscripts in the possession of Don Juan de Espina, must have also seen an apograph of the Treatise on Painting since he paraphrases a few chapters of it in his *Dialogos de la Pintvra*, published in Madrid in 1633. Finally, we must mention Francisco Pacheco's *Arte de la Pintvra*, published in Seville in 1649. In his *Bibliografia Vinciana* Ettore Verga only mentions Pacheco's reference to the Last Supper and that Leonardo is referred to throughout the book as the teacher of Raphael. There are, however, several other references to Leonardo of special interest in that they are quotations from the Treatise on Painting (here given as Leonardo's *documentos*, followed by the chapter number). All together twenty-seven chapters are reproduced, in Spanish translation, and this two years before the Du Fresne edition of the Treatise. Obviously Pacheco had access to an apograph of the *Trattato*, perhaps the one that was later listed in the property of his son-in-law Velazquez. And so even Velazquez may be mentioned among those who had profited from Leonardo's precepts. For the first time, in 1649, some of these precepts are published as Leonardo's. Through much mutilation and abridgment of his literary remains only a shadow of Leonardo's mind is preserved. The age of Humanism is now a Paradise Lost.

# The Form of Movement
# in Water and Air

## by E. H. GOMBRICH

AN APOLOGY may be needed for an art historian proposing to approach a subject, however tentatively, that extends so far into the history of science as the one I have rashly undertaken to discuss. But of course one would have to be Leonardo to talk about anything in Leonardo—and if one were, one would probably never come to an end. I do not wish to dwell on the commonplace of Leonardo's universality. The problem is rather the unity of his thought. Every subject he approaches seems to absorb him completely and yet so expands under his gaze that we gain the impression that nothing else could have mattered to him throughout his life and that even his art should best be approached from this angle. This approach applies surely to his incessant studies of optics and of light and shade, to his studies of the geometry of equal areas in segments of circles, to his anatomical studies, or to his fascination with the balancing of weights. But none of these subjects, I believe, reoccurs with greater persistence than the subject of movement in water and air. The sheer bulk of his writings on that subject testifies to the key position it held in his mind. It was the only topic, apart from that of painting, for which a systematic search was made in Leonardo's notes, resulting in the seventeenth-century compilation entitled *Del Moto e Misura dell'Acqua* [1] which unites Leonardo's observations and diagrams in nine books totalling 566 paragraphs. The only modern collection of Leonardo's writings on water by Nando de Toni is confined to the MSS A to M in the Institut de France and even this selection comes to 990 notes.[2] Add to those the many pages devoted to the subject in the Codex Leicester,[3] in the Codex Atlanticus, and among the Windsor drawings as well as a few others and you will appre-

---

[1] First published by F. Cardinali in 1826 and again by Carusi-Favaro (Bologna, 1923).

[2] N. de Toni, *L'Idraulica in Leonardo da Vinci* (*Frammenti Vinciani,* III–IX) (Brescia, 1934–1935). Since this useful edition is not easily available, I have

here reprinted in the original all its passages that I quoted in this paper.

[3] Published by G. Calvi (Milan, 1909). For the source of a number of these notes see C. Pedretti, *Leonardo da Vinci on Painting: A Lost Book* (*Libro A*) (Berkeley and Los Angeles, 1964).

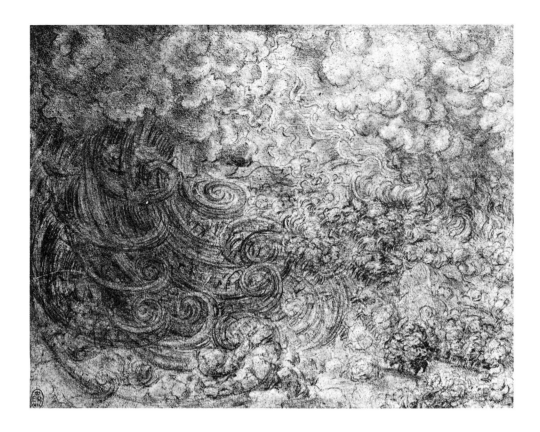

*Figure 1*
The Deluge. Windsor 12384.

ciate my claim that this subject was central to Leonardo's thought.[4] It concerned him as an engineer, as a physicist, as a cosmologist, and as a painter, and here as always it would be utterly artificial to divide up his mind into these modern compartments.

Take two of his most famous drawings in Windsor which have often been compared and rightly so. The one (fig. 1) belongs to the visions of the Deluge and of the End of the World which so preoccupied Leonardo's mind towards the end of his life [5] and which still exert such a fascination on twentieth-century artists and critics; the other (fig. 2) is a scientific study of the impact of

[4] J. P. Richter, *The Literary Works of Leonardo da Vinci* (2d ed. London, 1939), included only a very few of these notes in his influential anthology. The largest selection, in translation only, is in Theodor Lücke, ed., *Leonardo da Vinci, Tagebücher und Aufzeichnungen* (Zürich, 1952), covering 108 pages. Among general discussions of the subject that were accessible to me I should like to mention: A. Favaro, "Leonardo da Vinci e le scienze delle acque," in *Emporium* (1919), pp. 272–279; F. Arredi, "Gli studi di Leonardo da Vinci sul moto delle acque," in *Annali dei Lavori Pubblici* (*già Giornale del Genio Civile*) (1939), 17 (fasc. 4):3–9; "Le Origini dell'Idrostatica," in *L'Acqua* (1943), pp. 8–18; and A. M. Brizio, "Delle Acque," in *Leonardo da Vinci, Saggi e Ricerche* (Rome, 1954), pp. 277–289.

[5] K. Clark, *A Catalogue of the Drawings of Leonardo da Vinci in the Collection of His Majesty the King at Windsor Castle* (London, 1935), no. 12384, dated by the author *ca.* 1513.

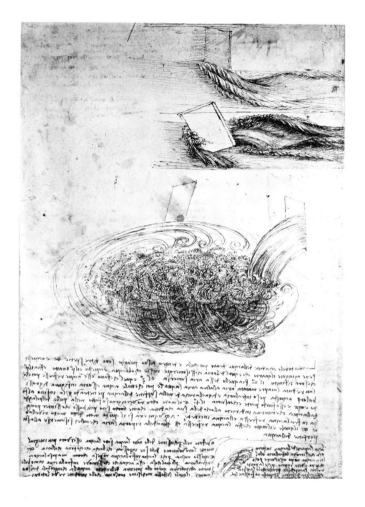

*Figure 2*
Impact of water on water.
Windsor 12660*v*.

water on water.[6] However different the two are in the scale of the phenomena they illustrate, they both share the interest in swirling movements and vortices that are so characteristic of Leonardo. Note that in the Deluge drawing it is the descending waters that appear to curl back in these spiralling movements, while in the scientific drawing the water is shown to well up and to form these complex curls and eddies round the rising rings of bubbles that surround the minor whirlpools.

It is obvious even to the casual observer that this drawing represents no mere impression of a particular sight that happened to take Leonardo's fancy. In fact, it belongs to a very large class of

---

[6] Clark, *op. cit.,* no. 12660*v*. C. Pedretti proposes to date this drawing *ca.* 1509, as kindly communicated to me.

drawings concerned with the same problem of the effect of falling water on the pool below. Such drawings with their accompanying explanation occur as early as MS A, from the early 1490's (fig. 3),[7] and reoccur persistently at least to the second Milanese period when Leonardo attempted to assemble his notes on water (fig. 4).[8]

I should perhaps explain what prompted me to take up the study of these astonishing drawings. It was the relation between seeing and knowing or more accurately between thought and perception, to which I have devoted my book, *Art and Illusion*.[9] There can be no more important witness for the student of this problem than Leonardo. He represents a test case for those of us who are interested in the interaction of theory and observation and are convinced that the correct representation of nature rests on intellectual understanding as much as it does on good eyesight. To Leonardo, of course, this would have been a commonplace. He would not have written the Treatise on Painting with all its scientific observations if he had not been convinced that a painter must be more than "merely an eye." In fact, it is clear that he had to defend his position against his fellow-painters who resented this intellectualism no less than some of their successors do to-day.

> At this point—we read in the *Trattato*—the opponent says that he does not want so much *scienza*, that practice is enough for him in order to draw the things in nature. The answer to this is that there is nothing that deceives us more easily than our confidence in our judgment, divorced from reasoning, as experience shows who is the enemy of the alchemists, the necromancers, and other simple minds.[10]

Leonardo's point is here surely that these charlatans also appeal to sense perception and make simpletons see ghosts or gold because they fail to combine their judgement with reason. It would hardly be necessary to stress Leonardo's intellectual bias were it not for the fact that in the history of science he has been represented for a long time as a person who simply looked and therefore knew more than all his contemporaries. It must be admitted that he sometimes talked as if this were the case. Exasperated as he was by the pride and ignorance of the bookish professors, he hammered it home that *sperientia* was his only mistress and guide. No wonder that the conception of science that saw in him the forerunner of Bacon and of inductivism stressed this observational bias of his writing in order to exalt his modernity. I need not say that this interpretation is obsolete. It is obsolete in the methodology of science where it is increasingly recognized that science does not progress by looking, but by taking thought, by the testing of theories and not by the collection of random observations.[11] It is obsolete also in Leonardo studies where we have learnt in-

[7] MS A is dated by Leonardo himself (fol. 114*v*) July 10, 1492. Here and throughout I am relying on the chronology of Leonardo's manuscripts given in A. Marinoni, "I Manoscritti di Leonardo da Vinci e le loro Edizioni," in *Leonardo, Saggi e Ricerche,* Appendix I.

[8] The Windsor drawings concerned date, according to C. Pedretti, from *ca.* 1509.

[9] London and New York, 1960.

[10] Cod. Urb., fol. 222*r* (McMahon, no. 686). The passage refers to a problem of light.

[11] K. R. Popper, *The Logic of Scientific Discovery* (New York and London, 1959).

174

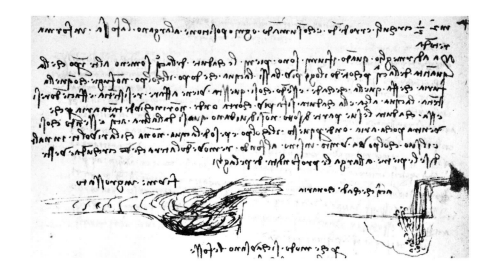

*Figure 3*
Sketch of waterfall.
MS A, fol. 59*v.*

*Figure 4*
Sketch of waterfall.
Windsor 12659*r.*

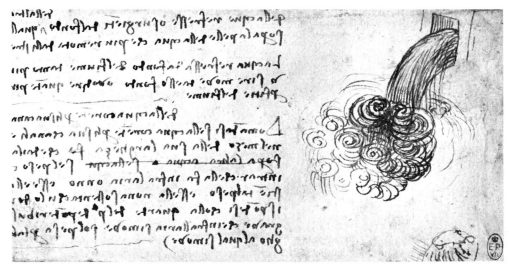

creasingly to see and understand this element of continuity in the master's work, that thrilling progress of his understanding that starts, like that of every human being, from the accumulated ideas of past generations but proceeds to check and criticize ideas in the light of *sperientia*.[12] This is surely as true of his studies of water as it is of his anatomical work. But while historians of science have provided us art historians with an admirable key to the understanding of Leonardo's anatomical drawings, no historian of hydraulics has as yet obliged us with a similarly detailed study of his drawings of water. In the absence of such a study art historians have sometimes fallen back

[12] K. D. Keele, *Leonardo da Vinci on the Movement of the Heart and Blood* (London, 1952), offers many instructive examples of this process.

*Figure 5*
Movement of water. MS F,
fol. 20*v*.

on the reflex movement of praising Leonardo's unfailing powers of observation and intuitive vision. I hope even the one example I have shown demonstrates the insufficiency of such a comment. It is clear that Leonardo's drawing is not a snap-shot of water falling upon water but a very elaborate diagram of his ideas on the subject. No waterfall or whirlpool permits us to see the lines of flow with similar clarity, nor do bubbles in turbulent water ever distribute themselves so tidily. Even those who are not used to watching these effects must surely agree with Professor Heydenreich that this beautiful drawing is an "abstract, stylized representation," [13] a visualization of forces, not a record of individual observations. There are innumerable such diagrams in Leonardo's notes about water, ranging from little pictures at the margin of a line to a mere visual indication of the content of a note. Some of these are mere pictographs repeating the information of the text,[14] many others support the description like an illustration in the tradition of geometrical or optical treatises, referring the reader to the letter symbols in the drawing. "The water m, n, descends in b, and strikes under the rock b, and rebounds c, and hence it rises up turning in q, and the things hurled in f, by the water struck by rock b, rebound at equal angles. . . " [15] The

---

[13] L. H. Heydenreich, *Leonardo da Vinci* (New York and Basel, 1954), note to plate 226.

[14] E.g., the small scribbles accompanying the enumeration of water conduits, C.A., fol. 70*v*.

[15] C.A., fol. 37*v, c:* "L'acqua m. n. disciende in b, e percuote sotto il sasso b, e risalta in c, e di li si leva in alto, ragirandosi in q., e le cose sospinte in f. dall'acqua percossa nel sasso b., infra angoli equali, risaltan [per] sotto la medesima linia q. b., cioè per la linia b. c., e la cosa, che qui si trova, va ragirando più che quelle che percotano il sasso infra angoli disequali, imperò che queste, ancora che si vadino regirando, esse [ne] fuggano insieme col moto del fiume." The accompanying diagram is unfortunately too faint to reproduce legibly.

176

*Figure 6*
Movement of water. MS C,
fol. 26r.

advantage of this method of description is clearly that it allows Leonardo to record the sequence of movements as in the following note, "Here the water close to the surface performs as you see, rebounding upwards and backwards in the impact, and the water that rebounds backwards and falls above the angle of the current goes under and does as you see above in a, b, c, d, e, f"[16] (fig. 5).

Leonardo certainly visualized his Treatise on Water as illustrated by countless such diagrams. Already some of the pages in MS C of 1490 (fig. 6) show the form which such a book might ideally have taken. He returns to it particularly in MSS A and F (figs. 7 and 8) and in some pages of the Codex Leicester. Some openings of Carusi's and Favaro's edition of the Codice Barberiniano, *Del Moto e Misura dell'Acqua*, give perhaps a fairer idea of the place Leonardo wished to assign to these diagrams than any selection made on the ground of their visual merit.

[16] "Qui l'acqua vicina alla superfitie fa l'ufficio che vedi, risaltano in alto e indietro nel suo percotersi, e l'acqua che risalta indietro e cade sopra l'angolo della corrente, va sotto a fa come vedi di sopra in a, b, c, d, e, f" (MS F, fol. 20r).

Yet, if anything is striking in these studies and notes about water, it is the predominance of the word and the role assigned to language. Whether he knew it or not, in the *paragone* between word and image the word was here very often in the lead.

There is much talk in contemporary art criticism and art teaching about the alleged difference between "verbal types" and "image types." The artist is said to be an "image type" and concern is frequently expressed lest his mind be corrupted by too much contact with the discipline of language. Nobody, of course, who has read through Leonardo's notes can doubt the importance that linguistic articulation held for him. His notes on water in particular show his striving for mastery of this medium; he quite systematically builds up a vocabulary of words and concepts with which to catch and evoke the fleeting variety of phenomena and fix them in his mind.

The patience with which he lists, divides, and subdivides these phenomena may well outlast the patience of the modern student of these notes. Indeed, no less an admirer of Leonardo than A. E. Popham has pronounced them to be almost unreadable.[17] And yet if one tries to work through this mass of notes, they acquire a singular fascination. Somehow the manner and the matter appear to fuse. Like the elusive phenomena they seek to describe and to capture, the stream of language meanders leisurely around obstacles only to rush headlong into abysses of metaphysical speculations where it turns and remains on the spot, seemingly caught in an impossible position from which there is no escape. Suddenly a fresh thought shoots up from the depths and the ideas flow again in eddies and waves seeking the central ocean of Leonardo's view of the universe and of the role that the elements are destined to play in its life and its death.

I shall not and cannot submit you to this ordeal by description and repetition, but it is essential to my theme that I give you at least an idea of this astonishing effort on the part of Leonardo to make his language sufficiently pliable to describe and to analyse the movement of water. There is a note in MS I, dating, it is believed, from *circa* 1497–1499, which simply lists an incredible number of words that may be used in the description of water flow: *Risaltazione, circolazione, revoluzione, ravvoltamento, raggiramento, sommergimento, surgimento,* and so on through sixty-seven concepts, such as *veemenzia, furiosità, impetuosità, concorso, declinazione, commistamento.*[18]

You see that when Leonardo penned his famous descriptions of the Deluge he could draw on this rich thesaurus of words and phrases he had collected himself.

---

[17] *The Drawings of Leonardo da Vinci* (London, 1946), p. 94.

[18] "Sommergere, s'intende le cose ch'entrano sotto l'acque. Intersegazione d'acque, fia quando l'un fiume sega l'altro. Risaltazione, circolazione, revoluzione, ravvoltamento, raggiramento, sommergimento, surgimento, declinazione, elevazione, cavamento, consumamento, percussione, ruinamento, discenso, impetuità, retrosi, urtamenti, confregazioni, ondazioni, rigamenti, bollimenti, ricascamenti, ritardamenti, scatorire, ver- sare, arriversciamenti, riattuffamenti, serpeggianti, rigore, mormorii, strepidi, ringorare, ricalcitrare, frusso e refrusso, ruine, conquassamenti, balatri, spelonche delle ripe, revertigine, precipizii, reversciamenti, tomulto, confusioni, ruine tempestose, equazioni, egualità, arazione di pietre, urtamento, bollori, sommergimenti dell'onde superficiali, retardamenti, rompimenti, dividimenti, aprimenti, celerità, veemenzia, furiosità, impetuosità, concorso, declinazione, commistamento, revoluzione, cascamenta, sbalzamento, conrusione d'argine, confuscamenti" (MS I, fols. 72r, 71v).

But it is not the words that matter here, but their power of creating distinctions and establishing categories. Throughout his life, I believe, Leonardo followed a method that might be called a method of permutation and combination. Far from starting entirely with observation, he asked himself what categories of a given phenomenon might occur a priori, as it were.[19] MS F, dating from some ten years later, is particularly rich in such attempts to map the full range of possibilities for waves or currents or whirlpools.

Of the vortices on the surface and of those created at various depths of the water, and of those which take up the whole of that depth and of the mobile and of the stable ones, of the oblong and the round ones, of those which do not change and those which divide, and of those which convert into those where they join up, and of those which are mixed with falling and reflecting water and turn that water around. What kind of vortices turn light objects on the surface without submerging them, what kind are those that do submerge them and turn them at the bottom and then leave them there, what kind are those that detach things from the bottom and throw them up to the surface of the water, what are oblique vortices and what upright ones and what level ones.[20]

What makes these paragraphs even more awe-inspiring is that their form and context reveal them as plans for more detailed chapters of what Leonardo called "books." Sometimes we find page after page covered with these chapter headings which in their totality are to form a complete encyclopedia of the forms of water and of currents.[21] There is little doubt that in these schemes

[19] "Dell'oncia dell'acqua, e in quanti modi si può variare. L'acqua che versa per una medesima quantità di bocca, si può variare di quantità maggiore o minore per modi, de' quali il primo è da essere più alta o più bassa la superficie dell'acqua sopra la bocca donde versa; il 2°, da passare l'acqua con maggiore o minore velocità da quell'argine dove è fatto essa bocca; 3° da essere più o meno obbliqui i lati di sotto della grossezza della bocca dove l'acqua passa; 4° dalla varietà dell'obbliquità de' lati di tal bocca; 5° dalla grossezza del labbro d'essa bocca; 6° per la figura della bocca, cioè a essere o tonda o quadra, o triangolare, o lunga; 7° da essere posta essa bocca in maggiore o minore obbliquità d'argine per la sua lunghezza; 8° a essere posta tal bocca in maggiore o minore obbliquità d'argine per la sua altezza; 9° a essere posta nelle concavità e convessità dell'argine; 10° a essere posta in maggiore o minore larghezza del canale; 11° se l'altezza del canale ha più velocità nell'altezza della bocca o più tardità che altrove; 12° se il fondo ha globosità o concavità a riscontro d'essa bocca, o più alta o più bassa; 13° se l'acqua che passa per tal bocca piglia vento o no; 14° se l'acqua che cade fuor d'essa bocca cade in fra l'aria ovvero rinchiusa da un lato o da tutti, salvo la fronte; 15° se l'acqua che cade rinchiusa sarà grossa nel suo vaso, o sottile; 16° se l'acqua che cade, essendo rinchiusa, sarà lunga di caduta o breve; 17° se i lati del canale donde discende tale acqua sarà suoli o globulosi, o retti o curvi" (MS F, fol. 9v). There is a similar note on waves in MS I, fols. 87v, 88r-v, translated in E. McCurdy, *The Notebooks of Leonardo da Vinci* (London, 1948).

[20] "De' retrosi superficiali e di quelli creati in varie altezze dell'acqua; e di quelli che piglian tutta essa altezza, e de' mobili e delli stabili; de' lunghi e de' tondi; delli scambievoli di moto e di quelli che si dividono, e di quelli che si convertono in quelli dove si congiungono, e di que' che son misti coll'acqua incidente e refressa, che vanno aggirando essa acqua. Quali son que' retrosi che raggiran le cose lievi in superficie e non le sommergono; quali son quelli che le sommergono e raggiranle sopra il fondo e poi le lascian in esso fondo; quali son quelli che spiccan le cose del fondo e le regittano in superficie dell' acqua; qua' son li retrosi obbliqui, quali son li diritti, qua' son li piani" (MS F, fol. 2r).

[21] A few examples of such lists are printed in Richter, *op. cit.*, nos. 919–928 after C. Leic., fol. 15v, and C. Ar., fols. 35r-v, 45r, and 122r. There are longer such lists in C.A., fol. 74r-v.

Leonardo was influenced by the Aristotelian concept of science as a systematic inventory of the world. He wants to classify vortices as a zoologist classifies the species of animals.

I think I am right in saying that such a classification of whirlpools or of waves would mean little to a modern scientist. He would probably say that the distinction between vortices that carry objects up and those that drag them to the bottom is not valid because the same vortex that spirals down also throws water up. Moreover the concept of turbulence, which he uses to describe the state when normal flow is upset, operates with the idea of randomisation where the path of an individual particle becomes quite unpredictable.[22] Not that he does not also study the forms taken by waves and vortices, but what interests him is that there are, of course, mathematical relationships and these are of a complexity that often causes him to admit defeat.

Leonardo is frequently quoted for his beautiful saying that mechanics is "the paradise of mathematics." [23] A glance into the most elementary text-book of fluid mechanics will convince you that this branch is the hell of mathematics. The arithmetical and geometrical tools at Leonardo's disposal were, of course, utterly far removed from those he would have needed to fulfil the wildly optimistic hope with which he started out—the hope of completely mapping out and explaining any contingency in a field of physics that still eludes such rigid treatment.

The *History of Hydraulics* by Hunter Rouse and Simon Ince devotes only a few pages to Leonardo to turn to the mathematical achievements of Bernoulli in the seventeenth century and of d'Alembert in the eighteenth. But the authors grant that Leonardo should be credited with the formulation of one basic law which is now known as the principle of continuity. It says that "a river in each part of its length in equal time gives passage to an equal quantity of water, whatever the width, the depth, the slope, or the tortuosity." It follows from this principle that (as Leonardo puts it in MS A of 1492) "a river of uniform depth will have a more rapid flow at the narrower section than at the wider, to the extent that the greater width surpasses the lesser." [24]

This correlation, as you will realize, is a matter of thought rather than of sight; it is something that Leonardo reasoned out, not something he can have observed and measured.[25] Once you assume that water cannot be compressed, this principle follows, for the narrower course must then speed up the flow to keep step, as it were, with the wider portions of the river.

I have said that we have learnt to speak with greater respect of deduction than did the historians of science who were so strongly under the spell of Baconian inductivism. And thus we can appreciate again Leonardo's original plan to make the science of water a deductive science starting

[22] J. R. D. Francis, *A Textbook of Fluid Mechanics* (London, 1958). The best introduction to these problems for laymen I have found in O. G. Sutton, *The Science of Flight* (A "Pelican Book") (London, 1955).
[23] MS E, fol. 8v.
[24] "Il fiume d'equale profondità, avrà tanto più di fuga nella minore larghezza, che nella maggiore, quanto la maggiore larghezza avanza la minore" (MS A, fol. 57r). See also MS A, fols. 23v and 57v. Other formulations of the principle of continuity (C. Leic., fols. 6v and 24r; C.A., fols. 80v, b; 80r, b; and 287r, b) are quoted in extenso in F. Arredi, "Gli Studi," etc., as quoted above, n. 4.
[25] G. Bellincioni, "Leonardo e il Trattato del Moto e Misura delle Acque," in *Atti del Convegno di Studi Vinciani* (Florence, 1953), pp. 323–327.

*Figure 7*
Movement
of water.
MS A,
fol. 24*v.*

*Figure 8*
Movement
of water.
MS F,
fol. 92*v.*

from first principles like Euclid's Elements. These principles from which Leonardo started he found, of course, in the traditions of Aristotelian science.

Thus we read in MS C dating from 1490:

> All elements removed from their natural place desire to return to that place, most of all fire, water, and earth. And the more this return is effected along the shortest path, the straighter is that line and the more straight it is, the greater is the impact when it is opposed.[26]

[26] "Quanto più l'acqua correrà per la declinazione d'equale canale, tanto più fia potente la percussione da lei fatta nella sua opposizione. Perchè tutti li elementi, fuori del loro naturale sito, desiderano a esso sito ritornare, e massime foco, acqua e terra; e quanto esso ritornare fia fatto per linea più breve, tanto fia essa via più diritta, e quanto più diritta via fia, maggiore fia la percussione nella sua opposizione" (MS C, fol. 26*r*).

Here was a first correlation that could easily be verified by observation, the difference between a winding and a straight river course, illustrated in the accompanying diagram. It was the exemplification of a cosmic law.

We know with what awe Leonardo looked upon the operation of these laws and with what fascination he sought to reason out the consequences that followed from their universal validity. Thus he devised in the same early note-book, folio 23*v*, what we would call an ideal experiment of a purely deductive character:

> If there were a lake of vast extent without entrance and exit and unruffled by wind, and you removed a minute fraction of the bank below its surface, all the water above that cut would pass through this cut without moving any of the water below.

Leonardo draws a vessel of water covered by a film of oil that can be drained off without making the water stir (fig. 9). "In such a case," we read, "Nature, constrained by the reasons of its law that lives implanted within her, effects that the surface of the water contained within the closed banks remains everywhere at equal distance from the centre of the earth." [27]

Leonardo could not know anything of the friction caused by the current thus created. But, needless to say, this very attempt to construct an ideal situation of what we would call an "ideal flood" testifies much more to his scientific genius than would the alleged accuracy of his eye.

There is a second general law that Leonardo applied in his discussion of movement—the law of reflection or rebound which he drew upon in MS A of 1492: "It is clearly seen and it is known that the waters that strike against the banks of rivers move like balls thrown against the wall which are reflected at similar angles to the angle of their impact and then hit the opposite walls" [28] (fig. 10).

Leonardo as a water engineer was particularly interested in this effect that suggested to him the possibility of predicting the main points subject to erosion. He constantly returns to such situations in which the water is obstructed on one bank and through the consequent rebound

[27] "Ogni parte d'acqua, infra l'altra acqua senza moto, diace di pari riposo con quella che nel suo livello situata fia. Qui la esperenzia ne mostra che, se fussi un lago di grandissima l'arghezza, il quale in sè diacesse senza moto di vento d'entrata o d'uscita, che tu levassi una minima parte dell'altezza di quella argine che si trova dalla superficie dell'acqua in giù, tutta quell'acqua, che si trova dal fine di detta tagliata argine in sù, passerà per essa tagliatura e non move o tirerà con seco fuori del lago alcuna parte di quella acqua, dove essa acqua mossa e partita diaceva. In questo caso, la natura, costretta dalla ragione della sua legge, che in lei infissamente vive—che tutte le parti di quella superficie dell'acque che senza alcuna entrata o uscita sostenute sono, equalmente dal centro del mondo situate sono. La dimostrazione, si è di sopra: diciamo che l'acqua del detto lago da argine sostenuta sia *n o a f*, e che *n m r a* sia olio sopra a essa acqua sparso, e che essa tagliatura dell'argine, sia *m n*. Dico che tutto l'olio che si trova da *n* in su, passerà per essa rottura, senza muovere alcuna parte dell'acqua a lui sottoposta" (MS C, fol. 23*v*).

[28] "Si vede chiaramente e si conoscie che le acque che percuotano l'argine de' fiumi, fanno a similitudine delle balle percosse ne' muri, le quali si partano da quelli per angoli simili a quelli della percussione e vanno a battere le contraposte pariete de' muri" (MS A, fol. 63*v*).

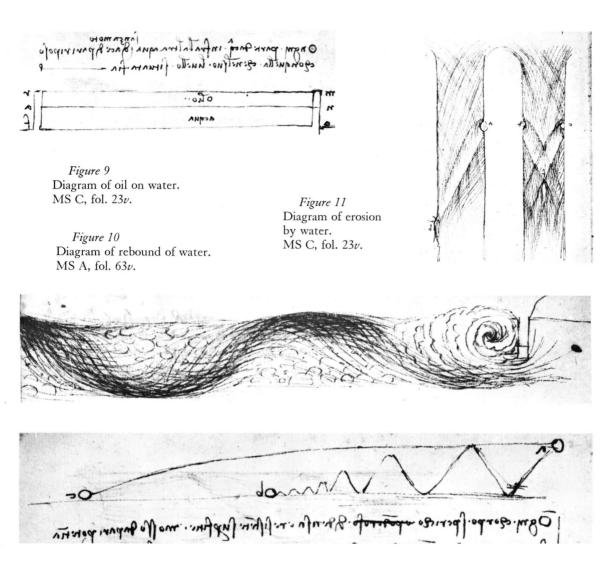

*Figure 9*
Diagram of oil on water.
MS C, fol. 23v.

*Figure 10*
Diagram of rebound of water.
MS A, fol. 63v.

*Figure 11*
Diagram of erosion
by water.
MS C, fol. 23v.

*Figure 12*
Diagram of the law of
rebound. MS A, fol. 24r.

damages the opposite bank [29] (fig. 11). But as a theoretical physicist the comparison between the bouncing ball and the reflection of water held an even greater promise for him. For this movement of the ball, so he thought, followed a strict law not only in its shape but also in the length of the path traversed. He was convinced, as we know from MS A, that if you throw a ball obliquely to the ground its zigzag path between the bounces will be exactly as long, and take as much time for completion, as if you had thrown the ball horizontally through the air (fig. 12).

[29] MS C, fols. 24v and 26r.

183

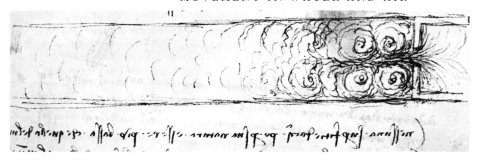

*Figure 13*
Vortices
of water
turning back.
MS A, fol. 60*v*.

He clearly attached immense importance to this imaginary law which you might compare with the law of the preservation of energy: "Oh, how miraculous is thy Justice, First Mover! Thou didst not want to deprive any force of the order and equality of its necessary effects!" [30]

For Leonardo this law followed from another of Aristotle's premises and its application will show you the bearing all this had on Leonardo's preoccupation with vortices:

Quite generally—we read in the same early note-book—all things desire to maintain themselves in their nature. Hence the current of water desires to maintain its course according to the force that caused it, and when it finds an opposing obstacle, it completes the length of the initiated course by circular and whirling movements.[31]

These movements, too, "will traverse the same length during the same time as if the path had been straight." [32] Combine this law with the principle of continuity and you have the explanation of the vortices Leonardo was so fond of drawing, curling outward when the course of the water widens. For this widening of the river-bed must slow the water down and thus create an obstacle for the water rushing in at greater speed that has to be compensated for in turning movements [33] (fig. 13):

[30] "O mirabile giustizia di te, primo motore! Tu non ai voluto mancare a nessuna potenzia l'ordine e [e-] qualità de' sua necessari effetti" (MS A, fol. 24*r*).

[31] "Universalmente, tutte le cose desiderano mantenersi in sua natura, onde il corso dell'acqua che si move, ne cerca mantenere il [suo corso], secondo la potenza della sua cagione, e se trova contrastante opposizione, finisce la lunghezza del cominciato corso per movimenti circolari e retorti" (MS A, fol. 60*r*). The Aristotelian source of the opening proposition is quoted by Leonardo in C.A., fol. 123*r, a:* "Dice Aristotile che ogni cosa desidera mantenere la sua natura."

[32] "Ogni movimento fatto da forza, conviene che faccia tal corso, quanto è la proporzione della cosa mossa con quella che move; e s'ella trova resistente opposizione, finirà la lunghezza del suo debito viaggio per circular moto o per altri vari saltamenti o balzi, i quali, computato il tempo e il viaggio, fia come se il corso fussi stato senza alcuna contraddizione" (MS A, fol. 60*v*).

[33] "L'acqua, che per istretta bocca versa declinando con furia ne' tardi corsi de' gran pelaghi, perchè nella maggior quantità è maggior potenza, e la maggior potenza fa resistenza alla minore, in questo caso, l'acqua sopravvenente al pelago e percotendo la sua tarda acqua, quella, sendo sostenuta da l'altra, non può dare loco, onde colla conveniente prestezza, a quella sopravvenente, non volendo attardare il suo corso, anzi, fatta la sua percussione, si volta indietro seguitando il primo movimento; con circolari retrosi finisce al fondo il suo desiderio, perchè in detti retrosi non trova se non è il moto di se medesima, colla quale s'accompagnan le volte l'una dentro all'altra, e in questa circulare revoluzione la via si fa più lunga e più continuata perchè non trova per contrasto se non se medesima e questo moto rode le rive consumate con deripazione e ruina d'esse" (MS A, fol. 60*r*). See also C.A., fols. 354*r, e* and 361*r, b.*

184

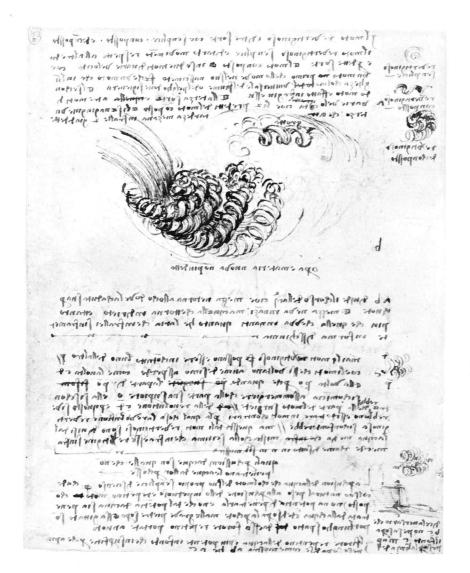

*Figure 14*
Waterfall and
corkscrew waves.
Windsor 12663r.

These movements, we have seen, will be exactly proportionate to the impulse that creates them. A waterfall, therefore, will necessitate a much greater length of vortex movements—all the more as Leonardo could not know how much of its energy is transformed into heat by friction.

I believe that Leonardo's diagrams of water become much clearer and even more beautiful if you read them as they were intended to be read, as illustrations of this interlocking system of axioms. The extended corkscrew eddies in the Windsor drawing no. 12663r (fig. 14) are a case in point. They are neither stylized nor observed; they are an indication of the strength of the water's impact which spends itself in these spiralling movements.

But the drawing also illustrates the complexity that Leonardo's thoughts had reached in the

185

treatment of these laws. For it was clear that in almost every given case the various factors or principles he saw at work would combine in shaping the movement observed. The principle of continuity, the movement of the river following the tendency of the water to seek its place nearest to the centre of the earth, the reflections and eddies on meeting obstacles, and the extra impetus caused by a waterfall—all had to be taken into consideration in accounting for the actual movement.[34]

One of Leonardo's most famous illustrated notes on water (fig. 15) is designed to exemplify such a combination. It is the note accompanying Windsor 12579r:

> Observe the motion of the surface of water, which resembles that of hair, which has two motions, one of which depends on the weight of the hair, the other on the direction of the curls; thus the water forms turning eddies, one of which follows the impetus of the main course, while the other follows that of incidence and reflection.

The point Leonardo here wishes to make is actually rather simple. He wants to remind us only of two factors, the spiralling movement of the vortex and the forward pull of the river.[35] Leonardo sometimes called the resulting formation a column-shaped wave.[36] The meeting and crossing of these waves and the resulting eddies were also to be systematized in the Treatise on Water.

Once more I should like to mention the staggering boldness and optimism of this programme to which Leonardo devoted so much time and effort. He knew that the phenomenon of the wave differed in principle from that of water flow. Dr. Keele, in his contribution, has quoted the famous passage in which Leonardo described and analysed the effect of throwing a stone into a stagnant pool with the ripples spreading outwards in ever widening circles,[37] adding that the movement of the waves did not shift the water masses, for he had observed the floating objects on the pond

---

[34] Windsor no. 12579r (Richter no. 389).

[35] A more complex example of this interaction is discussed on the drawing Windsor no. 12663r (fig. 14): "Il moto revertiginoso e di tre sorte, cioè semplice, conposte, e decomposte; il moto revertiginoso semplice e di tanto movimento respetto all'altre due predette sorte; e il moto conposto e in se due moti di varie velocità, cioè un moto primo ch'ello move nel suo nascimento, che è un moto in lunghezza chol moto universale del fiume o del pelago dove si genera, e 'l secondo moto e fatto infra giù e sù, e la terza sorte à tre moti di varie velocità, cioè li 2 predetti del moto composto, e li se agiunge un terzo che a tardezza mezzana infra 2 già dette." I owe a paleographic transcript of this text, which I have ventured to normalize, to Prof. Pedretti. An even more complex description which illustrates the cumulative effect of these interactions on Leonardo's style is in MS I, fol. 78v: "I retrosi son alcuna volta molti che mettano in mezzo un gran corso d'acqua, e quanto più s'appressano al fine del corso, più son grandi: e si creano in superficie per l'acque che

to[r]nano indietro dopo la percussione ch'esse fanno nel corso più veloce, perchè sendo le fronti di tale acque percosse dal moto veloce, essendo esse pigre, subito si trasmutano in detta velocità, onde quella acqua che dirieto l'è contingente e appiccata, è tirata per forza e disvelta dall'altra, onde tutta si volterebbe successivamente, l'una dirieto all'altra, con tal velocità di moto, se non fussi che tal corso primo non le può ricevere se già non s'alzassino di sopra a essa, e questa non potendo essere, è necessario che si voltino indirieto e consumino in se medesimo tali veloci moti, onde con varie circulazioni, dette retrosi, si vanno consumando i principiati impeti—e non stanno fermi, anzi, poi che son generati così girando sono portati dall'impeto dell'acqua nella medesima figura: onde vengono a fare 2 moti, l'uno fa in sè per la sua revoluzione, l'altro fa seguitando il corso dell'acqua che lo transporta, tanto che lo disfa."

[36] E.g., MS F, fol. 19r.

[37] MS A, fol. 61r. For a full translation, see Heydenreich, op. cit., I, 146–147.

*Figure 15*
Curls and waves
of water.
Windsor 12579*r*.

bobbing up and down on one spot. Leonardo's splendid intuition also grasped the comparison of this swaying motion with waves appearing to run over a cornfield without the individual stems being shifted from their place.[38] He also knew that this propagation of an impulse could be observed in moving water when the resulting circles would turn into elongated ovals,[39] and, if I interpret another passage correctly, he saw that the two movements of water and impetus could cancel each other out, resulting in a standing wave.[40]

I have tried to consult eminent specialists in hydrodynamics about the way these forces interact in a turbulent river, but they only shook their heads or shrugged their shoulders. There are too many variables; the forces at work are quite beyond computation even with modern means.

[38] "L'impeto è molte più veloce che l'acqua, perchè molte son le volte, che l'onda fugge il loco della sua creazione e l'acqua non si move del sito, a similitudine dell'onde fatte il maggio nelle biade dal corso de' venti, che si vede correre l'onde per le campagne, e le biade non si mutano di lor sito" (MS F, fol. 87*v*).

[39] C. Leic., fol. 14*v*.
[40] C.A., fol. 354*v*: "L'onda dell'impeto alcuna volta è immobile nella grandissima corrente dell'acqua, e alcuna volta è velocissima nell'acqua immobile, cioè nelle superficie de' paludi, perchè una percussione sopra dell'acqua fa più onde."

187

But Leonardo hoped originally to account for every eddy, and this despite the fact that he had to consider further complications arising from the interaction of water with the other elements. The earth of the river-bed and of the bank exerted friction that slowed down the movement of water in its vicinity,[41] as he was able to observe by watching the varying height of eddies caused by sticks placed at varying distance from the shore.[42] The earth carried in the turbulent water, increased its weight and therefore its impact.[43]

There is, in addition, the element of air which gets caught in falling water and desires to return to its proper place. In the Windsor drawing that investigates the effect of this contrary movement on the eddies (fig. 14) we find the characteristic heading *opera e materia nuova non più detta*, "new work and matter not treated previously." It concerns the idea that what impedes some of the water from following the course of the river downwards is the captured air in the form of foam. It is this air-cushion that prevents the vortices which turn in different directions from interfering with each other and cancelling each other out.[44]

I hope that even this selection of Leonardo's ideas [45] may enable us to return to our first example, Windsor 12660*v* (fig. 2), with fresh eyes and also to appreciate the text:

The movements of the falling water after it has entered the pool are three in kind and to these must be added a fourth which is the movement of the air that is drawn into the water by the water. And this is the first, and let it be the first to be defined; and let the second be that of the air drawn into water, and the third the movement of the reflected waters after they have yielded up the compressed air to the other air; when that water has risen in the shape of large bubbles it acquires weight in the air and hence falls back on to the surface of that water, pene-

---

[41] MS H, fols. *36v, 45r;* MS I, fol. *58r;* C.A., fols. *124r, a; 175r, c,* all quoted by F. Arredi, "Gli Studi," as quoted above, n. 4.

[42] "L'acqua, che correrà per canale d'eguale latitudine e profondità, fia di più potente percussione nello obbietto che si opporrà nel traverso mezzo, che vicino alle sue argini. Se metterai un legno per lo ritto in *f,* l'acqua percossa in detta opposizione, risalterà poco fuori della superficie dell'acqua, come appare nella sperienza *s;* ma se metterai detto legno in *a,* l'acqua si leverà assai in alto . . ." (MS C, fol. 28*v*).

[43] "L'acqua torbida fia di molta maggiore percussione nella opposizione del suo corso, che non fia l'acqua chiara" (MS C, fol. 28*r*); see also C.A., fol. 330*v, b:* "Delle materia intorbidatrice dell'acqua à il suo discenso tanto più o men veloce, quanto ella è più o men grave."

[44] "Opera e materia nuova, non più detta.

a b divide il corso dell'acqua, cioè mezza ne torna al loco dove la caduta sua percuote, e mezza ne va innanzi. Ma quella che torna indietro è tanto più che quella che va innanzi quanto è l'aria che infra lei si inframmette in forma di schiuma. Mai li moti revertiginosi possono essere in contatto l'uno dell'altro, cioè li moti che si voltano a un medesimo aspetto, come la volta c d, e la volta p o, perchè quando la parte di p o si comincia a sommergere colla parte sua superiore o, ella s'incontrarebbe nella parte del moto surgente della revoluzione c d, e per questo si verebbono a scontrare in moti contrari, per la qual cosa la revoluzione revertiginosa si confonderebbe; ma questi tali moti revertiginosi sono divisi dall'acqua media mista colla schiuma che infra esse revertigine s'inframmette, come di sotto in n.m. si dimostra.

quali percussioni d'acque son quelle che non penetrano le acque da lor percosse" (Pedretti's transcription; see above, n. 35).

[45] I cannot stress enough that it is a mere selection and that I have not even alluded to many other very persistent preoccupations of Leonardo, e.g., the way one watercourse may influence the direction of another into which it issues, or the relation of speed and deposits. Other problems I have omitted because I failed to catch Leonardo's meaning.

trating it as far down as the bottom, hitting and eating away that bottom. The fourth is the swirling movement on the surface of the pool of the water that returns to the place of its impact since it lies at a lower level between the falling and the reflected water. There is to be added a fifth motion called the welling motion, which is the movement of the reflected water when it carries up the air to the surface that was submerged with it.

I have seen in watching the impact of ships that the water below the surface observes its revolutions more completely than the one that lies open to the air, and the reason for this is because water has no weight within water but water has weight within air. Hence water that moves within stagnant water has as much strength as has the impetus that is imparted to it by the moving object and this impetus consumes itself in the aforementioned revolutions.

That part of the impetuous water, however, that finds itself between the air and the other water cannot carry out so many [revolutions], because its weight impedes its agility and therefore it cannot complete the whole revolution.[46]

I ventured to quote this long and, in every sense of the word, tortuous passage because it surely illustrates my point that a drawing like this must be read as a diagram visualizing Leonardo's theoretical propositions rather than a kind of snap-shot achieved by a miraculous pair of eyes. Clearly some of these propositions are correct while others would not be accepted in this form by modern scientists.

You will have observed, for instance, that despite the distinction that we saw Leonardo make between wave movement and flow he here seems to equate waves with incomplete vortices, that is, with a flow pattern. He was even partly right, in so far as the individual particle in a wave tends to move up and down in a wheel-like motion, but here Leonardo's partial insight sometimes misled him into drawing waves curling backwards, as if the undulation itself strove to complete the circle.[47]

---

[46] Having translated this note in the text, I have ventured to retain it here in the paleographical transcription I owe to Prof. Pedretti:

"Li moti delle chadute dellacque (*dentr*) poi chella e dentro assuo pelagho sono dj tre spetie (*de*) e acquestj / se ne agiugnie il quarto che e quel dellaria chessi somergie in sie [= insieme] chollacqua e cquesto e il p° inatto effia il p°/ che sara djfinjto il 2° fia quello dessa aria somersa el 3° e quel cheffano esse acque refresse poiche / lan rēduta la inpremutata aria allaltra aria laquale poi chettale acqua essurta infigura dj grossi / bollorj acqujsta peso infrallaria e dj quella richade nella superfitie dellacqua penetrãdo(*q*)la insino al fõdo e (*que*) e esso fondo percote e chonsuma il 4° e il moto (*che*) revertiginoso fatto nella pelle del pelagho / dellacqua che ritorna indjrieto allocho della sua chaduta chome (*locho*) sito piu basso che ssinterpong/ha in fra lacqua refressa ellacqua incidēte . agivnjerasi il quīto moto detto moto rivellan/te (*e*) il quale e il moto cheffa lacqua refressa (*ch*) quandella riporta laria che collej si somerse alla su/perfitie dellacqa.

oveduto nelle perchussione delle nave lacqua sotto lacqua osservare piu integral/mente la revolutione delle sue inpressionj chellacha che chõfina chollaria ec / e quessto nascie perche lacqua infrallacqua nõ pesa (*chome*) ma pesa lacqua / infrallaria . per la qual chosa . essa acqua che chessimove infrallacqua immobile / tanto a dj potentia quãto ella potentia dellinpeto acquella chongiũtali dal suo / motore il quale se (*stessa*) medesimo consuma cholle predette revolutionj.

ma la parte delacqua inpetu/osa chessitrova infrallaria ellal/tra acqua nõ po osservare (*e*) chõ / ta tēpo il deto inpeto perche la ponde/rosita la inpedjscie proibendole lagilita / effacilita del moto e per questo nõ finjsscie la / intera revolutione."

[47] Cf. the allegorical drawing Windsor no. 12496 (Popham no. 125).

189

To stress this "deductive" and theoretical character of many of Leonardo's diagrams, however, does not necessarily mean that the formations he illustrated could not really occur in nature. Just as Ptolemy's system of astronomy was capable of "saving the phenomena" observed in the night sky, so Leonardo's largely Aristotelian mechanics could frequently be moulded to accommodate what he saw. It is no criticism of his genius to say that the modern high-speed camera sees more and occasionally sees differently. Some of the forms of movement it frequently records cannot be matched from any of Leonardo's studies, but several can be. Many of Leonardo's drawings of vortices arising immediately behind an obstacle with the water or air curling round and back against the stream from both sides show a close resemblance to certain photographs made of similar patterns (figs. 16 and 17). Whether it is necessary to attribute this similarity to Leonardo's rapid and acute vision is perhaps another matter.[48] Actually an ideal vortex can result in an almost static pattern and can be watched at leisure.[49]

But we have seen that it would still be dangerous to infer that Leonardo looked upon these vortices in the same light as the modern scientist does. There is evidence that his interest in this whole phenomenon was sparked off by another legacy of Greek science which had occupied the mind of man for many centuries. It is the idea that nature abhors a vacuum and that any displacement occurring in a fluid which threatens to cause such a vacuum is therefore immediately compensated for by a contrary movement filling the vacant place. The first detailed description of this circular movement occurs in Plato's *Timaeus* where the consequence of breathing is discussed:

Inasmuch as no void exists into which any of the moving bodies could enter, while the breath from us moves outwards, what follows is plain to everyone, namely, that the breath does not enter a void but pushes the adjacent body from its seat; and the body thus displaced drives out in turn the next; and by this law of necessity every such body is driven around towards the seat from which the breath went out and enters therein, filling it up and following the breath; and all this takes place as one simultaneous process, like a revolving wheel, because no void exists.[50]

Plato connects this circular movement with the circulation of the elements in the universe. There is no proof that Leonardo knew this particular passage, but there is, of course, a famous

---

[48] For some exquisite photographs and instructive diagrams, see Theodor Schwenk, *Sensitive Chaos, The Creation of Flowing Forms in Water and Air* (London, 1965); and also Francis, *op. cit.*, pl. 8.

[49] MS H, fol. 16r. There is a most interesting record of introspection in MS A, fol. 58v, in which Leonardo tries to account for the sensation that water moves more rapidly than it does: "Perchè il movimento dell'acqua, benchè sia più tardo che quello dell'omo, pare sempre più veloce. La ragione di questo si è, che se tu riguardi il movimento dell'acqua, l'occhio tuo non si più fermare, ma fa a similitudine delle cose vedute nella tua ombra, quando cammini, che se l'occhio attende a comprendere la qualità dell'ombra, le festuche o altre cose che sono contenute da essa ombra, paiono di veloce moto, e parrà che quelle sieno molto più veloci a fuggire, di detta ombra, che l'ombra a camminare."

[50] Plato, *Timaeus*, 79B. I use the translation by R. G. Bury in Loeb's Classical Library. My attention was drawn to this passage and its implications for Leonardo studies by Sir Karl Popper.

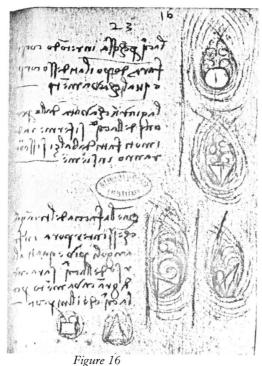

*Figure 16*
Diagram of eddies. MS H,
fol. 16*r*.

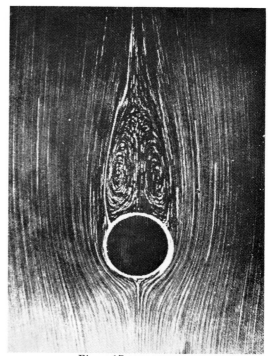

*Figure 17*
Modern representation of flow
behind cylinder.

critical reference to Plato's *Timaeus* in MS F in connection with the geometrical theory of elements.[51] There are many instances, though, where this kind of reasoning influenced Leonardo's thought. He postulated in MS A that the movement on the surface of the water must be compensated by a contrary movement along the bottom, attributing such a movement also to the depth of the sea.[52] Even his theory of the times in which the attraction of the moon is rejected relies on this idea of a contrary motion due to the water of rivers pushing into the ocean [53] (fig. 18).

[51] MS F, fol. 27*r* (Richter no. 939).

[52] "Ogni acqua, che per innondazione move la sua superficie per un verso, si move nel suo fondo per contrario corso. Questa ragione si prova in questa forma, cioè: noi vediamo al mare mandare le sue onde inverso la terra, e benchè l'onda che termina colla terra sia l'ultima delle compagne e sia sempre cavalcata e sommersa dalla penultima, non di meno la penultima non passa di là da l'ultima, anzi, si sommerge nel luogo dell'ultima, e sendo così sempre questo sommergimento in continuo moto, dove il mare confina con la terra, è necessario che dopo quello sia un contrario moto in sul fondo del mare, e tanto ne torna di sotto, inverso la cagione del suo movimento, quanto esso motore ne

caccia da sè da la parte di sopra" (MS A, fol. 57*v*). This is one of several passages indicating that Leonardo did not always distinguish clearly between wave motion and flow. It is interesting to note that, according to a recent handbook of oceanography, "certain phenomena that appear to be associated with breakers are not yet understood. The existence of undertow has not been satisfactorily explained, and is doubted by some observers" (H. v. Sverdrup, Martin W. Johnson, and R. H. Fleming, *The Oceans* [New York, 1942], p. 537).

[53] "Del frussi e reflusso del mare e sua varietà: corre l'onda del fiume contra al suo avvertimento . . . el ritirno dell'onda alla riva . . ." (C.A., fol. 281*r, a*).

191

But the most important role was reserved for this theory of reflow in Aristotle's physics where it became known as the theory of *antiperistasis*.[54] It is well known that this much debated theory arose in answer to an obvious difficulty created by Aristotle's theory of motion. He believed that here on earth, or rather in the sublunar sphere, rest was the normal state for things in their proper place and that movement could only displace them contrary to their inherent tendency as long as they were pushed. Once contact with the pushing force was lost they should therefore return to their proper position. Unfortunately, this deduction could not be reconciled with the simple fact that a stone continues to fly upwards when it has left the throwing hand, and an arrow when it has left the string. It was here that the theory of reflow into a vacuum was stretched to avoid a break-down. Displacing the air the stone or arrow would create a void in its wake and hence the air would rush in, curling back and pushing the projectile forward.

Aristotle himself had qualms about this simple explanation, but the idea that the cause of the motion must lie in the medium was retained for a long time. It was certainly accepted by Leonardo, as is well known, in his first Milanese period.[55] We find a graphic description and illustration in MS A where he interprets the acceleration of a body falling through the air as due to the push and pull of the air eddies it creates and compares it with the movement of a boat through water: ". . . And since no place can be a vacuum, the place whence the boat leaves desires to close and creates a force like a cherry-stone pressed between the fingers, and creating this force it presses and catches the boat."[56]

The comparison, added in the margin of the note, between the action of the medium and that of the fingers that make a slippery cherry-stone shoot forward could not be more clear nor more plausible.

There is a similar account in the Codex Atlanticus intended to explain why fish move faster in

[54] For a full discussion of this theory and the debates on "impetus" it necessitated, see A. Maier, *Zwei Grundprobleme der scholastichen Naturphilosophie* (Rome, 1951).

[55] Much of the evidence is assembled in A. Uccelli, *I Libri del Volo di Leonardo da Vinci* (Milan, 1952), pp. 29–32.

[56] ". . . Essendo adunque quest'aria sospinta, ella ne sospigne e caccia dell'altra e genera dopo sè circolari movimenti, de' quali il peso mosso in essa è sempre centro, a similitudine de' circoli fatti nell'acqua, che si fanno centro del loco percosso dalla pietra, e così, cacciando l'un circolo l'altro, l'aria ch'è dinnanzi al suo motore, tutta per quella linea è preparata a movimento, il quale tanto più cresce, quanto più se l'appressa il peso che la caccia: onde trovando esso peso men resistenza d'aria, con più velocità raddoppia il suo corso a similitudine della barca tirata per l'acqua, la quale si move con difficoltà nel primo moto, benchè il suo motore sia nella più potente forza, e quando essa acqua, con arcuate onde, comincia a pigliare moto, la barca seguitando esso moto, trova poca resistenza, onde si move con più facilità; similmente la ballotta, trovando poca resistenza, seguita il principiato corso, insino a tanto che, abbandonata alquanto dalla prima forza, comincia a debolire e declinare. Onde, mutato corso la preparata fuga fattale dinnanzi dalla fuggente aria, non le servono più, e quanto più declina, più trova varie resistenze d'aria e più si tarda, insino a tanto che ripigliando il moto naturale, si rifà di più velocità. Ora io concludo, per la ragione della ottava proporzione, che quella parte del moto che si trova tra la prima resistenza dell'aria e il principio della sua declinazione, sia di maggiore potenza, e questo è il mezzo del cammino, il quale è fatto per l'aria con retta e diritta linea. E perchè nessun loco può esser vacuo, il loco donde si parte la barca, si vuol richiudere e fa forza, a similitudine de l'osso delle ciliege dalle dita premuto, e però fa forza a preme e caccia la barca" (MS A, fol. 43*v*).

*Figure 18*
Representation
of the theory
of tides. Codex
Atlanticus,
fol. 281r, a.

water than birds in the air, though air being thinner one would expect the opposite. I am far from sure that Leonardo's observation was correct but his explanation again draws on *antiperistasis:*

> This occurs because water in itself is denser than air and hence heavier and for this reason it is faster in filling up again the vacuum that the fish leaves behind it. Also the water that it strikes in front is not compressed as is the air in front of the bird and creates a wave that by its movement prepares and augments the movement of the fish.[57]

Some of these ideas actually remained with Leonardo throughout his life. Thus we find in the late MS G, which dates from after 1510, a famous comparison between the body of fishes and of

[57] C.A., fol. 168*v*, *b*, quoted by Uccelli, *op. cit.*, p. 32.

well-built boats, which is sometimes quoted to show Leonardo's anticipation of the stream-line principle (fig. 19). But this is only one side of the story. The text reads:

> These three ships of equal size, length, and depth below the water, moved by the same force will move at different speeds because that ship that directs its broad end forward is faster, for it is like the shape of birds and of fish. And such a ship divides in front and at the sides a large quantity of water which, with its revolutions, pushes the boat from two-thirds of its length behind. . . .[58]

Of course Leonardo was wrong in believing that the shape of the rear end would make the water push the boat forward, though he was right in so far as this shape prevents drag and facilitates the forward movement.

It is well known that by this time Leonardo had explicitly rejected the idea of *antiperistasis*, at least as far as the action of the air was concerned. There is a long discussion of the impossibility of this notion in the Codex Leicester which leaves no doubt on this score.[59] But a habit of mind is not so easily discarded, least of all after the age of fifty. The theory had focused his attention on phenomena which are both striking and widespread—the backward turning of fluids—and these movements continued to engage his interest to the end. Thus he explained the closing of the valves of the heart by the turning movement of the blood [60] and I am told by Dr. Keele that he may well have been right in this surmise.

It is important to remember at this point that for all its absurdity Aristotle's theory had a supreme virtue which made it hard to give it up. I mean that virtue of simplicity that can subsume the most disparate phenomena under one unitary law. To-day, if I understand these matters rightly, physicists are puzzled by the apparent independence of the basic forces of attraction in nature, the force of gravity and the electro-magnetic forces that account for the cohesion of matter. Aristotle could explain both these tendencies by the formula that all things desire to maintain their nature. In ordinary life this desire manifests itself in the elasticity of objects—though neither Aristotle nor Leonardo had a separate word for this important concept. The bow or the spring that bounces back when deformed is the most obvious illustration of this "law" which any engineer would come across,[61] but Leonardo, in a characteristic passage, uses it also to account for the form of draperies (fig. 20):

[58] "Questi 3 navigli, d'eguale larghezza, lunghezza e profondità, essendo mossi da egual potenzie, faran varie velocità di moti, imperocchè il naviglio che manda la sua parte più larga dinanzi è più [ve]loce ed è simile alla figura delli uccelli e de' pesci muggini; e questo tal naviglio apre da lato e dinanzi a sè molta quantità d'acqua, la qual poi colle sue revoluzioni strigne il naviglio dalli due terzi indirieto: e l contrario fa il naviglio *d c*, e l *d* [= *e*] *f* è mezzano di moto in fra li due predetti" (MS G, fol. 50*v*).

[59] C. Leic., fol. 29*v;* see also C.A., fol. 176*v, c.*

[60] Keele, *op. cit.,* p. 83 (after Q. IV, fol. 11*v*).

[61] Leonardo used the "force" of elasticity in various novel mechanical devices, relying on twisted ropes or on springs. The most interesting of these attempts to prolong the effect through coupling a series of springs (MS B, fol. 50*v*) ensuring a continuous movement; cf. Ivor B. Hart, *The World of Leonardo da Vinci* (London, 1961), pp. 304–305.

Everything by nature desires to maintain its being. Drapery being of equal density and thickness on both sides desires to remain level; hence when it is constrained by some fold or plait to depart from that flatness, you can observe the nature of that force in that part where it is most constrained. . . .[62]

The nature of the force that Robert Boyle was to call elasticity is, I believe, the model of all force for Leonardo. The central importance that the idea of "percussion" assumed in his early physiology of the senses, so clearly brought out by Dr. Keele in his contribution to this symposium,[63] confirms this interpretation. Leonardo's much quoted notes on the nature of force, likewise dating from the first Milanese period, also fall into place. They sound indeed less mystical if we assume that in writing them Leonardo thought of the release of a catapult or the uncoiling of a spring, where the force is really "created and infused by accidental violence . . . giving to these bodies the likeness of life . . . it lives by violence and dies by liberty . . . it dwells in bodies outside their natural course and habit . . . it exists throughout the body where it is caused . . . no sound or voice is heard without it." [64]

What inspired Leonardo was probably the realization that given the physics of Aristotle all force is ultimately of this kind. The theory of *antiperistasis* is a theory of elasticity, the medium through which the body moves bounces back and compels the projectile forward. Indeed it winds and unwinds not dissimilar to a coil or a spring. But even all natural movement, free fall no less than the upward rise of air or of fire, is seen as the consequence of that same law that all things desire to maintain their natural place. To lift a stone up and let it fall is no different, in principle, from stretching a rubber band and releasing it. Unless prevented by obstacles, it will seek its proper place near the centre of the earth.[65]

Looked upon in this way, the universe is like an enormous, wound-up clock; the forces we observe in it are due to previous violent actions that create movement. Water runs downhill because heat had drawn it up;[66] its force and fury is the function of its desire to return,[67] just as in one of the most poetic of all Leonardo's passages the desire of the soul to return is a desire for its undoing, for the release of the spring.[68]

It was no minor matter for Leonardo when this unified theory appeared to give way under the

[62] Ash., fol. 4r (Richter no. 390).

[63] This volume, p. 40.

[64] C.A., fol. 302r (Richter no. 1113B). For a similar passage from MS A, fol. 34r, see Heydenreich, *op. cit.*, p. 119.

[65] It appears that Leonardo had improved on Aristotle's somewhat animistic version of this law by assuming that the varying density of the elements alone caused some to rise and some to seek the bottom, relying again on the "force" of compression. For this important interpretation and its sources, see F. Arredi, "Le Origini dell'Idrostatica" (quoted above, n. 4),

which appeared unfortunately in a very inaccessible periodical.

[66] MS A, fol. 55v (Richter no. 941). For the relevance of this idea to Leonardo's physiology, see Keele, *op. cit.*

[67] On the page of C.A., fol. 123r, where Leonardo quotes Aristotle's law of maintenance, he also notes: "La gravità e la forza desideran non essere, e però ciascuna con violenza si mantiene suo essere."

[68] "Or vedi la speranza. . . ." (C. Ar. fol. 156v; Richter no. 1162).

impact of observation and criticism. It is possible to detect a note of scepticism and disillusion in some of the notes that date from this last period; thus we read in MS K dating from *circa* 1507:

The water that moves through the river is either called, or chased, or it moves by itself. If it is called or rather commanded, what commands it? If it is chased, what chases it? If it moves of itself, it shows itself to be endowed with reason, but bodies which continuously change shape cannot possibly be so endowed, for in such bodies there is no judgement.[69]

Even where these changing shapes are concerned there is a new awareness in MS G, the latest of the note-books, of the immense variety and unpredictability of the "infinite number of movements" in water currents, with a marvellous description of a floating object carried along by the jostling waves:

. . . which movement is sometimes fast and sometimes slow, and sometimes it turns right and sometimes left, now up and now down, revolving and turning around itself now this way and now the other, obeying all its movers and in the battle arising between these movers it always falls prey to the victor.[70]

There is a similar awareness of the limits of human knowledge in the note on one of the Windsor drawings concerned with whirling water:

Navigation is not a science that has perfection, for if it had it would save (us) from all peril, as birds are able to do in storms of rushing air and fish in storms at sea and in flooding rivers where they do not perish.[71]

Had Leonardo renounced his ambition to map out all the forms of movement in water and air? Had he given up building the "bird"? We know that in these very years he also abandoned the analogy between macrocosm and microcosm which had guided his thought about the circulation of water and of blood. But though these unifying ideas had broken under his hands, he still

---

[69] "L'acqua che pel fiume si move, o ell'è chiamata, o ell'è cacciata, o ella si move da sè; s'ella è chiamata, o vo' dire addimandata, quale è esso addimandatore? s'ella è cacciata, che è quel che la caccia? s'ella si move da sè, ella mostra d'avere discorso, il che nelli copri di continua mutazion di forma è impossibile avere discorso, perchè in tal corpi non è giudizio" (MS K *iii,* fol. 101*v*).

[70] "L'acqua corrente, ha in sè infiniti moti, maggiori e minori che 'l suo corso principale. Questo si prova per le cose che si sostengano infra le 2 acque, le quali son di peso equale all'acqua, e mostra bene pell'acque chiare il vero moto dell'acqua che le conduce, perchè alcuna volta la caduta dell'onda inverso il fondo le porta con seco alla percussione di tale fondo e refretterebbe con seco alla superficie dell'acqua, se l corpo notante fussi sferico: ma ispesse volte nol riporta perchè e' sarà più largo o più stretto per un verso che per l'altro, e la sua inuniformità è percossa dal maggiore lato da una altra onda refressa, la qual va rivolgendo tal mobile il quale tanto si move, quanto ell'è portato, il qual moto è quando veloce e quando tardo, e quando si volta a destra e quando a sinistra, ora in su e ora in giù, rivoltandose e girando in se medesimo ora per un verso e ora per l'altro, obbidendo a tutti i sua motori, e nelle battaglie fatte da tal motori sempre ne va per preda del vincitore" (MS G, fol. 93*r*).

[71] "La naujcatiõ non e sciẽtia / fatta che abbi perfectione per/che se cosi fussi essi si sal/verebono da ognj pericolo / come fã li ucelli nelle fortu/ne deuenti. dell aria couenti. e i pessci notãtj / nelle fortune del mare e dj/luuj de fiumi quali nõ periscã (Windsor fol. 12666*r*).

Figure 19
Shapes of fishes and boats.
MS G, fol. 50v.

Figure 20
Elasticity of
drapery.
MS A, fol. 4r.

Figure 21
Diagram representing the
compressibility of air. MS E,
fol. 70v.

used their fragments as he had to if he was not to give up the search altogether. In his studies of the air and wind, though he had given up the notion of *antiperistasis*, he continued to assign a great deal of importance to the elasticity of the medium. It is well known that it is precisely this reliance on the compressibility of air that separates Leonardo's studies of flight from modern aerodynamics, where this characteristic is neglected in speeds lower than that of sound.[72] Leonardo remained convinced that it was the compression of the air under the flapping wings of the bird that provided the lift in seeking to regain its normal density. He also much overrated the degree to which the air in front of a moving body was condensed and that in its wake rarefied. It was to this fact that he attributed the turning movements of an object falling through the air. The falling panel compresses the air which therefore pushes it towards the rarefied air and causes it to turn [73] (fig. 21).

[72] R. Giacomelli, "La scienza dei venti di Leonardo da Vinci," in *Atti del Convegno di Studi Vinciani*, Florence, 1953, pp. 374–400.

[73] MS G, fol. 73v. See also MS E, fol. 70v: "L'aria si condensa dinanzi alli corpi che con velocità la penetrano, con tanto maggiore o minore densità, quanto la velocità fia di maggiore o minore furore."

I believe it is this theory which accounts for the most striking feature in Leonardo's so-called Deluge drawings, the way the falling waters curl back as if they formed vortices in the air. The unwinding of the universe is not a simple collapse; it results in fresh vortices that spend their fury in the air, causing winds and tornados.

I hope it is apparent that Leonardo's preoccupation with these swirling and spiralling movements was not entirely a matter of aesthetic preference. Not that his artistic sense did not respond to the beauty of such forms. We need not speculate here, for he said so. In all Leonardo's meticulous descriptions of natural phenomena there are only very few where he allows himself an expression of delight. There is at least one in his notes on water, from his second Milanese period, where he discusses that interpenetration of the elements which is caused by heat. He suggests an experiment with boiling water to which a few grains can be added:

> Through the movement of these grains you can quickly know the movement of the water which carries them, and by means of this experiment you can investigate many beautiful movements which occur when one element penetrates the other.[74]

Imagine the delight that Leonardo with his love of intricacy and interlace must have felt at the crossing and recrossing of waves.

I have spoken at the outset of the unity of Leonardo's thought, and I am certainly convinced that the conception he had formed of the working of impulse and recoil that together create the variegated shapes of water also had its echoes in Leonardo's compositions.

What else is the Last Supper but such a study of the impact a word is seen to make on a group recoiling and returning (fig. 22)? I know that this sounds far-fetched, but this metaphor would not have surprised Leonardo. On the last page of the Codex Leicester he quotes the beautiful

---

[74] "Libro del moto che fa il foco penetrato all'acqua pel fondo della caldara e scorre in bollori alla superficie d'essa acqua per diverse vie, e li moti che fa l'acqua percossa dalla penetrazione d'esso foco. E con questa tale sperienza potrai investigare li vapori caldi che esalan della terra e passan pell' acqua ritorcendosi perchè l'acqua impedisce il suo moto e poi essi vapori penetran pell'aria con più retto moto. E questo sperimento farai con un vaso quadrato di vetro, tenendo l'occhio tuo circa al mezzo d'una d'esse pariete e nell'acqua bollente con tardo moto potrai nettere alquanti grani di panico, perchè mediante il moto d'essi grani potrai speditamente conoscere il moto dell'acqua che con seco il porta, e di questa tale esperienza potrai investigare molti belli moti che accagiono dell'uno elemento penetrato nell'altro" (MS F, fol. 34v). There is another passage, MS F, fol. 48r, of somewhat doubtful reading: "Per fare pelgli [sic, perhaps belli] e spettacoli d'acqua pannicolata, ponendo molti vari ob-

ietti in una corrente bassa eguale e veloce." The same technique is described, without reference to its aesthetic effect, in C.A., fol. 126v. Prof. Pedretti informs me that the incorrect transcription of a note in the Quaderni d'Anatomia (IV., fol. 11v) has so far failed to explain the technique of Leonardo's glass model of the valve of the heart. The note reads as follows: "fa quessta / prova dj / uetro e / moujci dẽtro a/cqᵃ e panicho" (Make this trial in the glass [model] and have water and millet move into it). It is exactly the experiment described in MS F. Prof. Pedretti also tells me that Leonardo's aesthetic intentions at the time of his experiments with "acqua pannicolata" are shown by his notes and drawings concerning "mistioni" (MS F, fols. 42r, 55v, 56v, 73v, 95v; MS K iii, fol. 115r; C.A. fols. 105v, a, 201v, a), a sort of plastic material imitating semi-precious stones—a frozen image of the movements of liquids: "uetro pannjchulato damme inventionato" (Windsor no. 12667v).

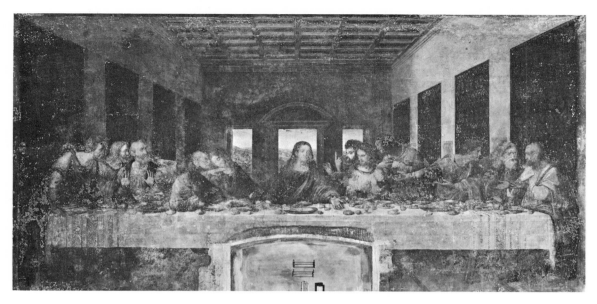

*Figure 22*
The Last Supper.

image from Dante's Paradiso (XIV) illustrating the effect of the words of St. Thomas, who stands outside the circle, on Beatrice in the centre, and then back on her to the circumference:

> *Dal centro al cerchio, e sì dal cerchio al centro*
> *Movesi l'acqua in un ritondo vaso*
> *Secondo ch'è percossa fuori o dentro.*

(From centre to circumference and again from circumference to centre moves the water in a round vessel according to whether it is knocked outside or inside.)

We may link this image with one of the more mysterious of Leonardo's notes on the Propagation of Impulses:

Water hit by water creates circles around the point of impact. The voice in the air creates the same along a greater distance; even larger ones in fire, and longer still the mind in the universe, but since the universe is finite the impulse does not extend to the infinite.[75]

I do not pretend quite to understand this mysterious speculation but I think it justifies our thinking of the actions of rational beings as compelled by similar dynamic laws as those governing the course of water and air.

Once we are on this track we may also compare the central group of the *Battle of Anghiari*

[75] "L'acqua percossa dall'acqua, fa circuli dintorno al loco percosso; per lunga distanza la voce infra l'aria; più lunga infra 'l foco; più la mente infra l'universo: ma perchè l'è finita, non si astende infra lo infinito" (MS H, fol. 67r). Cf. Prof. Marinoni's comment in his contribution to this volume.

*Figure 23*
The Deluge. Windsor 12378.

with the clash of forces interpenetrating in a whirlpool. I would not insist on these comparisons for, of course, they are not needed to prove the effortless transition in Leonardo's *oeuvre* between the studies of water and his artistic creations. As we have seen, the descriptions and drawings of the End of the World cannot be isolated from Leonardo's scientific diagrams and notes (fig. 23).

These astounding creations have found such a vivid response in the doom-laden atmosphere of the twentieth century [76] that I could not add much to what has been written about them. There is only one point that I should like to make and that is a highly speculative one. It is usually assumed that these drawings represent the private meditations of the ageing artist. There is indeed in these sketches an element of that perpetual monologue on which we seem to eavesdrop whenever we try to penetrate into the master's universe. And yet I do not see why this should apply more to the drawings of the Deluge and of Doomsday than to others of his notes and plans. Might he not have planned such a work, a work that would embody his insights into the workings of the elements and the phenomena of nature down to the minutest effect?

I must here warn you that I am going to indulge in unsupported speculations, but I think it

[76] J. Gantner, *Leonardos Visionen von der Sintflut und vom Untergang der Welt* (Bern, 1958).

*Figure 24*
Michelangelo.
The Deluge,
Sistine Ceiling.

would not be out of keeping with Leonardo's character if one connected the crystallization of that project to his rivalry with Michelangelo. Arriving in Rome in December 1513 and staying there off and on till 1516, he cannot but have seen the Sistine Ceiling where he would have found that his erstwhile competitor had progressed even further in the rendering of the human body but that he had retreated even further from the rendering of all the atmospheric effects that for Leonardo constituted the glory of painting. A glance at Michelangelo's rendering of the Deluge (fig. 24) in particular would have convinced Leonardo that his master was not *universale*, no more than *il nostro Botticelli* had been who made *tristissimi paesi*.[77]

Leonardo could still beat him there. Gantner has noticed the distant similarity between Michelangelo's Deluge composition and Leonardo's Windsor drawing no. 12376 (fig. 25) but, more cautious than I, he did not draw any conclusions from this.[78] Might not Leonardo have set to work to demonstrate the rendering of the Deluge or of Doomsday as a vast cosmic catastrophe? Might he not even have dreamt of such a commission?

I repeat that I cannot prove or even make likely the hypothesis that Leonardo hoped to

[77] Cod. Urb., fols. 33*v*-34*r* (McMahon no. 93).    [78] Gantner, *op. cit.,* p. 200.

201

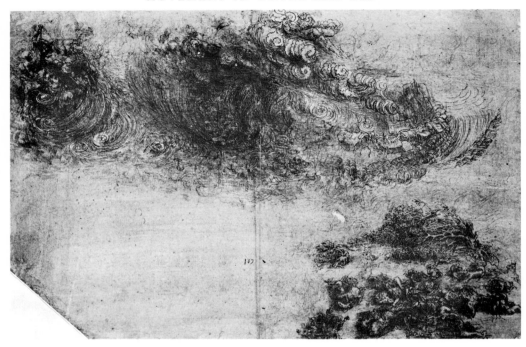

*Figure 25*
The Deluge. Windsor 12376.

crown his studies of the movement of water and air by a work in Rome that would challenge the
great Michelangelo and present a cosmic diagram of the unwinding of the universe. But maybe
we can still catch the last reverberations of such a plan, the circles left by the impact of his mind
on the mind of others.

We remember that where Vasari speaks of the effect that the art of Michelangelo had on
Raphael he attributes to the younger master motives like those I have attributed to Leonardo.
He makes him deliberately avoid a direct competition with Michelangelo's mastery of the nude
and rather concentrate on those compartments of painting his rival had neglected, including
"fires, turbulent and serene air, clouds, rain, lightning." [79]

Vasari may, of course, have made up this interpretation, as he made up others. He may simply
have rationalised the contrast he saw between Raphael's second stanza and his first. But it is also
possible that his story contains an important grain of truth. After all he had a very good source:
he still knew Raphael's favourite pupil Giulio Romano and had been his guest in Mantua some
twenty years after the master's death.

[79] Vasari-Milanesi, IV, 376 ff.

*Figure 26*
Giulio Romano. Wall of Sala
dei Giganti.

I have always felt that the elusive presence of Leonardo in Raphael's work is so strong that we should assume a personal contact between the two, perhaps both in Florence and in Rome. This is a wide field, but we need not explore it to admit at least the possibility that Giulio Romano still knew something of Leonardo's talk and even of his plans to outclass Michelangelo. For this would explain that it was Giulio Romano who both preserved and traduced such a project in that sensational virtuoso piece, the *Sala dei Giganti* (fig. 26), which Sir Kenneth Clark has so surprisingly and yet so rightly linked with Leonardo's conception of art.[80] One hesitates to place the two side by side, but Leonardo's sketches not only contain the blowing wind-gods and the falling mountains, his description even includes the motif of those who "not satisfied with closing their eyes with their own hands, placed one over the other and covered them so as not to see the cruel slaughter of the human race by the wrath of God."[81] And if we look from Giulio's coarse frescoes

[80] K. Clarke, *Landscape into Art* (London, 1949).     [81] Windsor, fol. 12665*r* (Richter no. 608).

*Figure 27*
Sala dei Giganti.
Floor Mosaic.

down to the floor mosaic (fig. 27), we find there the configurations which have preoccupied us, the vortex and the waves, stylized, of course, and possibly misunderstood but still conceivable as reflections of an idea the artist may have heard of in his youth.

But if there was such a lingering memory of Leonardo's project, it was finally blotted out by his surviving rival. Michelangelo's Last Judgement makes us doubt whether even a Leonardo could have evoked a more shattering image *de die illa tremenda*. By the time it was painted science and art had begun to go each its own way.

# Concluding Remarks:
# Science and Art
# in the Work of Leonardo[*]

## by JAMES ACKERMAN

THE MOST GRATIFYING RESULT of this symposium has been that it encourages optimism for the future of humanistic studies. At a time when esoteric specialization so often reduces meaning and inhibits communication, a group of specialists has shown the wit to present discoveries and concepts on the frontier of research in a way that excited fellow scholars and at the same time appealed to an audience of the most diverse interests.

A further gratification has been the proof that, after generations of illustrious publication on Leonardo, fresh insights may still be brought to the subject through the stimulus of modern concepts and innovations in areas outside our own field. This has underscored the creative nature of the historian's calling and has shown that there may be a Leonardo for every generation, perhaps for every moment. In his introductory paper Sir Kenneth Clark revealed a sphere of Leonardo's experiences of the art of antiquity which had been unknown until this moment in spite of the voluminous study of Leonardo's sources, much of it on this very theme. Earlier scholars had sought in antiquity more obvious stimuli for Leonardo's imagination; Sir Kenneth found them in places where they were least expected and proved by his more subtle approach how they could illuminate the criticism of Leonardo's art as well as reveal its roots. Professor Marinoni, in the most profound observations on Leonardo's literary style which have been made, also gave us a wholly new perspective on the artist which, like Sir Kenneth's, reinforced the image of Leonardo's genius for endowing his references to tradition and contemporary practice with his own individual

* This paper is greatly indebted to the essay of Erwin Panofsky, "Artist, Scientist, Genius: Notes on the Renaissance-Dämmerung," in *The Renaissance* (New York, 1962; first published 1953). It has benefited from the criticisms of my colleagues at the symposium, Profs. Gombrich, Heydenreich, and O'Malley.

stamp. Marinoni's characterization of the percussive force of a unique linear style of prose provided a surprising analogy with Dr. Keele's interpretation of Leonardo's theories of sense perception, in which the principle of percussion was convincingly shown to be the concept unifying the investigation of optics, hearing, and touch.

Professor Heydenreich crowned a lifetime of Leonardo studies in demonstrating how the artist, without having completed a single building, altered the future course of architecture—partly through his influence on Bramante—and created an ideal of monumental mass and space based on the science of perspective. In an exciting demonstration of his superior bibliographic technique Professor Pedretti found clues in Dr. Belt's manuscript 35 of the Treatise on Painting for dating the earliest copies in the generation immediately following Leonardo. Dr. Reti and Bern Dibner in their studies of Leonardo's technology revealed a master mechanic whose practical schemes were the product of prophetic theories of force, weight, and motion. This insight into the theoretical foundation of Leonardo's engineering was extended in Professor Gombrich's study of the notebooks on hydraulics to include an analysis, employing methods from recent psychology and philosophy of science, of the relative weight of verbal and visual formulations in Leonardo's scientific method.

Although these papers have treated Leonardo's approaches to quite diverse subjects, they have found common ground in their analysis of the interrelation of his empirical investigation and abstract theory, and in their penetration to the unities of concept on which Leonardo's experiments and hypotheses in the arts and sciences were based. These are timely themes for our generation, which has produced sciences and technologies so complex that even within single disciplines communication is blocked among experimenters, theorists, and those responsible for the practical application of research. As our habits of specialization isolate the arts from the sciences and the sciences from one another, we become increasingly intrigued by Leonardo's capacity to encompass and extend almost the entire body of knowledge of his time. Our Leonardo, then, is likely to emerge as the model of the all-encompassing mind, the Universal Man. But, if we seek a lesson for our time, this image has to be examined with skepticism and reformulated with critical insight; a hardheaded analysis of what Leonardo formulated and how he went about it will do us more good than the invention of the myth of a culture hero. We ought to ask what art and science meant to Leonardo and what sort of synthesis of them he achieved.

First of all, we should admit that while Leonardo's learning was more integrated than ours is it was far short of being "universal." He had little or no interest in history, moral philosophy, theology, law, economy and trade, politics, classical literature, or, except as a practitioner, music —a list that includes practically everything that was believed in his time to be the province of the educated man. It was for this reason that he was called *omo sanza lettere*—"a man without learning"—as he himself proudly confessed in counterattacks on the pedants of his time. The accusation was not strictly true because Leonardo picked up masses of disconnected facts and ideas in his reading, but he tended to poke at rather than to chew on books, and he preferred popular

206

manuals with excerpts to the original sources. Probably he learned more of the achievements of ancient and medieval science by ear than by poring over manuscripts and the few printed books available in his time; his Latin was weak, and he knew no Greek. But he knew whom to listen to and how to listen.[1]

For Leonardo, however, reading, listening, and other paths to knowledge always were integrated with observation; he distrusted learning that could not be supported by visual evidence and, by that token, recorded in drawings. When he did tackle an abstract problem such as the nature of force and resistance, it was usually because he wanted to find reasons for what he had found by observation. Let's hear what he said of his investigations:[2]

> First I make a certain experiment before proceeding farther, because my intention is first to present the experiment and then by reasoning to demonstrate why that experiment is compelled to behave as it did. And this is the true rule according to which speculations on natural effects must proceed. Since nature begins in reason and ends in experiences, we have to follow the opposite route, beginning with experiences and on that basis investigating the reason.

That statement, similar to one quoted by Professor Marinoni, might be called the first law of empirical science. But before saying any more about Leonardo's significance as a scientist or as an artist, we ought to consider what science and art meant in the Renaissance.

"Scientia" and "ars" are words of pure Latin derivation which, so long as Latin was alive, frequently were used together, but not in the sense in which we understand them today. What was meant by *ars* was simply manual proficiency or technique, and what was meant by *scientia* was knowledge or theory.[3] Whether one spoke about anatomy or about painting, the art was the technical skill needed for designing an excavating machine or laying in a glaze, and the science was the body of principles and the tradition of learning that gave the activity some meaning. This is the distinction that Leonardo made when he said "those who fall in line with practice without *scientia* are like pilots who board a ship without a rudder or compass, who are never certain where they are going";[4] I regret to say that the standard English edition of the Treatise on Painting translates *scientia* as "science," when Leonardo meant "theory."[5] The concept of *scientia* as the philosophy guiding creative activity offered the possibility of a true unity of knowledge in the Middle Ages and Renaissance because it was on a level sufficiently generalized to encompass all disciplines.

[1] G. de Santillana, "Leonard et ceux qu'il n'a pas lus," in *Léonard de Vinci et l'expérience scientifique au seizième siècle* (Colloques internationaux du Centre de la Recherche Scientifique, 1952) (Paris, 1953), pp. 43–59; A. Chastel, "Léonard et la culture," in *ibid*, pp. 251–263 E. Garin, "Universalità di Leonardo," in *Scienza e vita civile nel Rinascimento italiano* (Bari, 1965), pp. 87–107.

[2] MS E, fol. 55r.

[3] See J. S. Ackerman, "Ars sine scientia nihil est: Gothic Theory of Architecture at the Cathedral of Milan," in *The Art Bulletin*, XXI (1949), pp. 84–111.

[4] *Codex urbinas latinus* 1270, fol. 39v. Leonardo uses the Latin *scientia*, not the Italian *scienza*.

[5] *Treatise on Painting*, trans. and ed. A. Philip McMahon (Princeton, 1956), I, 48, par. 70 (for the original passage, see II, 39v).

But the union of *ars* with *scientia* which Leonardo thought was essential was as difficult to achieve in those days as it is in ours. Most of the scholars and philosophers trusted only abstract book learning, and most of the artists and technicians only shop practice. When Leonardo came of age there was a young and growing intellectual movement, Humanism, which gradually had gained ascendancy over the scholastic, theological case of late medieval thought. The humanists were not necessarily preoccupied with humans; it was their achievement to have brought to life the knowledge and the languages of the ancient world by discovering and editing the surviving Greek and Roman manuscripts and by reformulating philosophy, science, and the arts on ancient models. Humanism might better have been called Hellenism or something of the sort. Its achievements and influence were increased greatly by the fortuitous perfection of printing just at this time—not only the printing of words, which usually comes to mind in this connection, but the printing of images by the process of engraving.

According to the traditional description, the Humanist Renaissance was an age of rediscovery of man and of the world around him, a time in which the superstitions and abstractions of the Middle Ages were cast aside to make way for modern thought. To call this generalization a half-truth would be generous; if Humanism were the measure, then we should have to confess that in some respect the Renaissance held back invention and discovery by directing attention to a distant and sanctified past.[6] From the very start the majority of scholars then, like the majority now, got involved in parochial preoccupations. Stimulating as it was to have Greek science made available in well-edited and translated volumes, it soon proved that what was stimulated in that atmosphere was a love of books. For many humanists, the world of the ancient scientists was not just a guide to the study of nature, it was an article of faith. A lecture on anatomy in the university, for example, would involve the reading or reciting of passages by the professor from the ancient Roman authority, Galen, while the actual dissection was performed by a servant, whose discoveries cannot have conformed exactly to the text, since the taboos of Galen's time compelled him to use monkeys and other animals as a clue to human anatomy.[7]

The lesser humanists scorned Leonardo for his undignified ways of getting information: he did his own dissections and got his hands dirty. And he replied with biblical fervor: "O human stupidity, do you not perceive that you have spent your whole life with yourself and yet are not aware of that which you have most in evidence, and that is your own foolishness? And so with the crowd of sophists you think to deceive yourself and others, despising the mathematical sciences in which is contained true information." [8]

But not all of the humanists were pedants; some, like Leon Battista Alberti and Nicholas of Cusa, and Marsilio Ficino, formulated concepts and provided tools without which Leonardo would not have been able to work. And it must be admitted that the criticisms leveled at Leo-

---

[6] An interpretation first articulated by Leonardo Olschki, *Geschichte der neusprachlichen wissenschaftlichen Literatur* (Heidelberg, 1919).

[7] Cited by Panofsky, *op. cit.,* pp. 141 ff., and figs 7 and 8.

[8] Windsor "Quaderni Anatomici," II, fol. 14*r*.

nardo by the humanists were not unfounded. In the vast range of his investigations he rarely achieved the ideal fusion of *ars* and *scientia* that was his stated goal. His observations had a way of leading him to more observations rather than to principles or laws of nature, and he seldom arrived at the mathematical description of phenomena (such as the general laws of percussion and waves discussed by Dr. Keele) which he regarded as the only path to certainty in science. As Professor Gombrich has shown, his investigations of hydraulic action were extraordinarily accurate and penetrating and led to practical applications, but his generalizations were visionary—poetic rather than mathematical.

In one sense Alberti came closer to Leonardo's goals than Leonardo did himself; Alberti was not as adept professionally as Leonardo in mathematics, painting, architecture, cartography, and other mechanical arts, but he was an earnest practitioner, as well as a scholar, one of those Professor Marinoni referred to whose powers of theorizing were not inhibited; he arrived at formulations in many fields and got them into print, which Leonardo never did. Alberti was the embodiment of the new Renaissance ideals, ideals to which Leonardo was never fully attuned. Yet Leonardo remains for us the more appealing ancestor, partly because he anticipated the age of empirical science, but even more because his empiricism never shadowed his vigorous poetic prose and his mysterious and fantastic imagination—that air of the Magus and prophet reminiscent at once of the Middle Ages and (as Santillana has observed) of the pre-Socratic Greeks, which permeates his investigations and gives them a spiritual unity that later science lost.

The contrast suggests the rough generalization that while Alberti embraced Renaissance ideals in both his *ars* or practice and his *scientia* or theory, Leonardo owed only his practice to the age of Humanism; his theories were often arcane, an amalgam of elements from the entire corpus of Western thought. The great difficulty of achieving a compromise between fantasy and mathematical description helps to explain Leonardo's failures at synthesis and, on the other hand, his eminent success in one *scientia* that admits and even welcomes a fusion of empirical observation, mathematical order, and imagination: painting. Only as a *painter* did Leonardo effectively alter the evolution of Western culture. But I do not mean "only as an artist," because Leonardo was uniquely successful in elevating painting to the level of natural philosophy; much of what was lost when his manuscripts disappeared was preserved in his pictures.

What we have heard and seen in the course of this symposium demonstrates the extent to which Leonardo's method as a scientist in the modern sense was rooted in the technical innovations of the Renaissance artist's studio. While the scholars who practiced the liberal arts stayed in the library, the artists who were considered lowly practitioners of the mechanical arts were inventing ways to represent rationally the things they saw. This involved two processes which were the cornerstones of Renaissance art and science: first, observation of the world about with the intention of describing its appearance, which implies a certain conviction in the validity of worldly experience and in the educational value of experiment; second, giving a rational order to this visual data, which means fitting the individual subjective experience into a generalized struc-

ture that is more permanent and valid. Professor Gombrich has illustrated the fusion of these methods in interpreting Leonardo's drawings of hydraulic action which, for all their apparent naturalism, are diagrams of logical deductions, not landscape vignettes.

As Leonardo said, the most reliable structure is that of mathematics. We think of mathematics as the language of science: it is the same for all observers, whether their field is astronomy or genetics and whether they write in Arabic or Italian; and in the fifteenth century it was the language of art, too. The novelty and significance of Renaissance art rests not in its interests in the objects of the everyday world—we find that in medieval art as well—but in its aim to submit sense data to mathematical laws. This is why early Renaissance art in Italy, for all its observation, is not simply realistic, but rather maintains a delicate equilibrium between empirical description and abstract mathematical order.

To illustrate the ways in which Renaissance artists subjected observation to mathematical rule, I should like to discuss three innovations in fifteenth-century studio practice which profoundly affected not only the arts but the entire complex of men's responses to the world around them: the newly created sciences of proportion, perspective, and the propagation of light.

Let us first examine the study of proportion. We are accustomed to refer to a standard measurement of a person's height in feet, of weight in pounds, of speed in miles per hour. Ratios of this sort were employed in antiquity and in the Middle Ages, but they were not developed into general systems.[9] In visual images, such as those of a Gothic tympanum or the Bayeux Tapestry, the size of men and trees was not established by a linear standard but by the requirements of the narrative and by social status. Since it was clear who was important and who was not in feudal society, this system was reasonably objective, so it lasted a long time. But it was rather insensitive to distinctions more subtle than "bigness" and "smallness." One could not say that a knight was $3\frac{3}{4}$ times as important (and therefore as big) as a serf. These mathematical concepts of "times as" and "equals," of fractions and ratios, and the like, are the cornerstones of exact description in art or science. Descriptive science is impossible without generally applicable standards of proportion as, for example, in cartography.

One cannot symbolize on paper the form of a city, country, or hemisphere without being able to fix relationships in size among small and large features according to a fixed scale. A medieval map is a guide to what to look for in a town or country but not to where it is or how far from anywhere else. The spectacular achievement of the one generation of Renaissance artists culminating in Leonardo that made possible the drawing of a plan such as figure 1 for the town of Imola had far-reaching consequences. Transferred to a global scale, for example, it made it possible for explorers to set out on the ocean with some idea of how far they might have to go and how long it would take them to find land. Without this faculty the history of our New World would have been quite different if, indeed, there were any history at all. Further, the ability to conceptualize

[9] E. Panofsky, "The History of the Theory of Human Proportions as a Reflection of the History of Styles," in *Meaning in the Visual Arts* (New York, 1955), pp. 55–107.

*Figure 1*
Plan of Imola
(Wind. 12284).

in proportional terms made it possible to give an orderly design to entire cities, so that the urban setting itself might become a work of art.

Dr. Keele has discussed Leonardo's quite different and more abstract application of proportional systems in the investigation of the mechanics of visual and aural stimuli. His figure 3 (p. 4) reproduces Leonardo's diagram of the diminishing intensity or clarity of the impact of sound "waves" in proportion to the increased distance from the point of percussion. Proportion also played an essential part in Leonardo's work on pulleys, as illustrated in Dr. Reti's examination of drawings (fig. 3; p. 73) that study the mechanics of the human arm in terms of the linear ratios of its parts.

For a Renaissance painter, of course, human proportions were of primary importance. His Gothic predecessor, in conformity with his aim of making size a function of significance, did study ways of standardizing the human figure, but they were as symbolic and abstract as the results suggest, and completely indifferent to organic relationships (fig. 2). We cannot say that in contrast to this the Renaissance was interested only in the truth. The aim of Renaissance art and science was to get, through mathematics, a plausible generalization. Just as the artist sought to reproduce not a particular man but man himself, the paragon, so the scientist sought to describe not a particular instance of nature but her general laws. This was *scientia;* it was concerned with the ideal more than with the actual.

An example of this is the drawing discussed by Sir Kenneth (p. 10) which Leonardo

211

*Figure 2*
Villard de Honnecourt,
page from his *Album*,
13th century.

made to illustrate (with slight emendations) a passage from the book by the Roman architect Vitruvius—the only treatise on architecture preserved from antiquity.[10] The point is that the well-proportioned man with his arms and legs outstretched fits into a circle, the center of which is at the navel, and that the arm span from fingertip to fingertip is equal to the height; or, to put it differently, the figure in this position may be inscribed in a square, the diagonals of which cross at the genitals. Now this illustrates how the Renaissance interest in proportion was sustained by the studies of the ancients; but remembering Leonardo's scorn of ancient book learning, we should give this drawing another look. Is it really very different from Villard's Gothic method except that the figures are regular and simple? Its abstract system is not in any way leavened by observation of nature; this man simply is forced into a mold. You have no idea how strange you would feel if your navel were half way between your toes and your crown. But the figure has one inestimable advantage from the Renaissance point of view: it admits operations in terms of ratios;

[10] Bk. III, ch. I.

*Figure 3*
Anatomical study
of the leg
(Wind. 12619).

*Figure 4*
Study of the
female organs
(Wind. 12281).

one of its parts can be compared geometrically to another. The text below states, in part: "From the beginning of the hair to the end of the chin is the tenth part of man's height; from the bottom of the chin to the crown of the head is the eighth part," and so on. This is an early drawing, and Leonardo must have felt that there was no harm in starting with ancient principles so long as one proceeded with constant checking against experience. In fact, a later anatomical drawing refers to the face as a ninth part of the height, not a tenth, as Vitruvius had it.

Leonardo never entirely abandoned this kind of ratio, but as he learned more about anatomy he extended it far beyond the narrow geometric limits of Vitruvius until he was comparing minute parts of the body not only in terms of vertical and horizontal measurement but in three dimensions and in every direction. It was this comparison that made it possible to put all parts

213

of the body structure into proper relation with one another. Applying the science of proportion to his anatomical research (fig. 3), Leonardo was able to produce vivid images of the body in which each part could be represented in its proper place, and of the proper size in relation to other parts, and he and his contemporaries developed schemata of anatomical illustration which required only minor changes throughout the centuries. Figure 3 demonstrates the interdependence of art and science in the Renaissance: no mere dissector could have communicated—or even remembered—his discoveries without being able to record them in terms of a visual scheme. Words are useless unless the image is first in mind, as Leonardo emphasized: [11]

> You who think to reveal the figure of a man in words . . . banish the idea from you, for the more minute your description, the more you will confuse the mind of the reader, and the more you will lead him away from the thing described. It is necessary, therefore, that you represent and describe.

The potentialities of Leonardo's method are beautifully illustrated in his drawing of the female anatomy (fig. 4). There are errors of fact in this description,[12] but they do not diminish its significance because once schemata of this sort had been invented anatomists could correct them easily, even if they could not draw, simply by showing a draftsman what needed to be changed. Later images of this kind provided a significant impetus to the science of surgery by showing the student where to look for particular organs and how big or small they would be.

If we ask how something as simple as proportion came to be at the root of so much learning, one answer is that proportion in fifteenth-century terms was not simple but grandiose; it was a symbol of the order of the universe, as Leonardo suggested when he said, "Proportion is not only found in numbers and measurements but also in sounds, weights, times, positions, and in whatsoever power there may be." [13] In sound, for example, proportion is what makes harmony, and it is significant that it was in Leonardo's lifetime that homophonic music, emphasizing chords, began to supplant polyphonic music, emphasizing separate lines.

One might say that this musical change replaced a linear style with one of greater depth and solidity and we have been seeing just that in art and science.[14] It is not only the rational proportions of elements in these drawings which make them so vivid and instructive, but the sense of depth and atmosphere. This reflection brings us to a second major discipline that distinguishes the fifteenth-century artist from his medieval predecessor: perspective.

Perspective is a mathematical technique of projecting three-dimensional images on a two-

---

[11] Windsor "Quaderni Anatomici," II, fol. 1r.
[12] Charles O'Malley and J. B. de C. M. Saunders, *Leonardo da Vinci on The Human Body* (New York, 1952), p. 456, no. 202.
[13] MS C, fol. 622.

[14] For revealing parallels between late fifteenth-century music, science, and art, see E. Lowinsky, "The Concept of Physical and Musical Space in the Renaissance," in *Papers of the American Musicological Society* (1941; published 1946), pp. 67 ff.

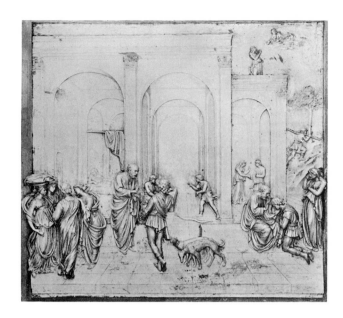

dimensional plane.[15] Like standards of proportion, it was invented primarily to rationalize visual data rather than to achieve "realism." A perspective construction assumes an observer with one eye standing in one position at a fixed distance from the object. The system as standardized by Leon Battista Alberti in the 1430's is illustrated in a relief from the doors of the Florence Baptistery by Lorenzo Ghiberti[16] (fig. 5). The artist, thinking of his picture frame as a window through which he sees the world, begins by dividing the lower border into a certain number of points (at distances of one ell or one-third the height of a person) from which he draws lines (orthogonals) to a central point on a level with the observer's eye. Then he makes a checkerboard pattern on the floor by drawing the same number of lines horizontally, progressively reducing the distance between them by an ingenious geometrical method that establishes the rate of diminution in relation to the assumed distance of the observer from the front of the picture. The purpose of the checkerboard floor is to establish a uniform standard of measurement throughout the illusionary space; wherever a person or a building is to be placed the sides of the little squares will indicate the scale of one ell (notice in fig. 5 that every figure measures three times the length of the front edge of the square on which he stands). Thus every object within the space is related to every other object and to the observer by a fixed proportion.

[15] E. Panofsky, "Die Perspektive als 'symbolische Form,'" in *Vorträge der Bibliothek Warburg* (1924/1925), pp. 258–330; E. Panofsky, *The Codex Huygens and Leonardo's Art Theory* (Studies of the Warburg Institute, 13) (London, 1940); John White's interpretation of Renaissance perspective (*The Birth and Rebirth of Pictorial Space* [London, 1957]) has been corrected, particularly with respect to Leonardo's perspective studies, by Decio Gioseffi, *Perspectiva artifialis* (Trieste, 1957), esp. pp. 106–120; see also the essays of A. Parronchi, *Studi su la dolce prospettiva* (Milan, 1964).

[16] As interpreted by Richard Krautheimer, "Linear Perspective," in *Lorenzo Ghiberti* (Princeton, 1956), pp. 229–253, and diagram 7.

As proportion was a means of relating things in a rational way to each other, so perspective was a means of relating things in a rational way to one's self. While proportion alone establishes only internal relationships within single objects (a man's head is one-eighth his total height) or between objects in the same plane (the man is one-eighth taller than the woman beside him, perspective carries the science of proportion into the third dimension and makes it possible to determine the relation of a man twenty feet away to a woman a mile off. Both are techniques of employing mathematical generalization to eliminate the uncertainties and inconsistencies of normal perception.

As a method of constructing an abstract space in which any body can be related mathematically to any other body, the perspective of the artists was a preamble to modern physics and astronomy. Perhaps the influence was indirect and unconsciously transmitted, but the fact remains that artists were the first to conceive a generalized mathematical model of space and that it constituted an essential step in the evolution from medieval symbolism to the modern image of the universe.

The perspective technique appealed to the artist-scientist primarily on a more earthy level; it proved to be indispensable wherever scientific or technological description was needed. The complex machinery illustrated by Dr. Reti and Mr. Dibner (figs. 17 and 2; pp. 84 and 104) could not have been represented by medieval drafting techniques, and we may assume that the capacity to draw such constructions is related to the capacity to conceive them. The interrelation of graphic technique and three-dimensional conception is particularly noticeable in the evolution of architectural design in the Renaissance.[17] In the church project discussed by Professor Heydenreich (fig 9; p. 133) perspective is employed for the first time to represent buildings in spatial terms, as if the stones were used like a mold to encompass great "positive" voids. This drawing gives us a convincing illusion of what it is like to be inside a structure, and it insists that we perceive spaces rather than surfaces. It is particularly significant because it shows Leonardo's power to expand the rules of perspective beyond the limitations of earlier theorists in order to adjust them better to actual experience: there are two "vanishing" points for the receding orthogonals—one for the lower story, since one would look at it straight on, another for the drum of the dome, since one would tilt one's head to look up. So in one sketch he records a sequence of spatial experiences. It was through such purely graphic exercises that Leonardo, as Professor Heydenreich showed, gave impetus to a new architecture.

A different technique is used in the magnificent embryological study (fig. 6), in which perspective and proportion join to reveal vividly an aspect of nature inaccessible to the average man and, in those days, even to many scientists. Such anatomical studies obviously were not produced by perspective in the sense of the "view through the window," but by foreshortening, which is a

---

[17] See Wolfgang Lotz, "Das Raumbild in der italienische Architekturzeichnumg der Renaissance," in *Mitt. des Kunschist. Inst. in Florenz,* VII (1956), 193–226; L. H. Heydenreich, "Zur Genesis des St. Peter-Plans von Bramante," in *Forschungen und Fortschritte* X (1934), 365 ff.

216

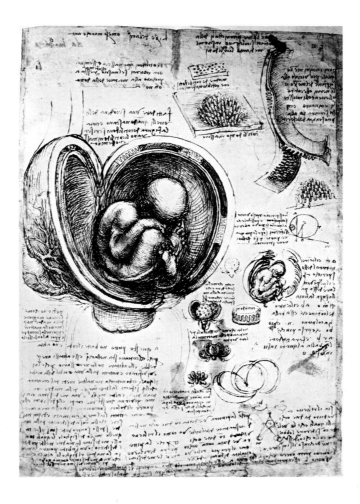

*Figure 6*
Embryological study
(Wind. 19102).

local application of the same principle of geometric projection, as refined by the painter Piero della Francesca in the generation preceding Leonardo's, and by Leonardo himself.[18]

But the perfection of foreshortening would not have produced such convincing images without the aid of another branch of perspective which, while it was to some degree susceptible to geometric rationalization, was more dependent on subjective experience: the depiction of light.

A diagram that Dr. Keele discussed (fig. 10; p. 44) shows the rays of light emanating from an object and coming to a focus in the eye; it looks rather like a perspective diagram because there too the lines are postulated as meeting at the eye. The difference is only that perspective lines, being abstract, can be extended infinitely, while light rays may have different intensities in relation to the intensity of the source and the nature of the atmosphere through which they pass.

The first research in the use of light to create an illusion of the third dimension was carried out

[18] Piero della Francesca, *De prospectiva pingendi,* ed. G. Nicco Fasola (Florence, 1942), esp. Bk. III; and Panofsky, *Codex Huygens,* pp. 62 ff., 98 ff.

by Masaccio in the 1420's. He discovered that the verisimilitude of figures could be increased greatly by employing a single light source throughout a picture (in his church frescoes he identified the source with the actual chapel window). As in linear perspective, the fixed position, in this case of the sun, unified and rationalized a practice that had been scattered and empirical.[19]

The earliest work of Leonardo exhibits an interest in refining the innovations of the early years of the century; his extraordinary studies of drapery (fig. 7) have never been surpassed as a demonstration of the power of light to suggest form. They revive a peculiarly effective technical device of fourteenth-century artists which early Renaissance draftsmen had almost forgotten in their concern for the effects of line rather than of mass: the sheet is prepared by applying an all-over wash of moderate reflective capacity (a deep rose tint in fig. 7), so that the light tones as well as the dark shadows and contours can be applied in pigment. In this way the illuminated areas are brought forward from the ground, whereas on untinted paper they simply are left untouched and remain identical with the ground. This traditional technique was used by Leonardo to give light a positive rather than a negative character.

The role of light in enlivening scientific recording is beautifully revealed in a depiction of the human skull (fig. 8) in which Leonardo used a two-way section made by cuts at a right angle, which he had invented in order to clarify his anatomical presentations. The method is entirely dependent on perspective foreshortening; the light and dark simply make the result more convincing. Lighting does not contribute any additional scientific information, but it communicates a sense of space within the skull that recalls the dome structures of churches and cathedrals in Leonardo's sketchbooks (fig. 13; p. 136). The parallel is not fortuitous; the right-angle cut in the skull probably was inspired by the architect's habit of representing a building in terms of the ground plan and cross section. It was Leonardo who perfected the device, invented by Filarete in the preceding generation, of combining in a single drawing the plan, section, and interior perspective of a building, and it is precisely this method that is applied to figure 8.

The geometrical techniques that were applicable to the description of architectural or anatomical structures could not be employed in the representation of flora. Leonardo's drawings of plants, trees, and flowers (fig. 9) were brought to life primarily by gradations of light and shadow, which helps to make them more real and more beautiful than those found in medieval and Renaissance herbals, where the leaves and flowers usually are flattened out to a two-dimensional image. But the very absence of mathematical or representational schematization introduces another dimension of the relationship of art and science in Leonardo's work. The botanical sketches represent particular plants, rather than the species, and they do so in such an individual way that they could not be repeated or even successfully imitated. Yet they surpass the generalizations of scientific illustration by transmitting a sense of the object's biological function as well as its form.[20]

---

[19] Lotz, *op. cit.*, pp. 197 ff.
[20] A distinction made by Prof. Heydenreich in his perceptive essays on the subject of this paper: *Arte e* *Scienza in Leonardo* (Milan, 1945); see also "Le dessin scientifique de Léonard," in *Les Arts Plastiques,* ser. 6, I (Brussels, 1953).

*Figure 7*
Study of drapery
(Rome,
Gal. Naz.
delle Stampe).

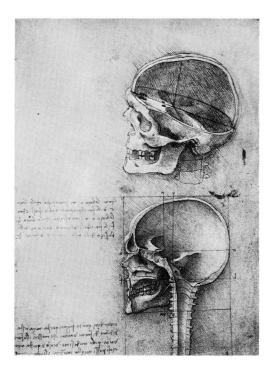

*Figure 8*
Sections of the human skull
(Wind. 19057).

In his last botanical studies (fig. 10) we find that Leonardo has advanced a step further toward a fusion that is characterized best in his own words:

> There are three kinds of perspective; the first is concerned with the principles of the diminution of things as they increase in distance from the eye, and this is called the perspective of diminution. The second is involved with the means of varying the colors as they increase in distance from the eye; the third and last extends to the explanation of how things should be less distinct the more distant they are; the names are as follows: linear perspective; color perspective; the perspective of displacement.[21]

This statement is an introduction to the nature of the synthetic achievement that carried

[21] MS A, fol. 98*v*.

*Figure 9*
Botanical study (Venice,
Galleria dell'Accademia).

Leonardo beyond his early Renaissance predecessors. Masaccio and Piero della Francesca practiced only the first perspective, of geometrical diminution; it was Leonardo who introduced the effects of an ambient atmosphere that one might breathe—a medium that binds together everything in the painted world.

We can see the difference even in a sketch of a clump of trees where color perspective is not a factor (fig. 11). It documents a radical innovation in that individual forms are absorbed in light; we do not see distinct trees but variations in optical texture. As an art historian, I should describe this vision as opening the door to a non-classical invasion that leads not to Raphael and Michelangelo, as Leonardo is supposed to do, but to the mature Titian, Rubens, and Rembrandt, and ultimately to Impressionism. But it also indirectly implies an extraordinary perceptual revolution, and this brings us to Leonardo's *scientia* of painting. In the neo-Platonic environment in which Leonardo was raised, objects in the visible world were held to be imperfect echoes of ideas of these objects existing in the mind of the Creator. Accordingly the uniqueness of things was very important; when one looked at a grove one knew it to be composed of a certain number of trees, and one's knowledge was considered a far more valid guide to reality than one's accidental sense impressions, which could only be delusive and could only transport one farther from the "truth." Earlier Renaissance artists always represented a world of discrete objects. This tiny

220

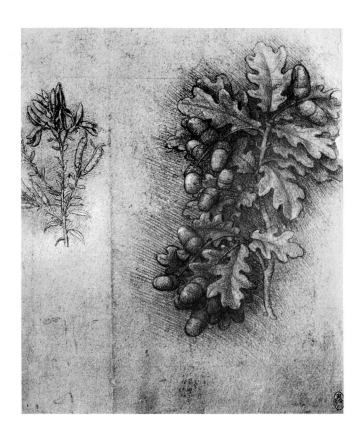

*Figure 10*
Botanical study
(Wind. 12422).

*Figure 11*
Sketch of a
clump of trees
(Wind. 12431).

sketch had far-reaching implications even of a philosophical nature; if reality was to be defined in terms of the sensual reactions of individuals at any moment, then every man would become a law unto himself. Plato's suspicion of the artist was fully borne out.

A panel such as the Madonna and St. Anne (fig. 12) illustrates the application of color perspective, and here again the technical innovation achieves far more than an advance in illusion.

221

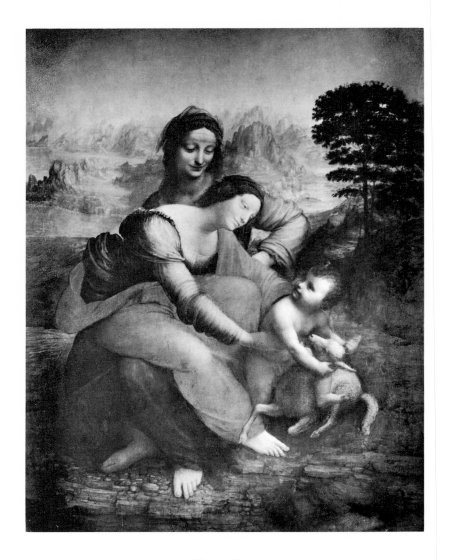

*Figure 12*
Madonna and St. Anne
(Paris, Louvre).

The atmospheric treatment of the figures is a means to describe not only their appearance but their inner states. In the haunting landscape there is evidence of Leonardo's close observation of natural phenomena, but his empirical evidence is subsumed in a vision permeated by his mystical philosophy of nature. In these hills and valleys Leonardo illustrates his theory, discussed by Professor Gombrich, that the waters of the earth pursue an eternal cycle, emerging in hilltop springs, passing by streams, then rivers, to the ocean to vaporize and return to the upper atmosphere, where the coldness causes precipitation that brings them back to the original springs. Moreover, inanimate nature is vitalized in Leonardo's cosmology:

222

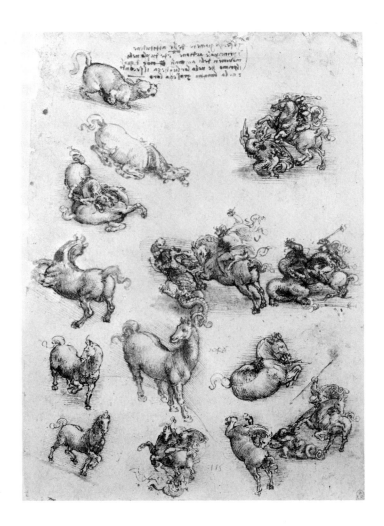

*Figure 13*
Animals in motion
(Wind. 12334).

If a man has a lake of blood in him whereby the lungs expand and contract in breathing, the earth's body has its oceanic sea which likewise expands and contracts every six hours as the earth breathes.[22]

In the same passage he refers to underground springs as veins.

If Leonardo's physical world echoed the biological, the process was also reciprocal. He made studies of animals whose motions extend their anatomical potential to the point of emulating the spiraling action of water and wind (fig. 13).

[22] MS A, fol. 55*v*.

Professor Gombrich showed us how, as Leonardo's interest in the vital forces of nature continued, its scope became more cosmic; he was fascinated and obsessed with catastrophic destruction—by wind, by flood, and even by the kind of all-annihilating explosion we might think of as a peculiar nightmare of the atomic age. Out of this passion for cataclysm came some of the most splendid and moving achievements of his draftsmanship (fig. 14). This vision may be set to an equally vivid text from Leonardo's hand which will serve to illustrate the sense in which Leonardo is universal. The man who inspired Walter Pater to literary arabesques on the mysteries of the smile or glance in a lady's portrait could write for us, the grandsons of Pater:

> The rivers will remain without their waters; the fertile earth will put forth no more her branches; the fields will be decked no more with waving corn. All the animals will perish, failing to find fresh grass for fodder; and the ravening lions and wolves and other beasts that live by prey will lack sustenance; and it will come about after many desperate shifts that men will be forced to abandon their lives and the human race will cease to be . . . Then the surface of the earth will remain burnt to a cinder and this will be the end of all terrestrial nature.[23]

Such visions of the powers of nature gone awry did not emerge from the rational philosophy of the early Renaissance, nor from the empirical techniques of the studio. Yet they are, I believe, the key to Leonardo's unique *scientia*. Searching for the *ragioni*, the causes underlying the phenomena he observed, Leonardo continually found himself facing the necessity and his inability to define the forces operating on things. He called them "spiritual." For a scientist whose experiments were penetrating enough to overthrow the accepted views of the order of nature, and who could not bring himself to assign the realm of the unknown to the province of a rational God, chaos must have seemed as probable a condition as order. I do not mean, however, that Leonardo deduced the probability of chaos from his experiments. Rather, by virtue of his visionary and poetic disposition, he was attracted to a tradition outside of classical science and humanistic philosophy: the tradition of myth and saga, which is filled with cataclysmic finales, the wild unleashing of spiritual forces. And Kenneth Clark's paper has revealed how even within the orbit of classical art Leonardo discovered a Dionysiac spirit of a sort that seldom attracted Renaissance artists (fig. 22; p. 20). How non-classical mythical traditions reached him, I cannot yet say; if not through the astrologers and alchemists, then by other paths which have not been found simply because they have not been sought by scholars who have concentrated on Leonardo's legitimately scientific forebears. There is no place for myth in science as we know it, but I think that Leonardo's work shows that it could permeate a *scientia;* and it remained an essential factor in the work of Kepler.

The admirable fusion in Leonardo's works of art and science, in the modern sense, could not be sustained for long. The artists of the fifteenth century were able to develop the tools of empirical

[23] MS Arundel 263, fol. 155*v*.

*Figure 14*
Cataclysm
(Wind. 12380).

science because the fundamental problems of art and science were those that could be approached with the naked eye. Not long after, in the age of Gilbert, Harvey, and Galileo, technological progress and the accumulation of specialized information extended the range of scientific interest beyond the range of the eye, and artists could no longer be scientists.[24] But the potential for communication on the level of *scientia* remained. We find it in the seventeenth century and later, and I believe it is possible even today at the apex of specialization, if only we would penetrate through the technical detail to fundamental aims and principles.

I fear I have not succeeded in my remarks in synthesizing adequately the remarkable contributions to this symposium. Surely I have colored with my own biases the more scholarly and more original observations of my brilliant colleagues. But as the work of the historian might be described as the judicious application of biases to presumed events, I lacked the capacity to represent them as they deserved.

[24] See J. S. Ackerman, "Science and Visual Art," in *Seventeenth Century Science and the Arts* (Princeton, 1961), pp. 63–90.